UNVEILED

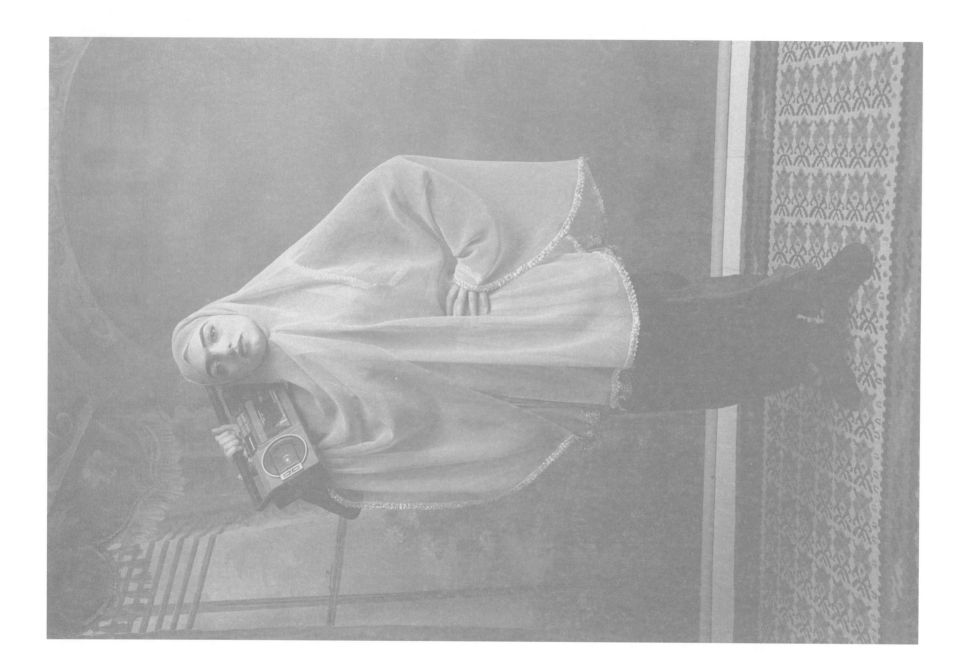

Shadi Ghadirian
Untitled from the Ghajar Series
1998–1999
C-print
203 × 152cm

شادي غديريان
بدون عنوان من سلسلة الغجر
١٩٩٩–١٩٩٨
صورة سي
سم ١٥٢ × ٢٠٣

Saatchi Gallery

UNVEILED
NEW ART FROM THE MIDDLE EAST

Booth-Clibborn Editions

LOOK AGAIN

Lisa Farjam

The Middle East today is routinely viewed through the all-too-predictable prism of strife, oppression, terrorism. From this vantage point it is perceived as dark, distant, ambiguous, other. Such handy clichés obscure a great deal—from vigorous civil societies to, as concerns us here, robust independent art scenes, in cities stretching from Marrakech to Tehran. They also obscure a history of cultural activity that goes back centuries; after all, the current activity in the art scene, exciting as it is, does not exist in a vacuum.

In twentieth century Iran, for example, the camera's rapid adoption by the bourgeoisie paved the way for generations of studio and itinerant photographers, making the Iranian relationship to

photography—and by extension, cinema— a fascinating area of study to this day. Meanwhile, in the earlier part of the 20th century in neighbouring Iraq, modernists had pioneered a distinctive style in painting and sculpture that referenced Western aesthetics but was also entirely its own (in Iraq, as in Egypt and elsewhere, a generation of art students went abroad to study in the Beaux-Arts institutes of the world, coming back to their countries of origin to spearhead novel hybrid art forms). In Sudan, a tremendous "Khartoum School" came of age in the 1960s, drawing inspiration from indigenous art forms, but also radically reconfiguring them.

Still, these histories were not extensively documented, and therefore eluded the notice of a wider public outside their own countries. As the art centres of the West slowly began to take notice of these movements, Britain's former colonies, the Arab populations in the suburbs of Paris, and contemporary art from sub-Saharan Africa all became the subjects of sweeping exhibitions and hefty volumes in museums around the world. While some of these shows were less interesting or complex than others, the instinct behind them was often a productive one. At the same time, many of these exhibitions provided artists with the first platforms they may have had to share their work with international audiences; that in itself was a powerful thing.

And then came the geopolitical earthquake that was 9/11. Suddenly, the Middle East was antithetical to the things liberal democracies loved and cherished most. In that faraway place, precious little value was placed on education, on civic life, or on the arts at large. Put plainly, such depressing, parochial views failed to account for any possibility of a vibrant cultural life in cities like Beirut, Cairo, Tehran.

On the occasion of the exhibition "Unveiled," we are afforded an opportunity to catch a glimpse of some of the extraordinary artistic expression emerging from the Middle East region and its Diaspora, expression that is in dialogue with its past, occasionally born of an unwieldy present, but also very much looking to the future.

Traditionally, the arts have been part of the story countries tell the world about themselves. Upon gaining their independence, one of the first things post-colonial countries went about doing, for example, was erecting a national museum. Heads of state co-opted culture for domestic political agendas too. Just think of Saddam Hussein's monumental architecture, Leopold Senghor's privileging of negritude as cultural expression, or the Shah's efforts to build up one of the best modern art collections outside of the West.

Opening art schools, too, has been a part of this story. Across the Middle East, national arts academies were established throughout the twentieth century. Prince Yusuf Kamal of the Egyptian royal family launched the School of Fine Arts in Cairo in 1908. Likewise, in 1931, the Iraqi government under King Faisal I began allocating scholarships for art studies abroad. In 1936 the Ministry of Education in Iraq founded the Music Institute that would eventually become the Arts Institute in 1939. The side-effects of such investments meant that a generation or two of young people had the chance to become professional artists. National collections were inaugurated and, in the particular case of Egypt, an arts biennale launched. Today, we are in the midst of witnessing the legacies of these state-initiated investments, along with the independent arts scenes that have sprung up around them.

Much ink has been spilled over how the Islamic Revolution of 1979 left Iran an inhospitable place for cultural expression. And yet, on the contrary, the Iranian art scene has rarely been so active. A glance at the country's formidable film industry is testament to that energy. The Revolution itself recognized the power of images. Officially sanctioned war documentaries, wall murals canonizing martyrs, as well as museums dedicated to the memory of wars fought revealed the diverse uses of the visual arts.

While the Revolution put a freeze on contemporary arts for a while, its aftermath gave birth to a new generation of artists and impacted ways of perceiving art. As thousands of young men volunteered to go to the front in Iran's eight-year war with Iraq, many of them traveled with their cameras in hand. In the meantime, painters and sculptors in the modernist tradition continued to produce work—from Parviz Tanavoli and Hossein Zenderoudi, to younger artists such as Khosrow Hassanzadeh.

The press fixates on the preponderance of anxious, discontented Iranian youth under the age of 30. Less is said about the subcultures between them. Tehran itself boasts a dense maze of private galleries. Artists stage public works in abandoned buildings, mosques, open fields. Others host galleries on the Internet, where they show and sell their work, as well as collaborate with local and foreign partners.

Brothers ROKNI and RAMIN HAERIZADEH are part of a generation of Iranian artists who are producing work that is born of the Iranian context in which they find themselves, but also not in any way limited by it. ROKNI, undoubtedly one of the most gifted painters working in Iran today, references traditions of Iranian portraiture in his work—accentuating, playing, and taking liberties with those traditions wherever he can. His elongated figures look like a bit like poofy cushions, oriental ballerinas en route to a ball. His playful, colloquial titles hint at the most subtle social satire that is both about this time and place, but also about any other.

Likewise, RAMIN teases convention in his digitally-manipulated photographic works, turning codes of portraiture—and even codes of gender—on their head. In these whimsical photo-montages, one notes a symmetrical quality, almost as if the artist is injecting a new life into classic Islamic geometries.

BARBAD GOLSHIRI, in the meantime, may be less subtle about taking on his surrounds—though no less powerful. The son of one of Iran's greatest writers, who was equally known for his activist credentials, golshiri does not shy from addressing the political. His "Where Spirit and Semen Lie" takes the epic Rimbaud quote "JE EST UN AUTRE" as its ostensible inspiration. In GOLSHIRI's work, the French poet and anarchist's photograph is presented, but his eyes are replaced with that of a politician's. A blue curtain in the background, in the meantime, evokes the curtains that we all live with, some more obfuscating than others. In his "The Portrait Of The Artist As A One Year Old," GOLSHIRI takes a baby photograph of himself and prematurely ages the face. Here, the violation of innocence is at once jarring, and poetic in its simplicity.

The poetic intermingling of life and death seems to be an ongoing concern for Iranian artist AHMAD MORSHEDLOO. Here, the elegiac solemnity of a young woman featured in one of his portraits is ravishing. Her body, lying as it is, is at once sarcophagus and shrine, clothed in flowers that seem to reference the burial sites of martyrs of the revolution.

SHADI GHADIRIAN's "Untitled from the Like Every Day Series" involves stylized domestic instruments—a broom, an iron, a tea cup—shrouded in a veil. GHADIRIAN, who is influenced by Qajar traditions in Iranian photohistory, does not how to the standard image of the darkly-clad Muslim woman; these veils are full of color and life. At the same time, by robbing her portraits of faces, and hence context, the photographer raises subtle questions about the role of convention, even routine, in the lives of women in her native Iran—but also just about anywhere. Amsterdam-based TALA MADANI equally takes iconography from her own culture as her point of departure. Her luscious tableaux, marked by bold primary colors, often star a sort of canonical Middle Eastern man with bushy eyebrows and a generous girth. She references many of the clichés we have about the Middle East (it is full of hirsute terrorists, and so on), though it is never clear who exactly the joke is on. The incongruity, the beauty of her lush strokes combined with the comic dandiness of her protagonist, is pleasingly enigmatic. And it just makes you giggle.

Sometimes, "place" is a compendium of geographies. SARA RAHBAR's *sculptural flags, for example, is a pastiche of western and eastern influences and everything in between. Or take* KHALED HAFEZ's *tableaux, which recreate a bizarre world in which the pharoanic meets the firmly contemporary.* JEFFAR KHALDI, *in the meantime, opts for a surrealist ethos in evoking the unreality of the Palestinian situation that he knows best in his vivid nightmarish paintings.* ALI BANISADR, *likewise, evokes the surreal in his dense canvases. They reference everything from medieval Persian history to the grueling Iran-Iraq war of the 1980s. And* NADIA AYARI *channels the particularity of her experience as a Tunisian, but then abstracts it into the powerful iconicity of the generalized and everyday: and here we have the fence, the religious book, the place of worship and so on—each more powerful than the next in their simplicity.*

A subtle irreverence is also at the heart of Iraqi-born HAYV KAHRAMAN's *canvases—gorgeous miniature-style evocations of Oriental women. Fine and lithe, they are captured here in the most unlikely of situations—say, presiding over a slaughtered sheep. Seductively decorative at first glance, they inspire a second take, as if to say that it is women who often bear the greatest weights. Fellow Iraqi* HALIM AL-KARIM, *in the meantime, presents images as triptychs that seem to hint at the distortions born of war. Abstracted from any trace of place or time, his photographic portraits come in and out of focus like any recurring nightmare would.*

New York-based Iranian artist LALEH KHORRAMIAN *paints, her surfaces encapsulating a sort of rumination on the medium itself. Often enormous in scale and intricately textured, her canvases look as if they have lived many different lives. These fantastic landscapes suggest another world, channeling a tradition of Persian miniatures, but also an unnamable time and place. Inspired in part by Persian calligraphy,* FARSAD LABBAUF's *works also references his cultural heritage. The weaving patterns of carpets and tile works are all recalled in the fragmented compositions of his work.*

Place is also ambiguous in the work of Baghdad-born AHMED ALSOUDANI. *While his canvases, which often take violence as their subject matter, are ostensibly about his native Iraq and its misfortunes, they are also somehow absent of context. At times, his paintings, Guernica-esque in ambition, appear to be referencing western art historical tropes. They have no centre; they are chaotic, harried, even furious.* ALSOUDANI *suggests violence without shoning too much of it, raising questions about how we represent strife, and also the Sontagian question of how we relate to the pain of distant others. His are, in the end, more psychological portraits than anything else.*

Syrian-born DIANA AL-HADID's crystalline sculptures seem to reflect her preoccupation with progress and its attendant promises. One of her labyrinthine structures is based on a plan for the Cathedral at Chartres. Another takes its name from a famed particle accelerator (namely the Large Hadron Collider at the Franco-Swiss border, which scientists are using to understand the Big Bang). And yet here, her sculptures appear as fallen as the Babels, sad odes to grand ambitions that have fallen by the wayside, fallen into obscurity.

That brings us to the "Unveiled" of the exhibition at hand, which inevitably carries with it multiple meanings, multiple resonances. Most immediately, there is the veil that one readily associates with this part of the world, the one that teases, that obscures, that hides—and most poignantly, that is to be fetishized as a marker of difference. The works presented here, in all of their diversity, mark one step in moving beyond the magic of the fetish.

And while the geopolitical is not a thread that runs through all artworks from the Middle East—indeed some of the artists featured here even settle into abstraction, others are uninterested in national origin at all—it is occasionally a reference point. The Beirut arts scene, for example, is remarkable in part because of its close-knit, collaborative nature, but also because of the abundance of work that is produced within its bounds in reference to the country's own turbulent histories. MARWAN RECHMAOUI, for example, has fashioned a large-scale recreation of the city of Beirut from black rubber. His map is carved up according to all of the Mediterranean city's sixty districts. It is remarkable for its intricacy, and then again, striking in its randomness. How did the map take on this particular form? Who drew it up in the first place? At hand here is the arbitrary nature of divisions, whether east or west, Christian or Muslim, or otherwise. In this way, RECHMAOUI's work reflects an ongoing preoccupation of many of his peers, namely the slippery nature of history and a related distrust of rarified signifiers of "truth"—whether in the form of a photograph, an archive, or even here, a map.

And this is just the beginning. From Los Angeles to Berlin to Beirut and beyond, artists from the Middle East are shattering tidy preconceptions and making us all rethink a part of the world that has been subject to one too many clichés. Independent initiatives such as Cairo's Town-house Gallery, Beirut's Ashkal Alwan, or Jordan's Darat Al Funun are providing platforms for a new generation of artists. In five short years from now, the emirate of Abu Dhabi will host one of the most dense concentrations of cultural resources the world has known and, in the meantime, Dubai is home to a burgeoning gallery scene as well as one of the most interesting additions to the art fair calendar we have seen in some time.

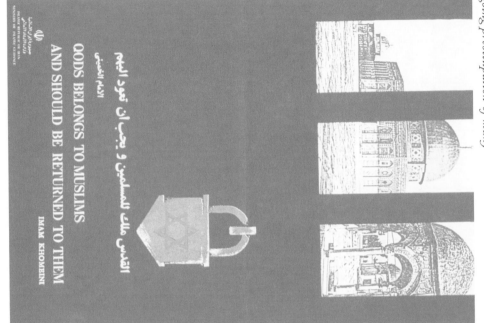

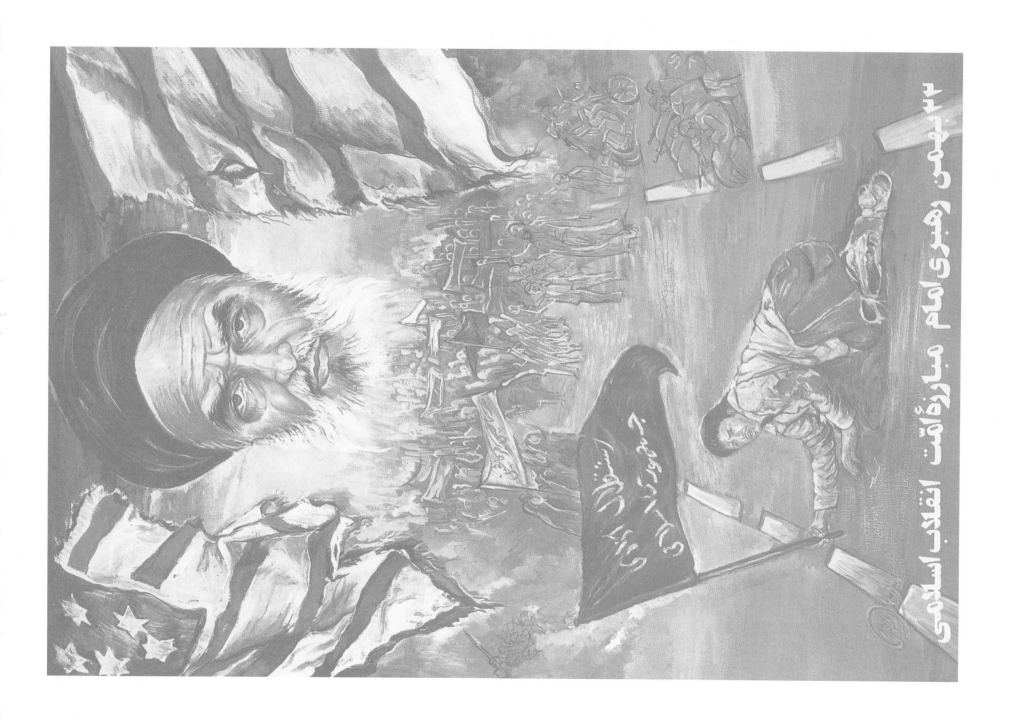

Diana Al-Hadid 01–04
Born 1981 in Aleppo, Syria
Lives and works in Brooklyn, New York, USA

Halim Al-Karim 05–13
Born 1963 in Najaf, Iraq
Lives and works in Denver, Colorado, USA

Ahmed Alsoudani 14–20
Born 1975 in Baghdad, Iraq
Lives and works in Berlin, Germany

Nadia Ayari 21–30
Born 1981 in Tunis, Tunisia
Lives and works in New York, USA

Kader Attia 103–105
Born 1970 in Paris, France (Algerian)
Lives and works in Paris, France

Ali Banisadr 33–36
Born 1976 in Tehran, Iran
Lives and works in New York, USA

Shirin Fakhim 92–97
Born 1973 in Tehran, Iran
Lives and works in Tehran, Iran

Shadi Ghadirian 54–60
Born 1974 in Tehran, Iran
Lives and works in Tehran, Iran

Barbad Golshiri 31–32
Born 1982 in Tehran, Iran
Lives and works in Tehran, Iran

Ramin Haerizadeh 37–41
Born 1975 in Tehran, Iran
Lives and works in Tehran, Iran

Rokni Haerizadeh 42–53
Born 1978 in Tehran, Iran
Lives and works in Tehran, Iran

Khaled Hafez 61
Born 1963 in Cairo, Egypt
Lives and works in Cairo, Egypt

Wafa Hourani 98–99
Born 1979 in Hebron, Palestine
Lives and works between Ramallah and London

Hayv Kahraman 66–70
Born 1981 in Baghdad, Iraq
Lives and works in Arizona, USA

Jeffar Khaldi 71–74
Born 1964 in Lebanon
Lives and works in Dubai, UAE

Laleh Khorramian 75–76
Born 1974 in Tehran, Iran
Lives and works in New York, USA

Farsad Labbauf 77
Born 1965 in Tehran, Iran
Lives and works in New York, USA

Tala Madani 78–91
Born 1981 in Tehran, Iran
Lives and works in Amsterdam, The Netherlands

Ahmad Morshedloo 100–102
Born 1973 in Mashhad, Iran
Lives and works in Tehran, Iran

Sara Rahbar 105
Born 1976 in Tehran, Iran
Lives and works in New York, USA

Marwan Rechmaoui 62–65
Born 1964 in Lebanon
Lives and works in Beirut, Lebanon

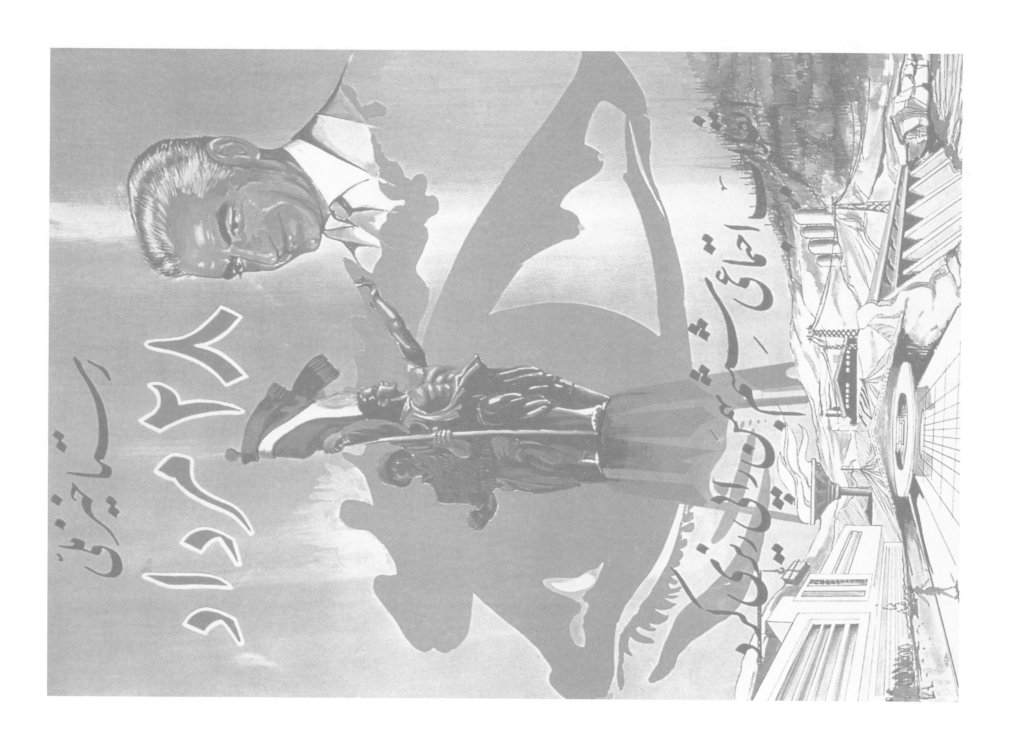

Corporate Partner

Gallery Patron
PHILLIPS
de PURY & COMPANY

Founding Patron
CHANEL

Dinesen

Media Sponsor
THE SUNDAY TIMES

Corporate Patrons
Allford Hall Monaghan Morris
Artistic Investment Advisers
Arup
ClearChannel Outdoor
Coutts & Co
ERCO
Goedhuis & Co
Jackson Coles
Loughton Contracts
Veuve Cliquot
Vitra
Walker Morris

The Saatchi Gallery would also like to thank:

B21 Gallery
Bodhi Art
Galeri Artist
Galerie Krinzinger
Goff + Rosenthal
Irena Hochman Fine Art
Jason Lee
John Martin Gallery
Leslie Tonkonow Artworks + Projects
Lombard-Freid Projects
Maria Vega & Ministry of Nomads
Mehr Gallery
Perry Rubenstein Gallery
Salon 94
Sfeir-Semler Gallery
Silk Road Gallery
Thierry Goldberg Projects
Union Gallery
Wedel Fine Art

The Saatchi Gallery gratefully acknowledges the following photographers who have contributed images of the artworks:

Tom Baker, Sam Drake, Chris Morgan, Justin Piperger, Tom Powel of Tom Powel Imaging, New York, Adam Reich and Steve White.

Foreword: Lisa Farjam

Design: Value & Service

First published in 2009 by Booth-Clibborn Editions in the United Kingdom
www.booth-clibborn.com

The images within the introduction are taken from Staging A Revolution: The Art of Persuasion in the Islamic Republic of Iran By Peter Chelkowski and Hamid Dabashi ©2000 Booth-Clibborn Editions

The information in this book is based on material supplied to Booth-Clibborn Editions by the Saatchi Gallery. While every effort has been made to ensure accuracy, Booth-Clibborn Editions does not under any circumstances accept responsibility for any errors or omissions.

A cataloguing-in-publication record for this book is available from the publisher.

ISBN
978-1-86154-313-4

Printed and bound in Hong Kong

01–02

Diana Al-Hadid
The Tower of Infinite Problems
2008
Polymer gypsum, steel, plaster, fibreglass, wood, polystyrene, cardboard, wax and paint
Part 1: 241.3 × 442 × 251.5 cm
Part 2: 160 × 210.8 × 266.7 cm

ديانا الحديد
برج المشاكل الأبدية
٢٠٠٨
جبس بوليمر، صلب، جص، فيبرجلاس، خشب، بوليستيرين، ورق مقوى، شمع وطلاء
الجزء ١: ٢٤١٫٣ × ٤٤٢ × ٢٥١٫٥ سم
الجزء ٢: ١٦٠ × ٢١٠٫٨ × ٢٦٦٫٧ سم

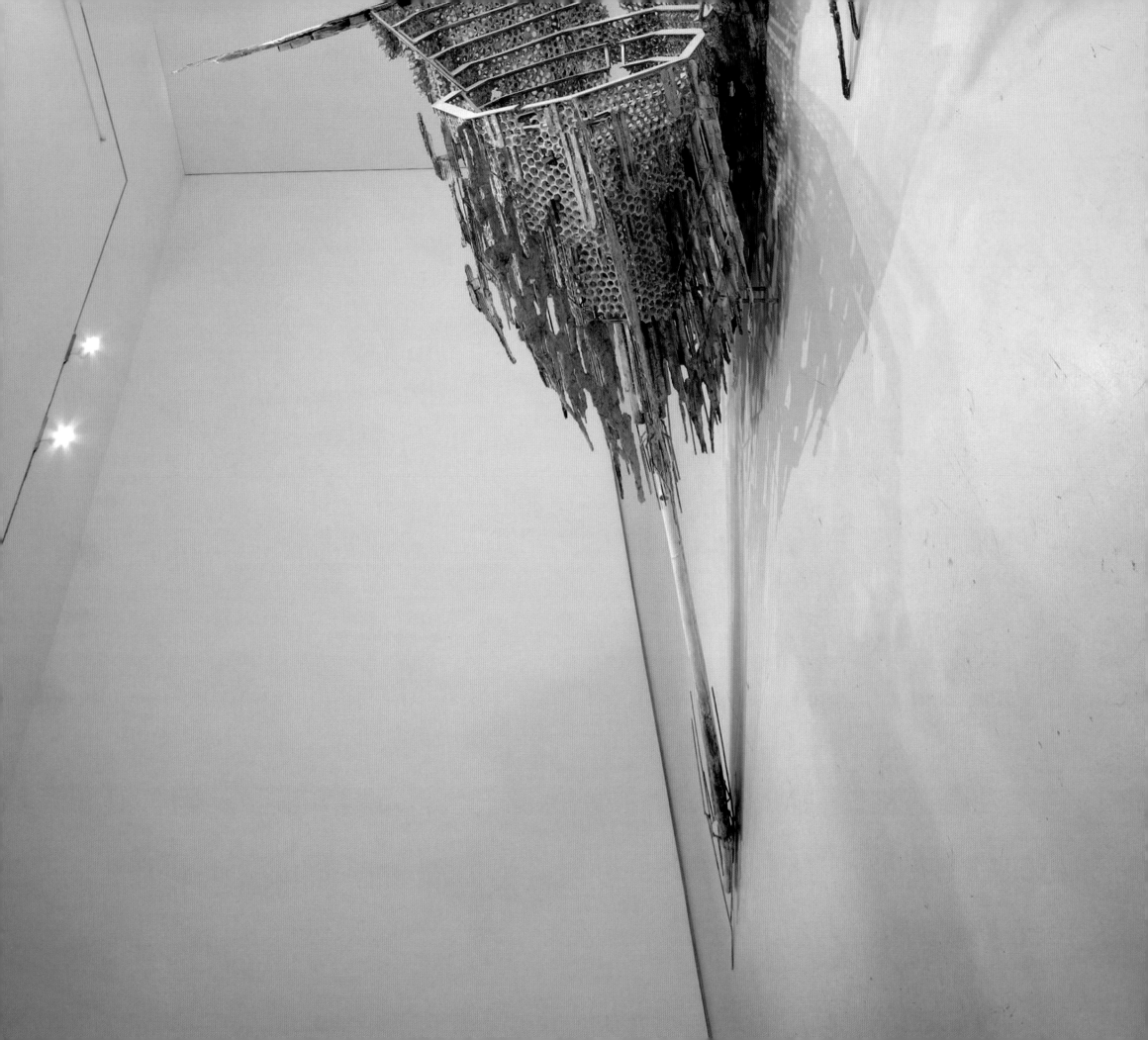

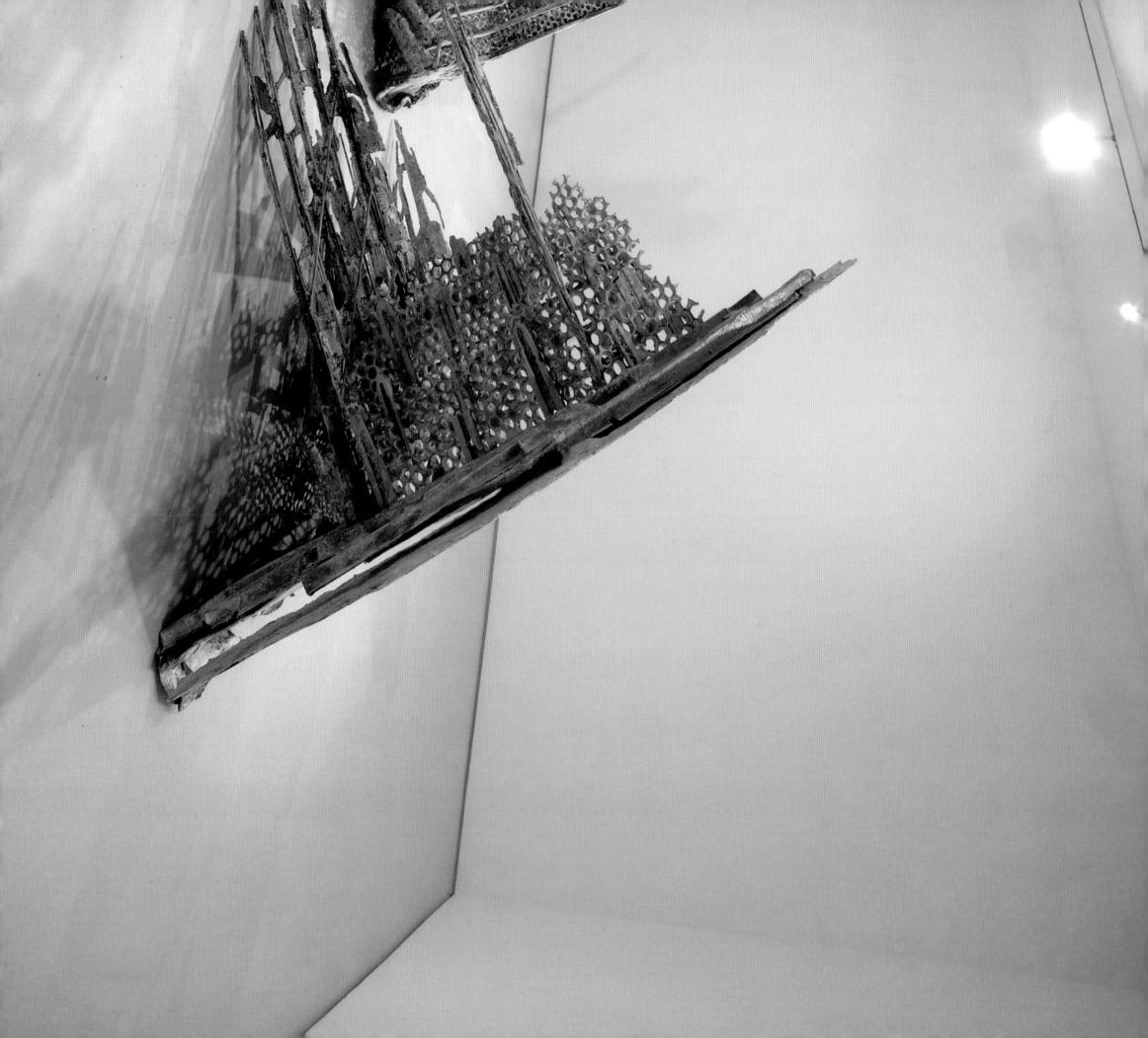

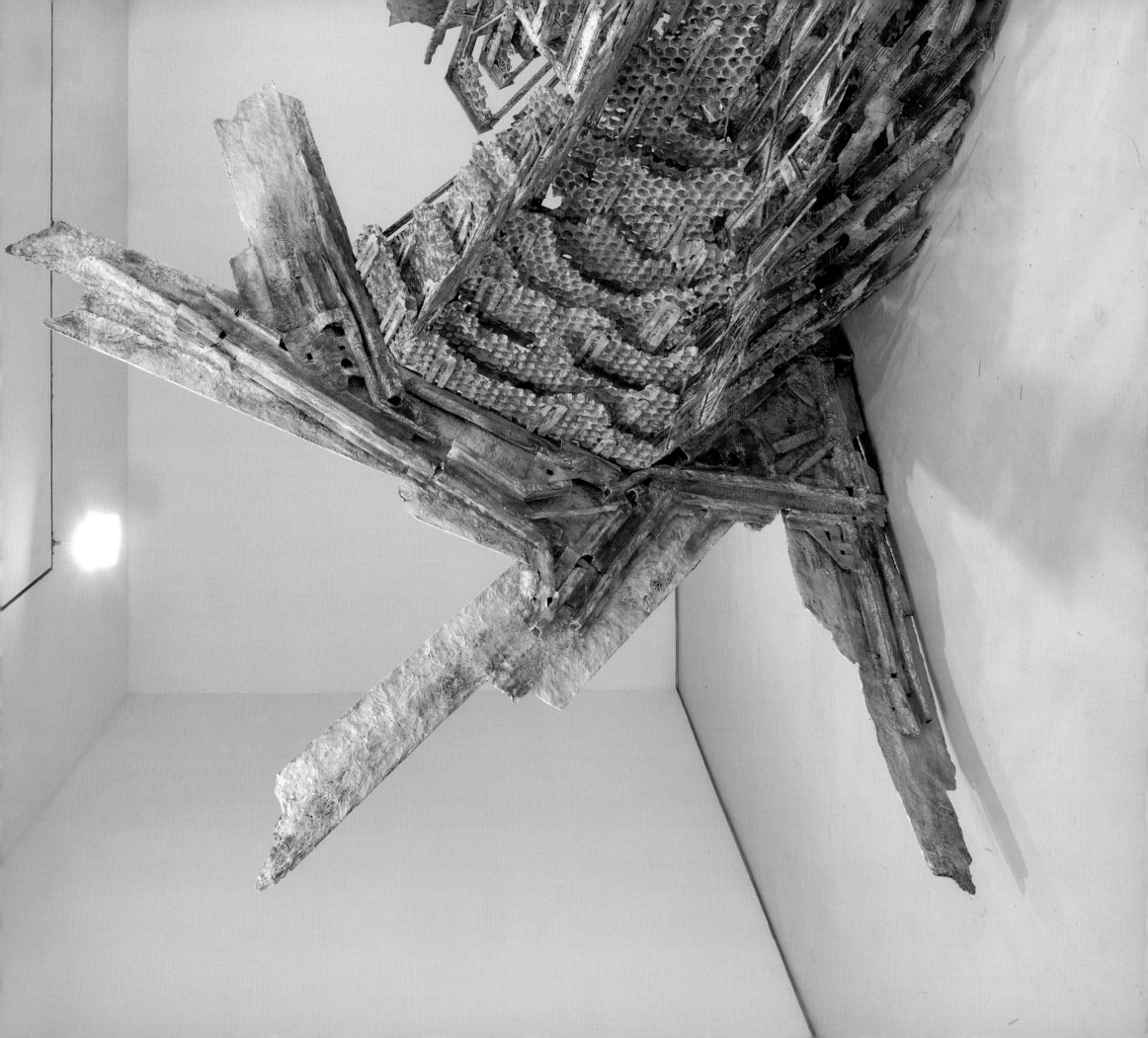

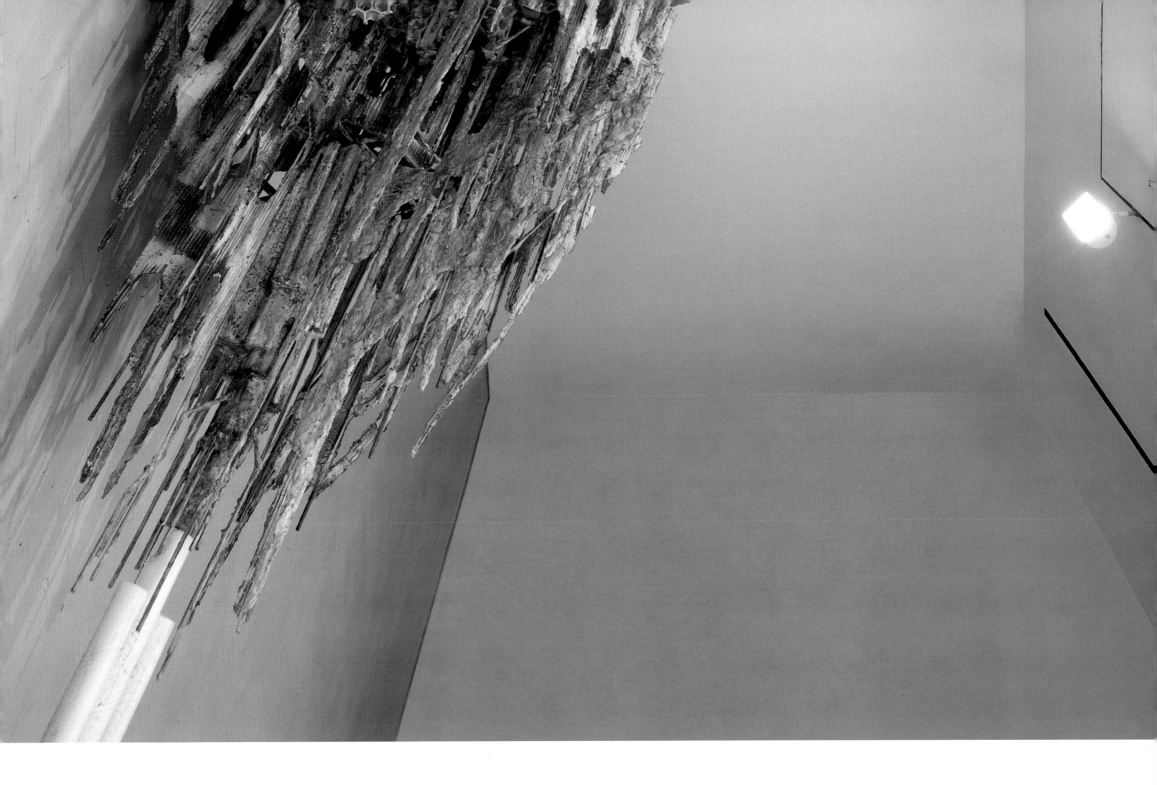

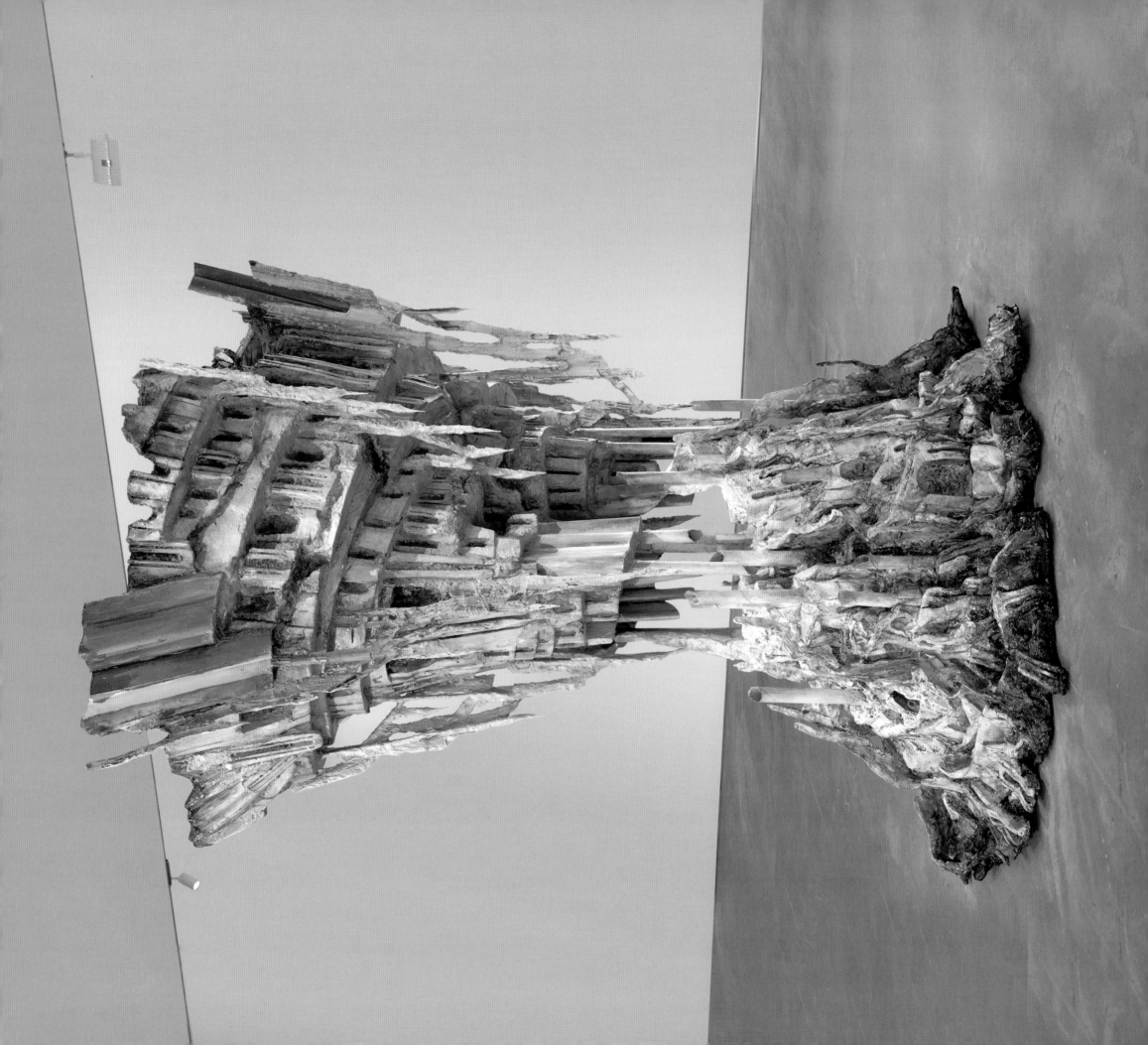

03 ١.٦

بيانا الحديد
أذابة ذاتي
٢٠٠٨
جبس بوليمر، صلب، بوليسترين، فلين، كرتون، شمع وطلاء
١٩٠.٥ × ١٤٧.٣ × ١٤٢.٢ سم

Diana Al-Hadid
Self Melt
2008
Polymer gypsum, steel, polystyrene, cardboard, wax and paint
190.5 × 147.3 × 142.2 cm

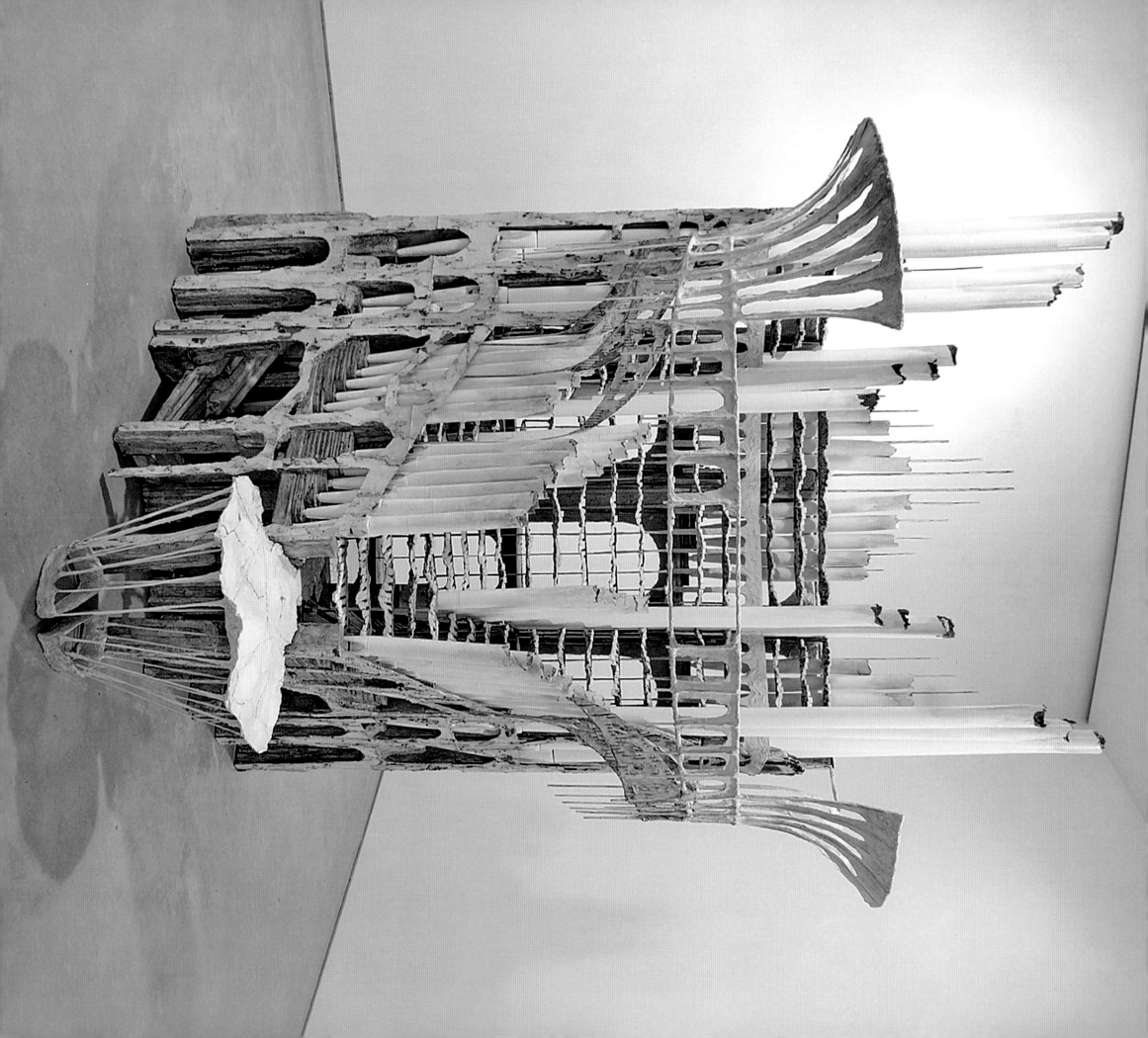

٠٤ 05

حليم الكريم Halim Al-Karim
الحرب الخفية Hidden War
١٩٨٥ 1985
طبعة لمبدا Lambda print
١٣٨ × ٣٢٤ سم (ثلاثية) 138 × 324 cm (Triptych)

١.٢ 06

حليم الكريم *Halim Al-Karim*
الوجه الخفي Hidden Face
١٩٩٥ 1995
صورة منضدة *Lambda print*
(ثلاثي داخلي) سم ٣٠٠ × ١٣٨ *138 × 300 cm (Triptych)*

(الساس) ١.٢ 07 (overleaf)

الفكرة الخفية Hidden Theme
١٩٩٥ 1995
صورة منضدة *Lambda print*
(ثلاثي داخلي) سم ٣٠٠ × ١٣٨ *138 × 300 cm (Triptych)*

١.١ 08

حليم الكريم Halim Al-Karim
الشهود الخفيون Hidden Witnesses
٢٠٠٧ 2007
صورة مضيئة Lambda print
سم ٢٠٠ × ١٣٨ 138 × 300 cm (Triptych)
(لوحة ثلاثية)

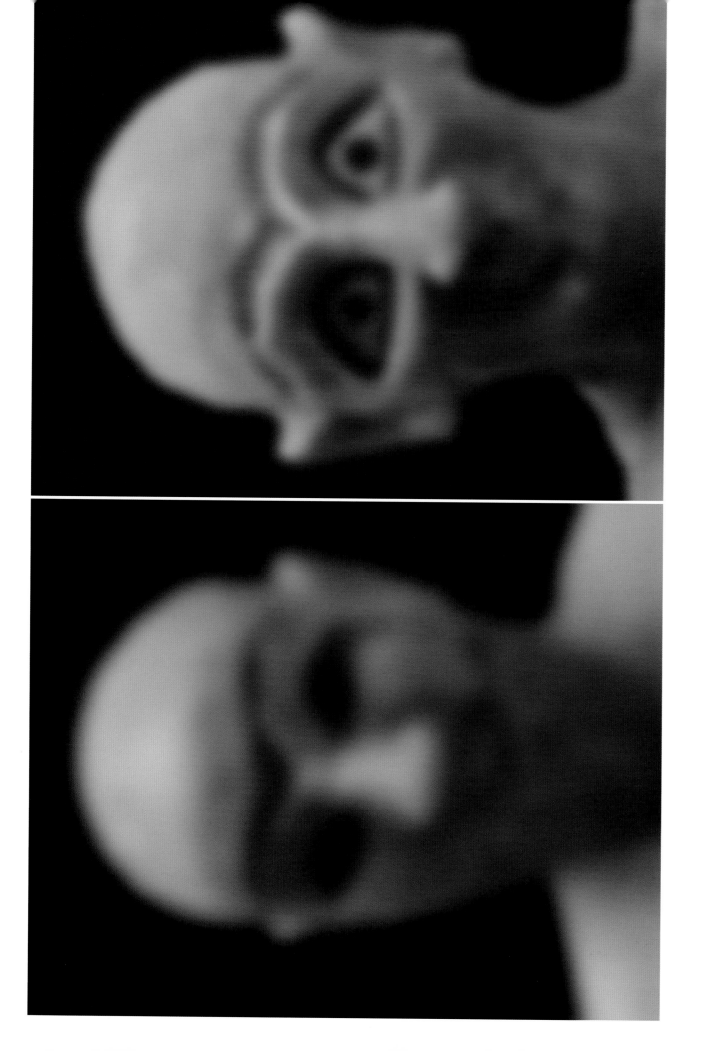

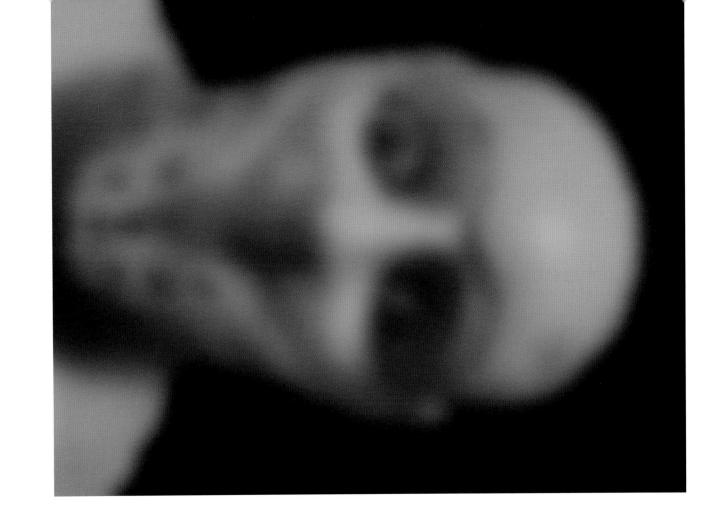

09

Halim Al-Karim
Hidden Prisoner
1993
Lambda print
158 × 369 cm (Triptych)

10 (overleaf)
Prisoner Goddess
1993
Lambda print
124 × 372 cm (Triptych)

حليم الكريم
السجين المختفي
١٩٩٣
طبعة لامدا
١٥٨ × ٣٦٩ سم (لوح ثلاثي)

١٠ (السجين)
إلهة السجين
١٩٩٣
طبعة لامدا
١٢٤ × ٣٧٢ سم (لوح ثلاثي)

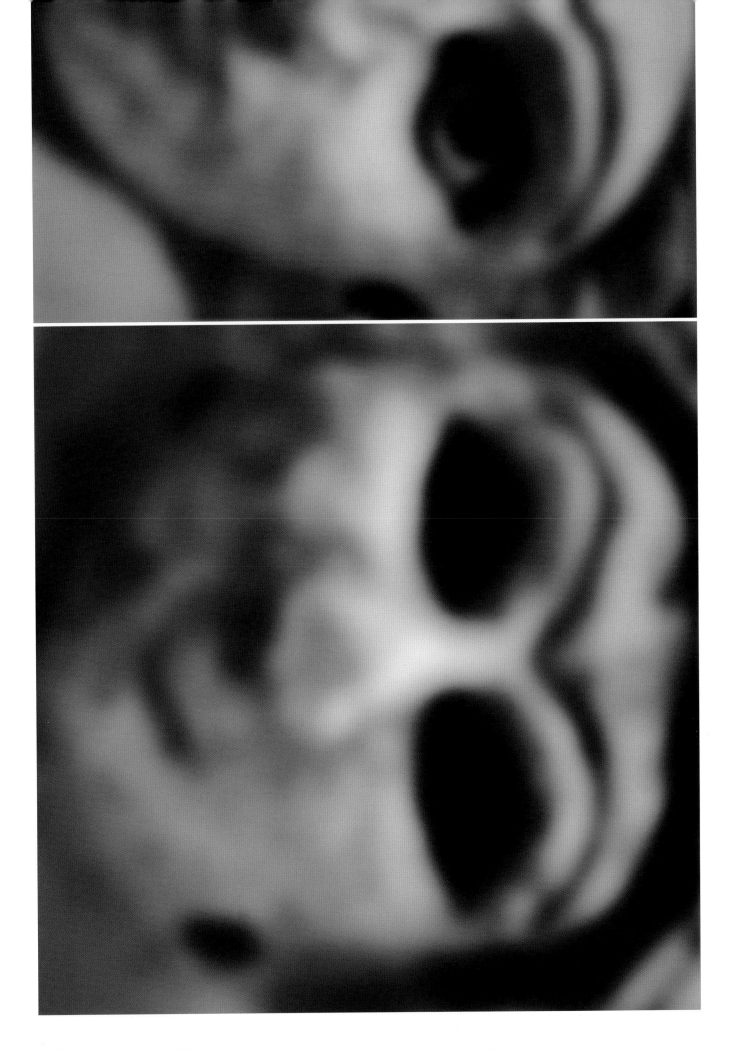

97 Halim Al-Karim
Hidden War 2
2003
Lambda print covered with white silk
200 × 330 cm (Triptych)

حليم الكريم
الحرب المخفية ٢
٢٠٠٣
صورة منضدة مغطاة بحرير أبيض
(اليح خلخي) سم ٣٣٠ × ٢٠٠

96 (السابق) 13 (overleaf)
Hidden Doll
2008
Lambda print covered with white silk
200 × 360 cm (Triptych)

الحريم المخفية
٢٠٠٨
صورة منضدة مغطاة بحرير أبيض
(اليح خلخي) سم ٣٦٠ × ٢٠٠

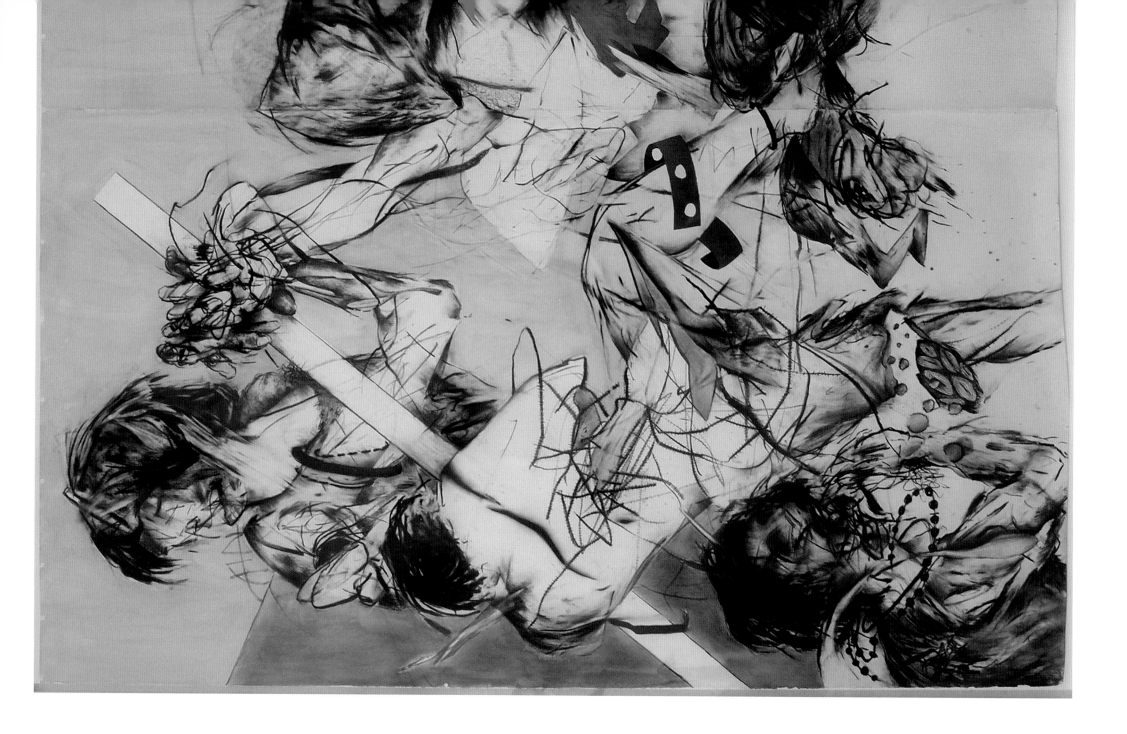

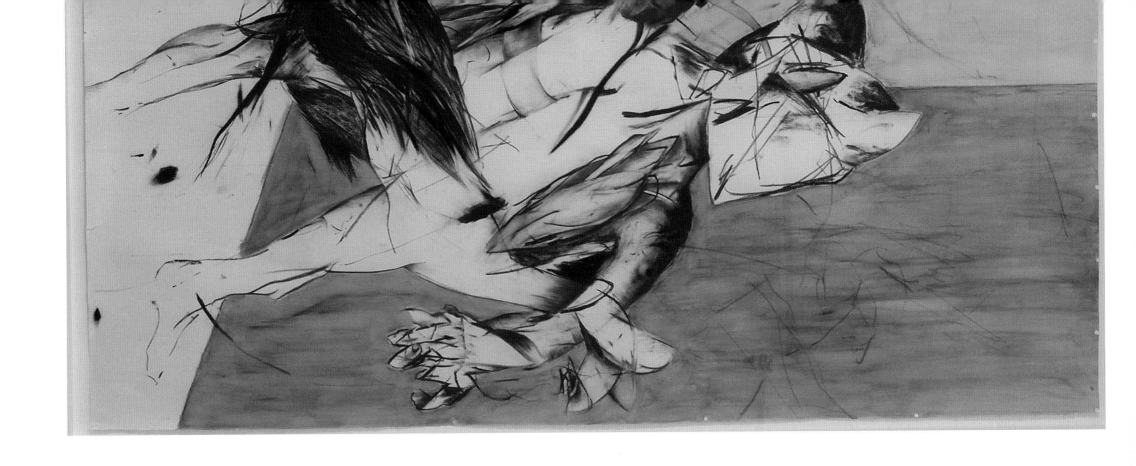

أحمد السوداني · Ahmed Alsoudani
We Die Out of Hand
٢٠٠٧ · 2007
فحم، باستيل، وأكريليك على الورق · Charcoal, pastel, and acrylic on paper
٢٤٣٫٨ × ٢٧٤٫٣ سم · 274.3 × 243.8 cm

٩٤ 15 Ahmed Alsoudani
 You No Longer Have Hands
 2007
 Charcoal, pastel, and acrylic on paper
 274.3 × 213.4 cm

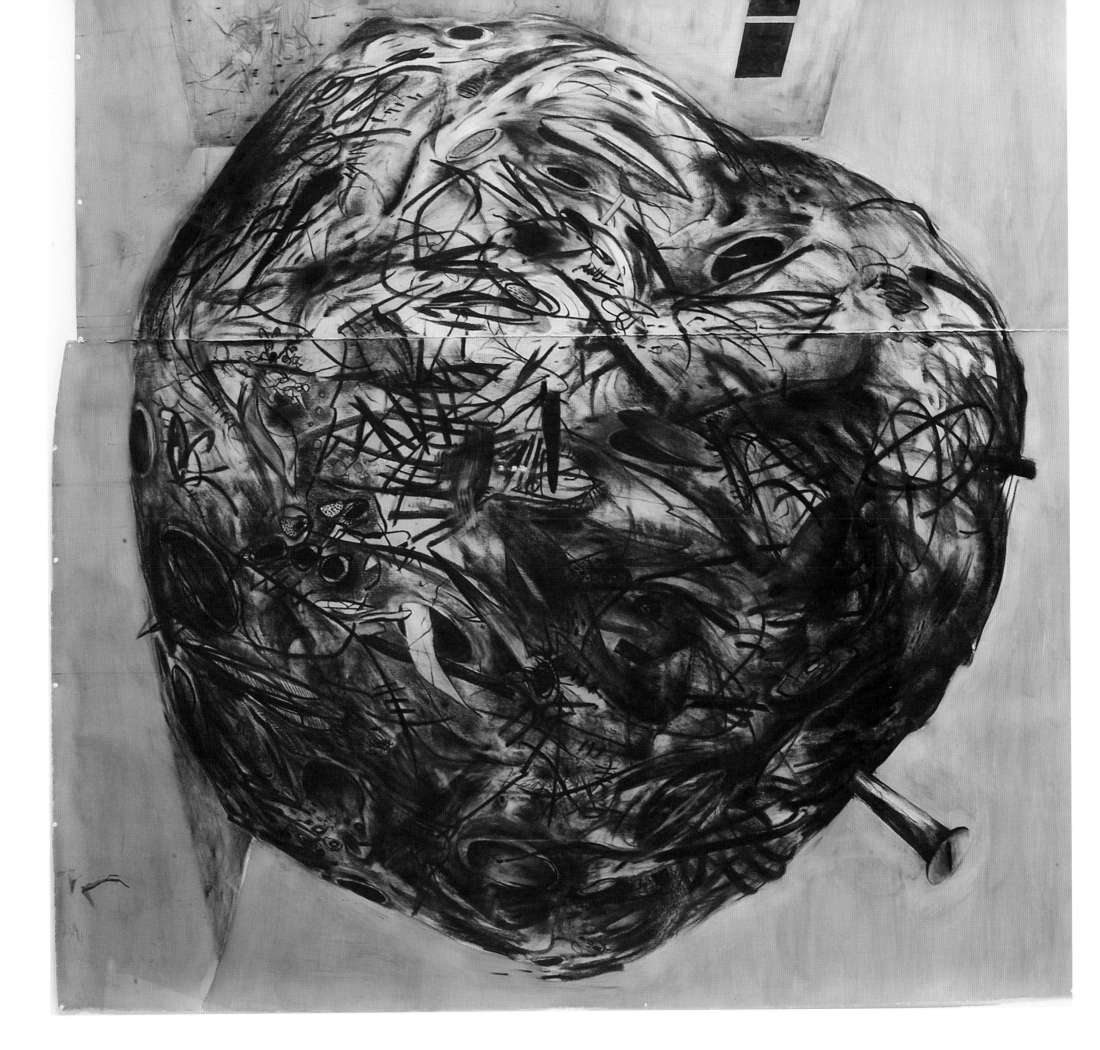

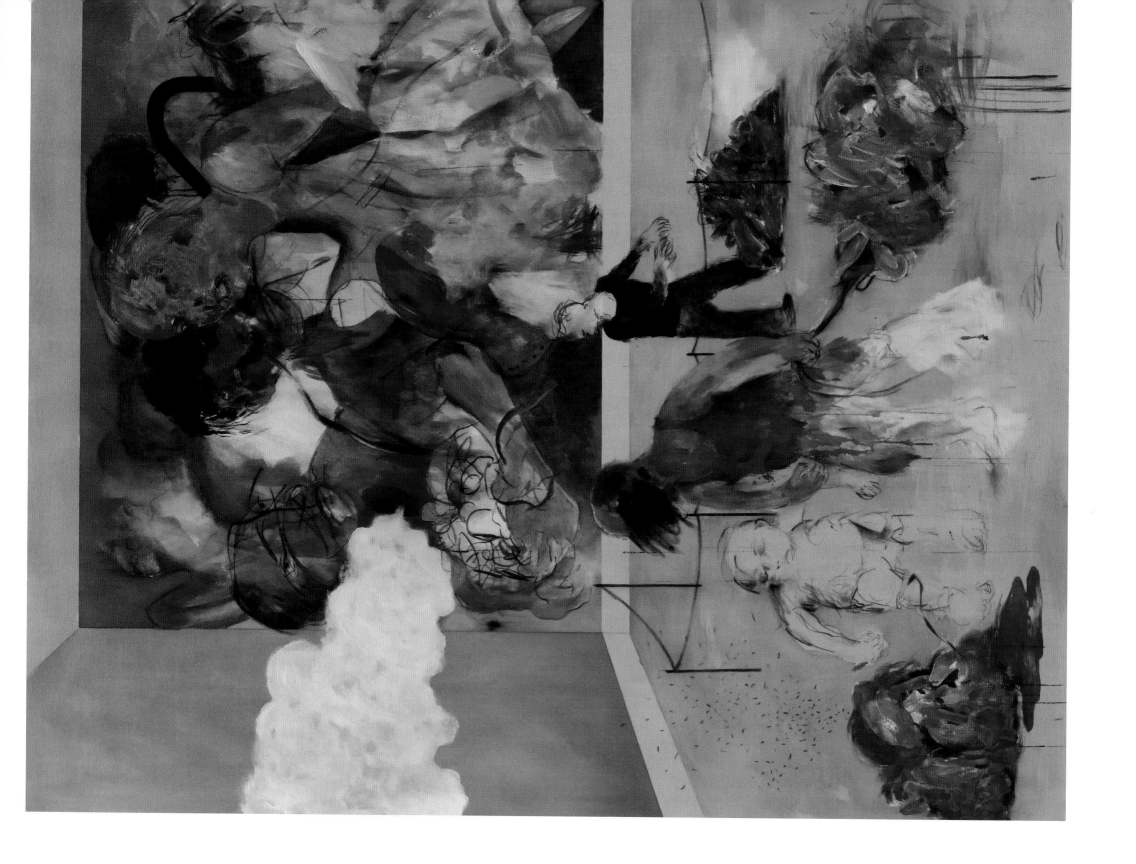

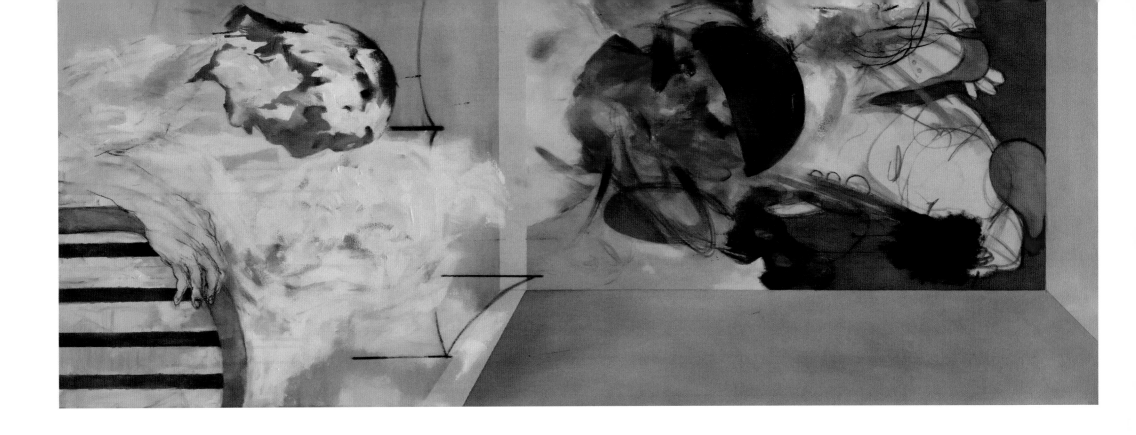

٤٢ 16

Ahmed Alsoudani
Untitled
2007
Oil, acrylic, ink, gesso on canvas
182.9 × 213.4 cm

أحمد الــسـوداني
بدون عنوان
٢٠٠٧
زيت، أكريليك، حبر، جيسو على قماش
٢١٣.٤ × ١٨٢.٩ سم

17

Ahmed Alsoudani
Untitled
2008
Charcoal, acrylic and pastel on paper
270 × 226 cm

أحمد السوداني
بدون عنوان
٢٠٠٨
فحم، باستيل، أكريليك على الورق
سم ٢٢٦ × ٢٧٠

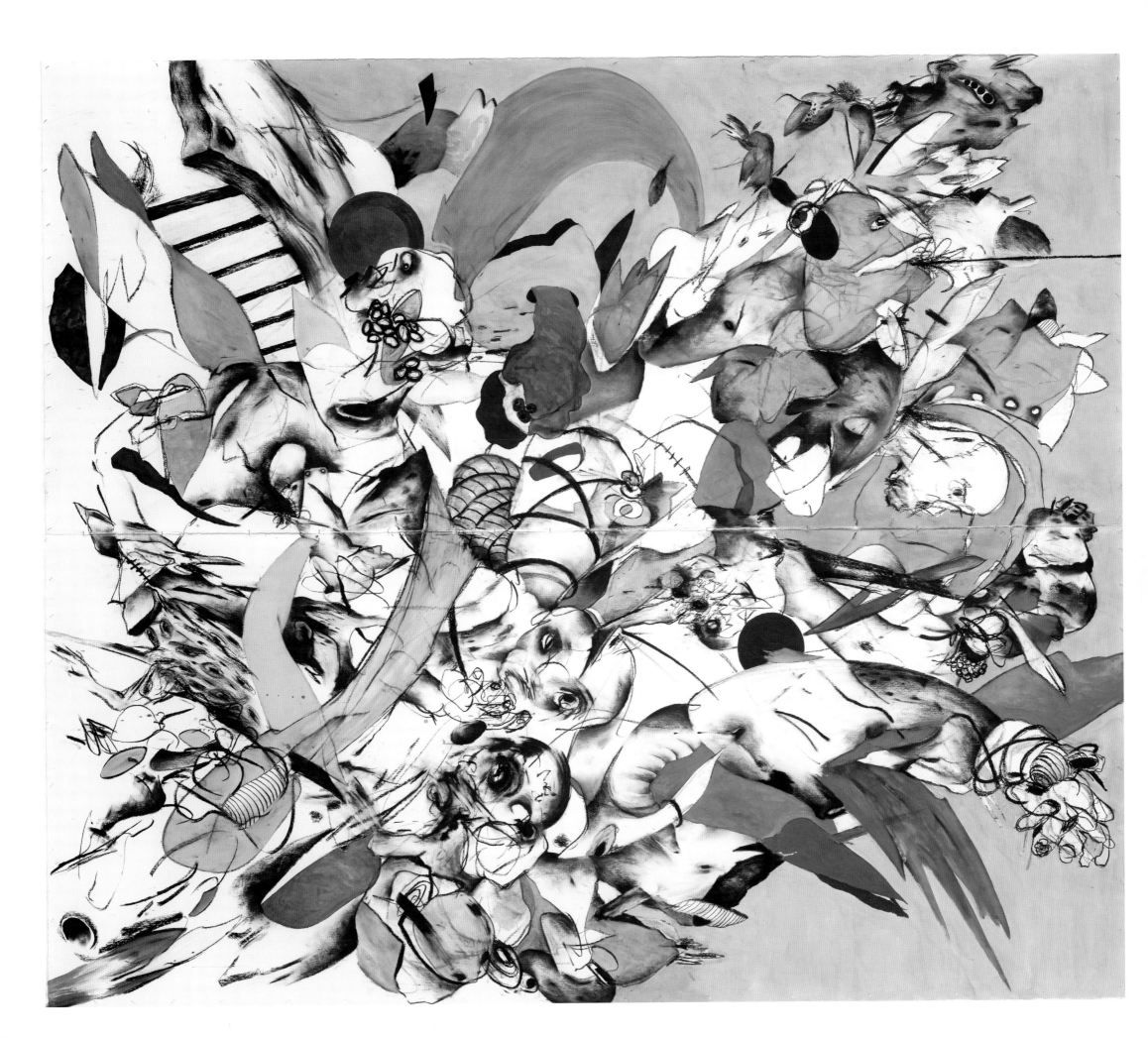

18

Ahmed Alsoudani
Untitled
2008
Oil, acrylic, charcoal gesso on canvas
213 × 184 cm

19 (overleaf)
Baghdad I
2008
Acrylic on canvas
210 × 370 cm

أحمد السوداني
بدون عنوان
٢٠٠٨
زيت، أكريليك، فحم على قماش قنب
١٨٤ × ٢١٣ سم

١٩ (السابق)
بغداد ١
٢٠٠٨
أكريليك على قماش قنب
٣٧٠ × ٢١٠ سم

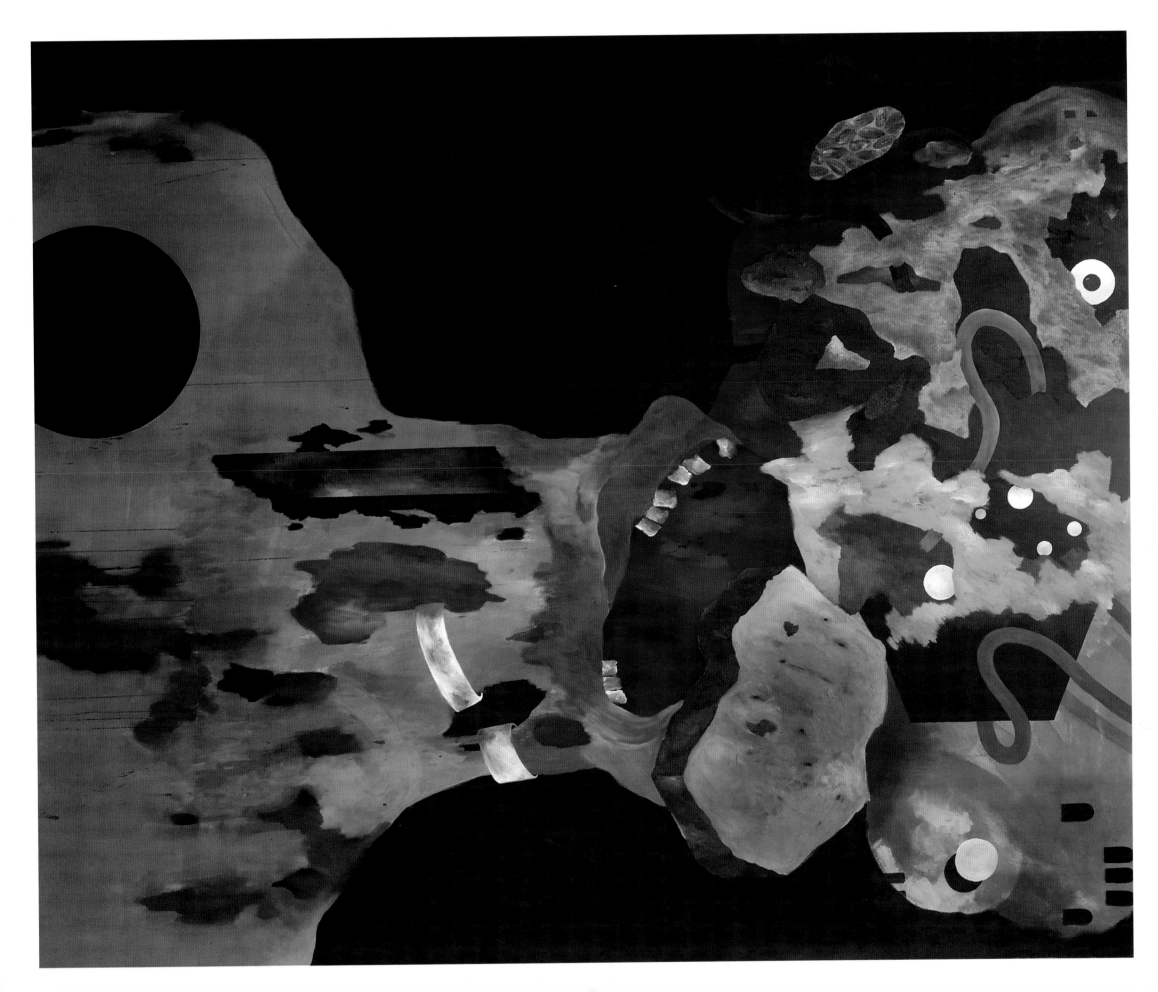

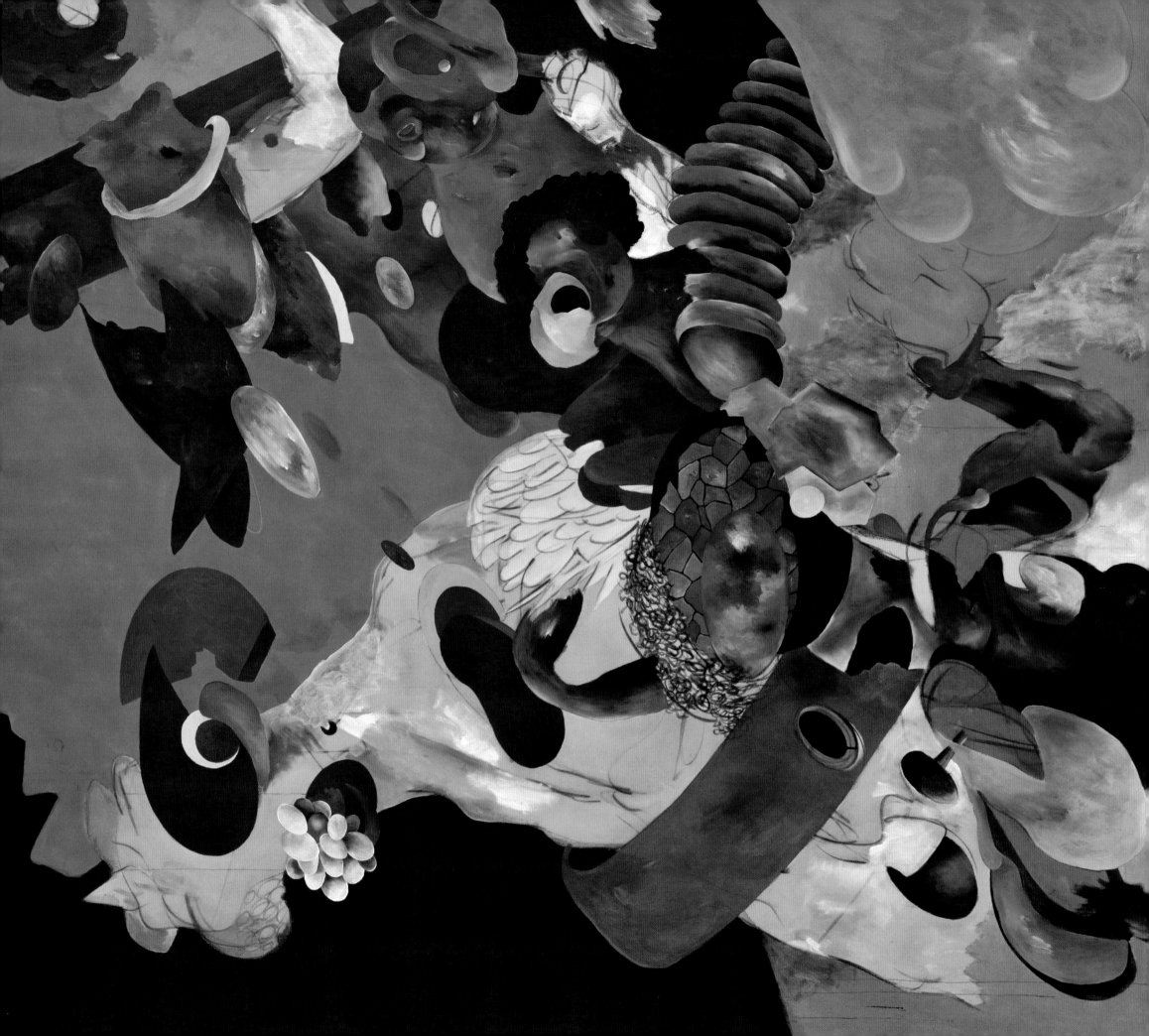

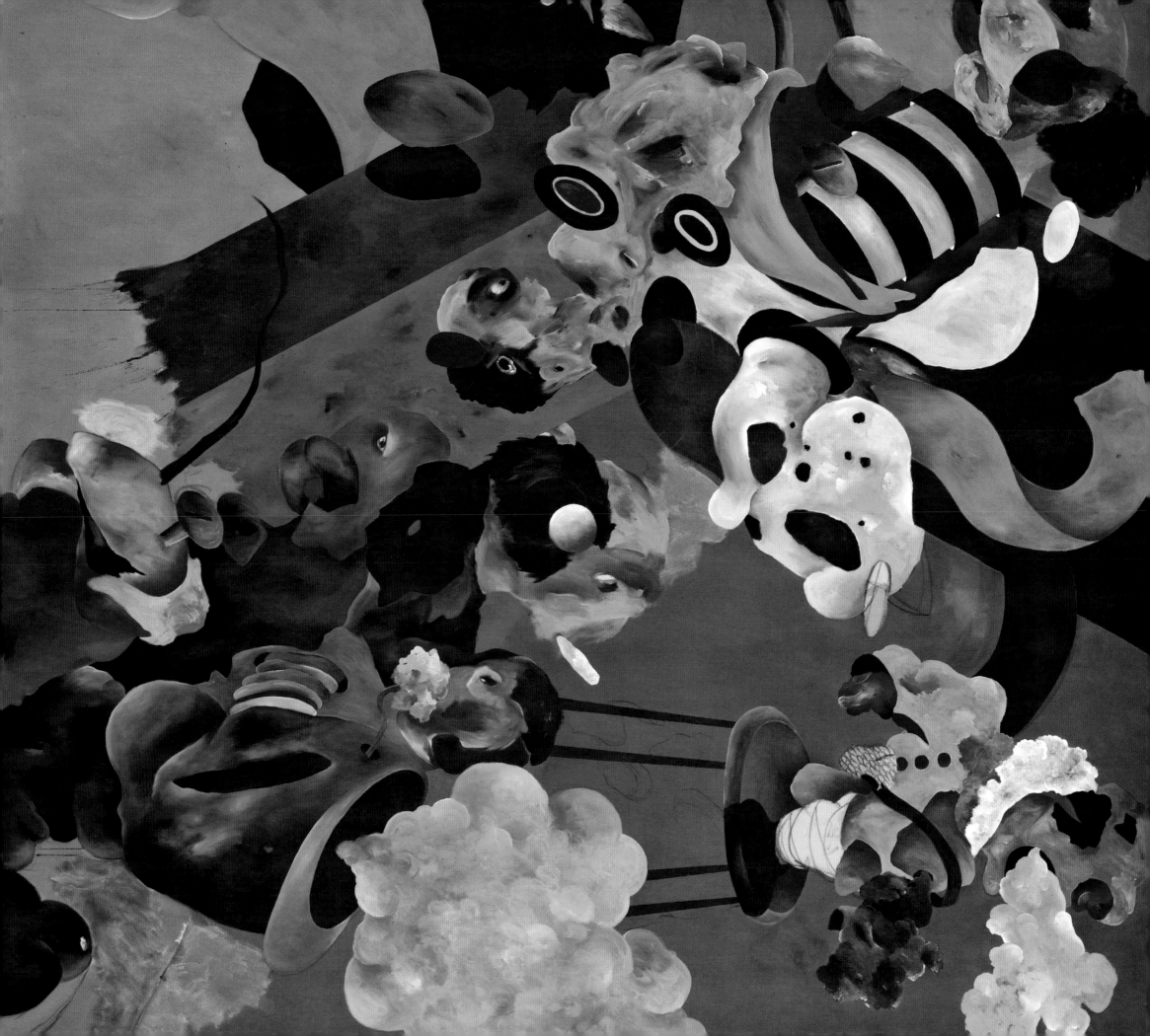

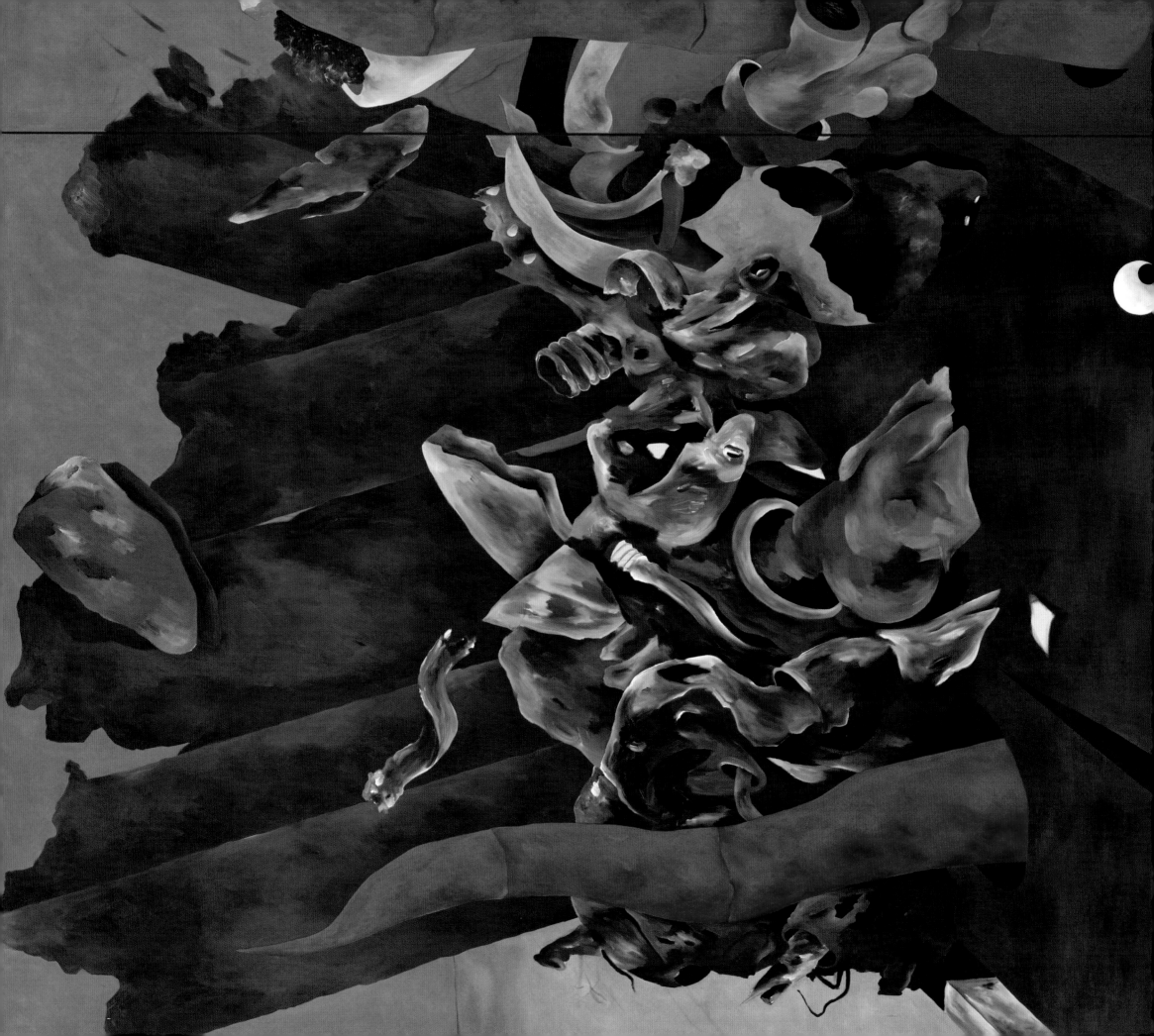

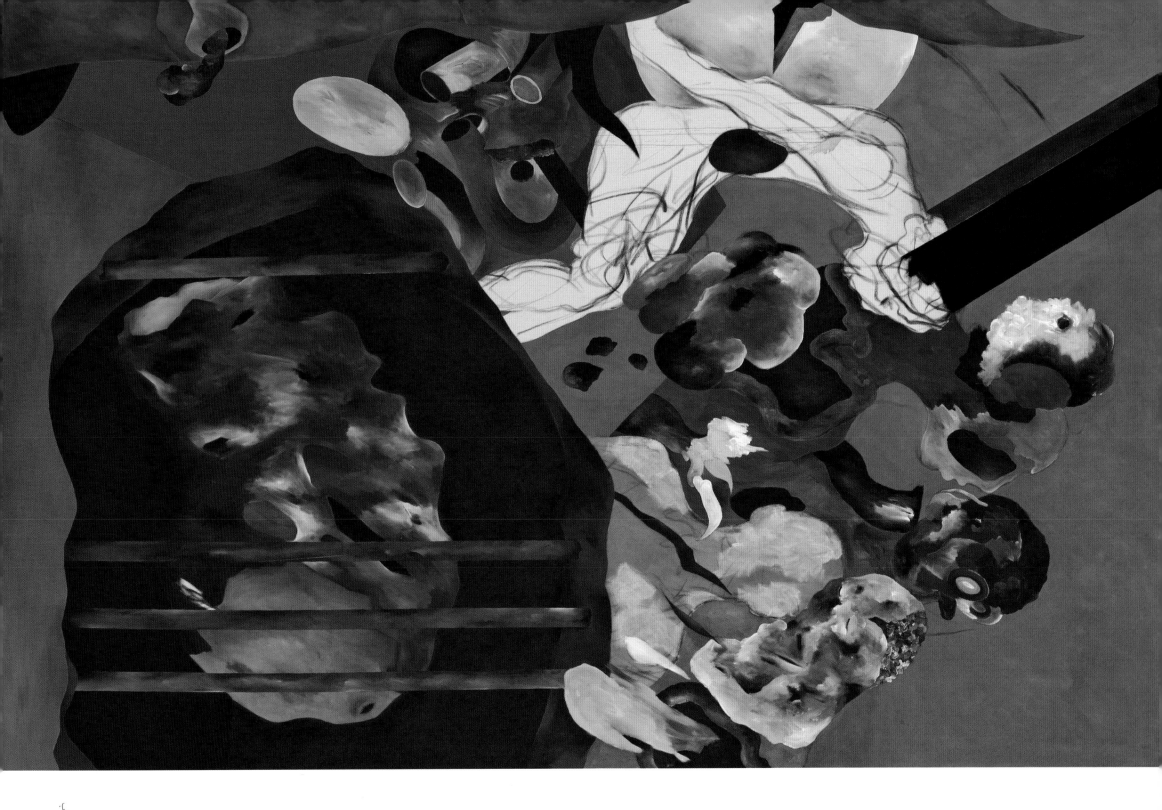

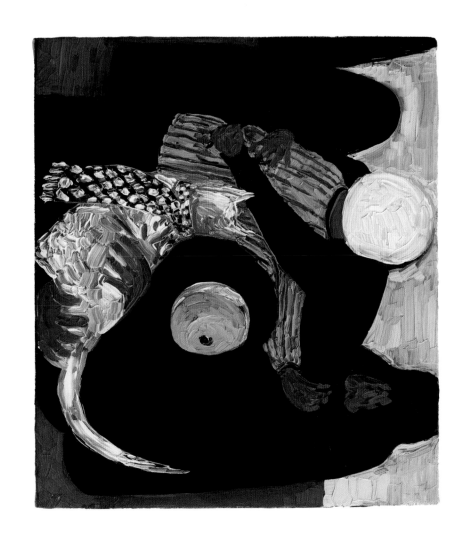

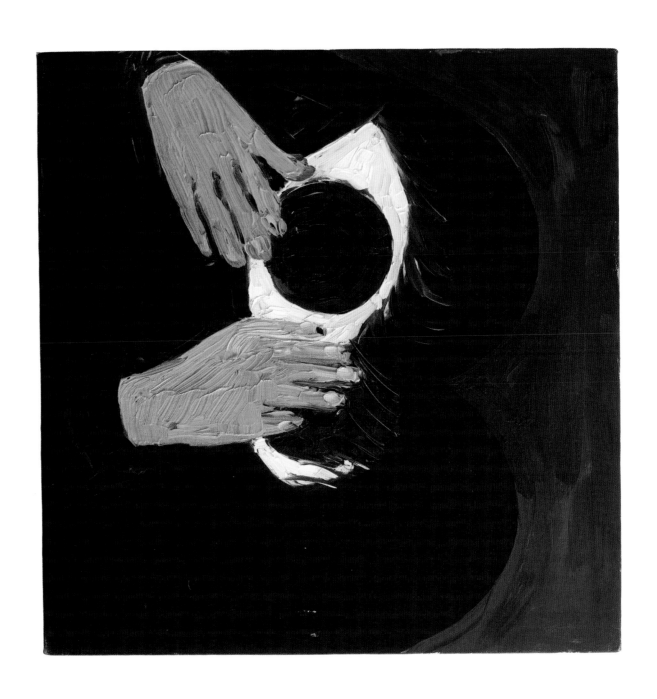

85

24

Nadia Ayari
SidiBou
2007
Oil on canvas
51 × 46 cm

نادية عياري
سيدي بو
٢٠٠٧
زيت على قماش قنب
سم ٤٦ × ٥١

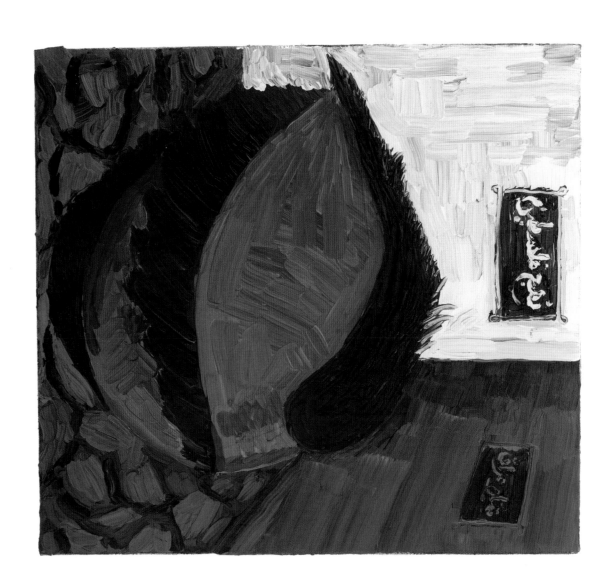

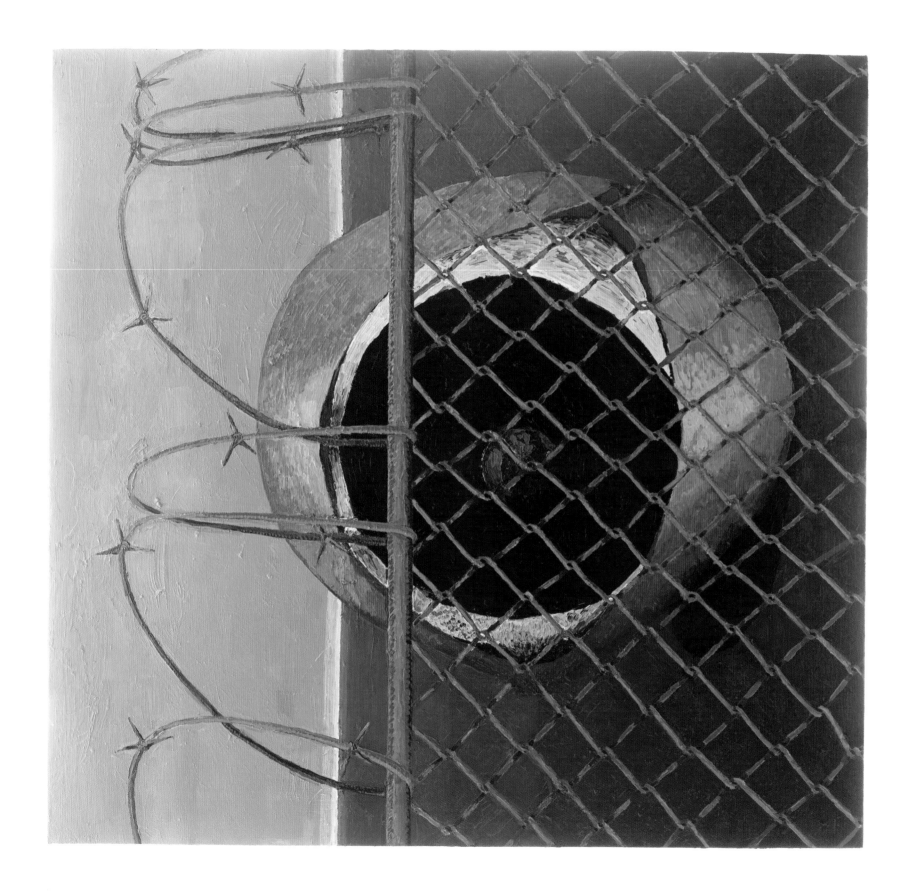

Nadia Ayari
The Fence
2007
Oil on canvas
152.5 × 142.5 cm

نادية عياري
السياج
٢٠٠٧
زيت على قماش
١٤٢٠٥ × ١٥٢٠٥ سم

26 (overleaf)
Syrian Dream
2008
Oil on canvas
40.5 × 35.5 cm

٨٣ (السابق)
حلم سوري
٢٠٠٨
زيت على قماش
٢٥٠٥ × ٤٠٠٥ سم

27 (overleaf)
Hive
2008
Oil on canvas
61 × 56 cm

٨٢ (السابق)
قفير
٢٠٠٨
زيت على قماش
٥٦ × ٦١ سم

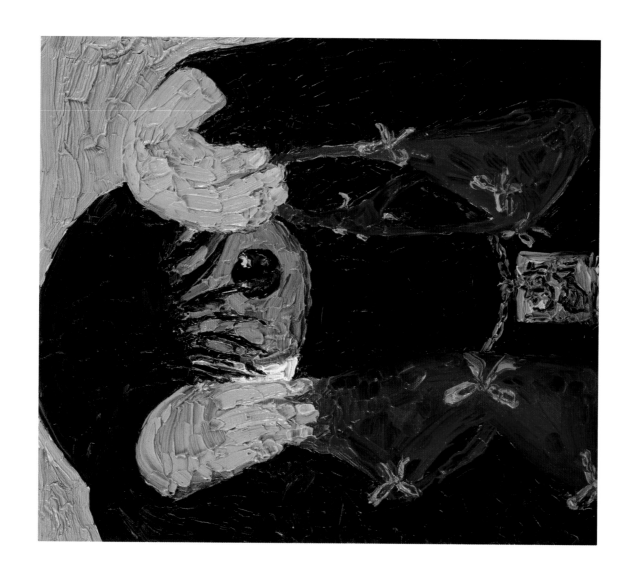

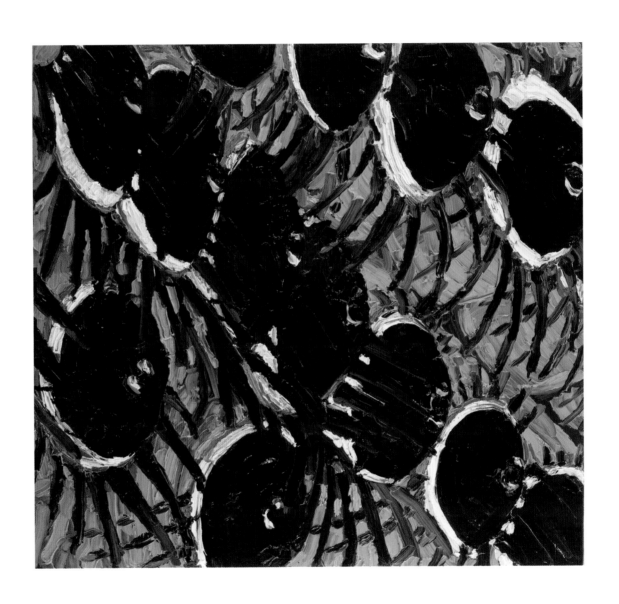

28
Nadia Ayari
The Book
2008
Oil on canvas
183 × 183 cm

29 (overleaf)
Brothel
2006
Oil on canvas
46 × 51 cm

30 (overleaf)
Beirut
2007
Oil on canvas
35.5 × 40.5 cm

٨١

نادية عياري
الكتاب
٢٠٠٨
زيت على قماش فني
١٨٣ × ١٨٣ سم

٨٠ (السابق)
ماخور
٢٠٠٦
زيت على قماش فني
٥١ × ٤٦ سم

٧٩ (السابق)
بيروت
٢٠٠٧
زيت على قماش فني
٤٠.٥ × ٣٥.٥ سم

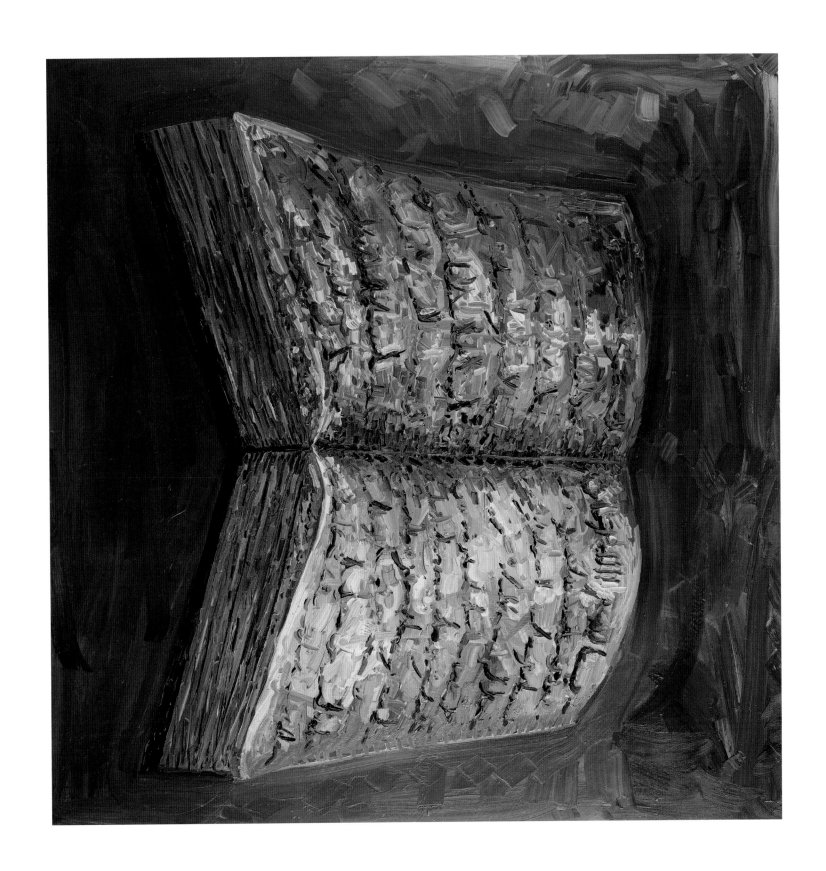

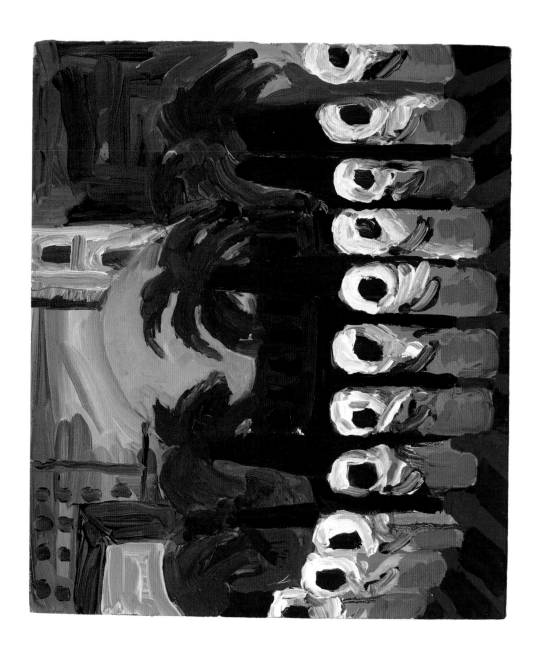

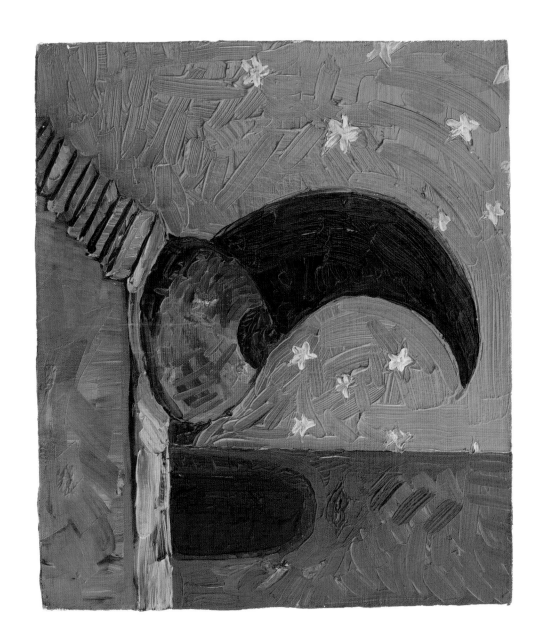

Barhad Golshiri
The Portrait Of The Artist As A One Year Old Child
2005
Print on canvas
107 × 149 cm

برباد گلشیری
صورة الفنان کطفل فی عامه الاول
٢٠٠٥
صورة علی قماش
سم ١٤٩ × ١٠٧

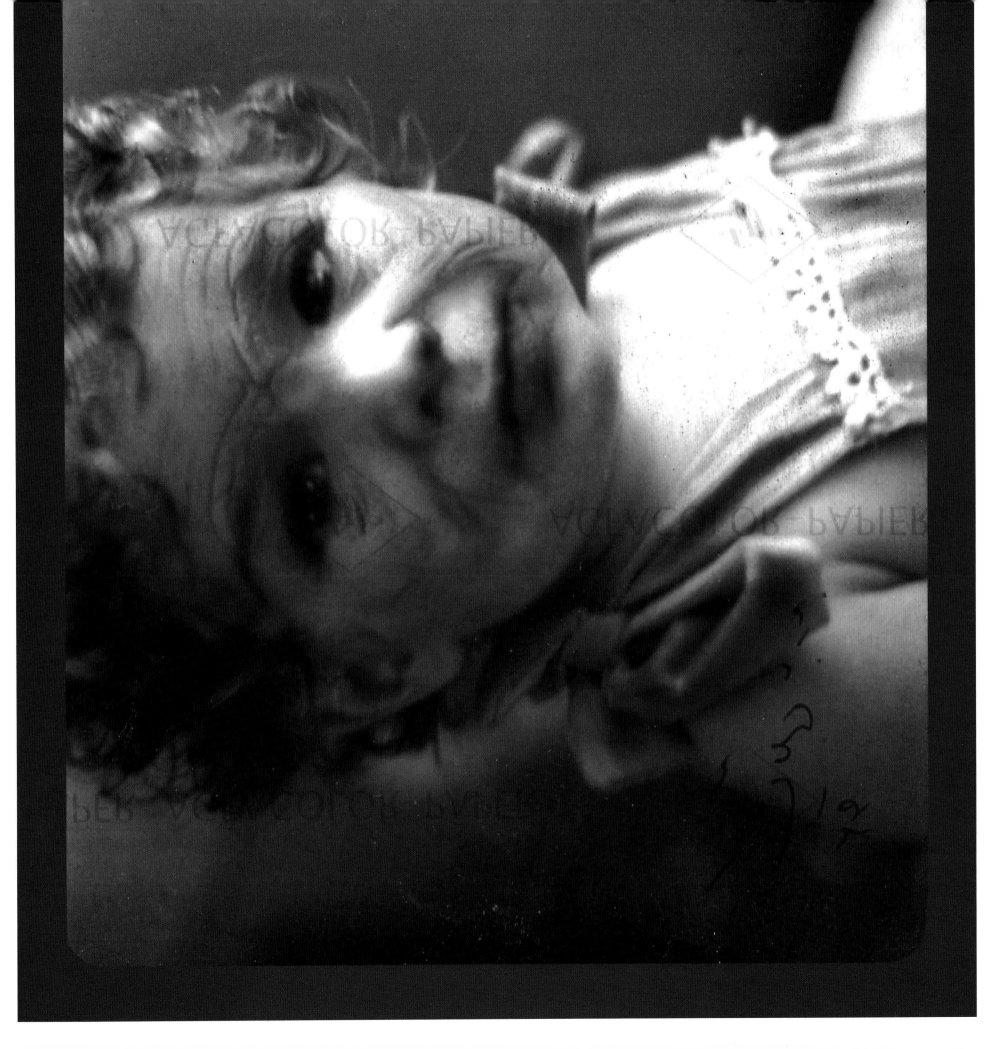

برباد گلشیری
جایی که روح و منی به هم رسیدند
۲۰۰۸
چیدمان
۲۳۰ × ۷۴ سم

Barbad Golshiri
Where Spirit and Semen Met
2008
Installation
230 × 74cm

74 33

Ali Banisadr
In The Name Of
2008
Oil on linen
137.2 × 183 cm

علي بني صدر
فـي بيـتـن
٢٠٠٨
زيت على قماش كتان
سم ١٨٣ × ١٣٧٫٢

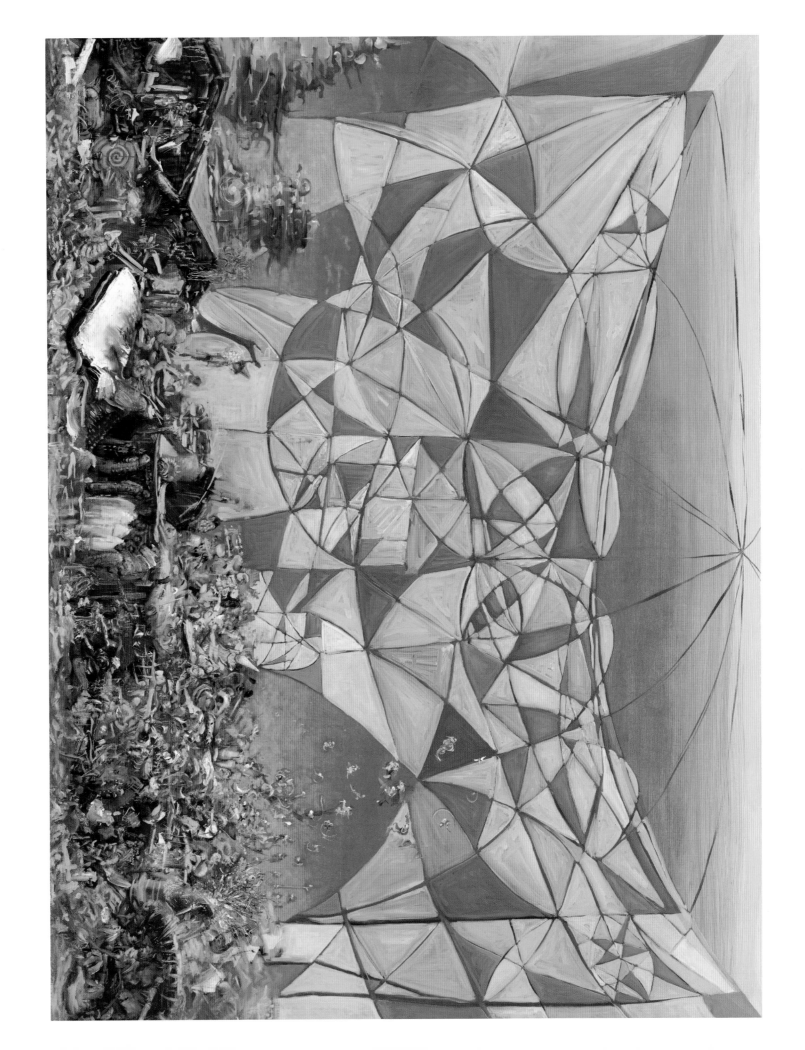

Vo 34

Ali Banisadr
Land Of Black Gold
2008
Oil on linen
137.2 × 193 cm

علي بني صدر
أرض الذهب الأسود
٢٠٠٨
زيت على قماش كتان
سم ١٩٣ × ١٣٧٫٢

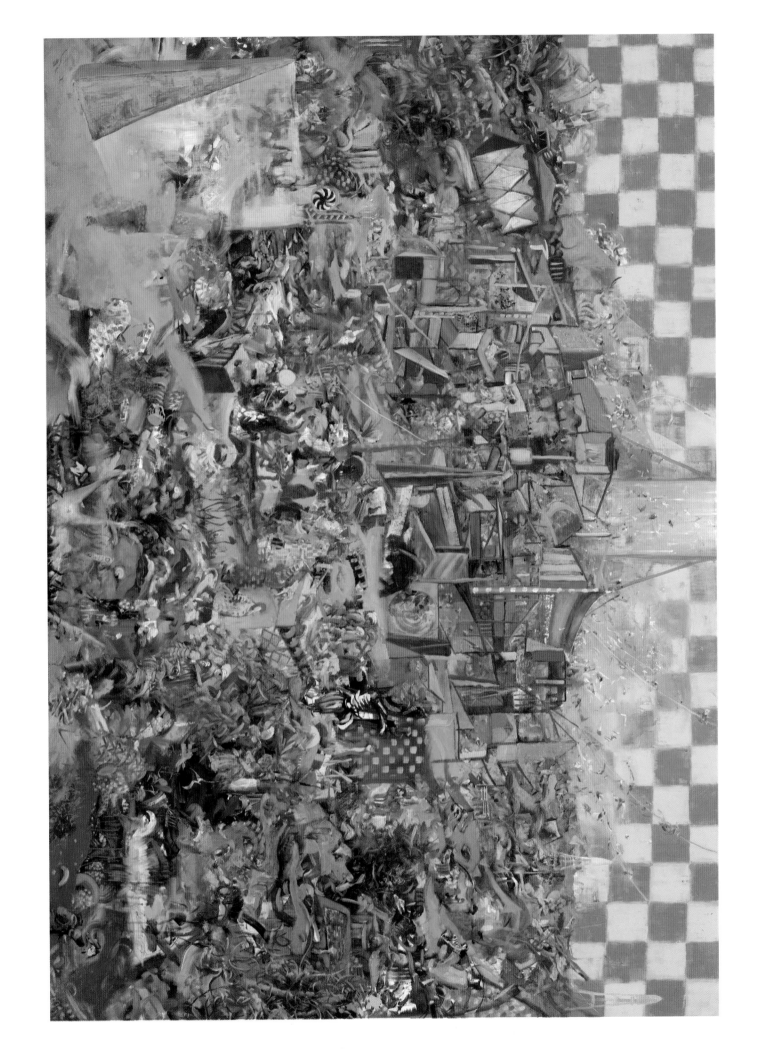

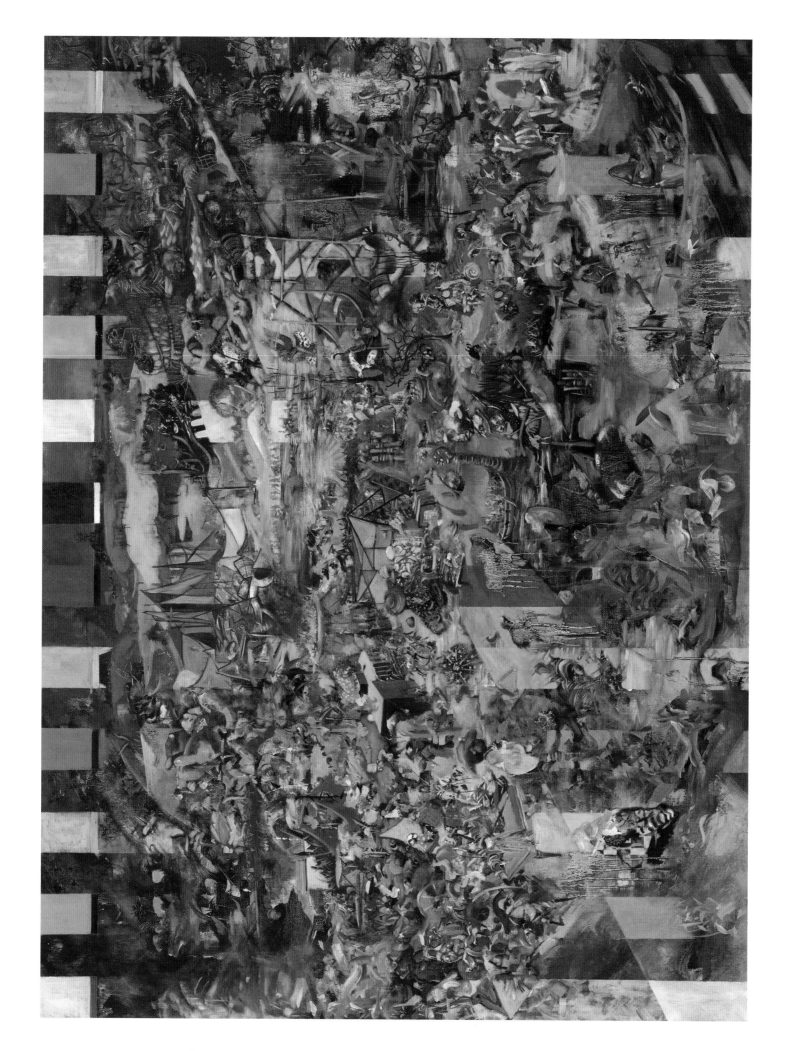

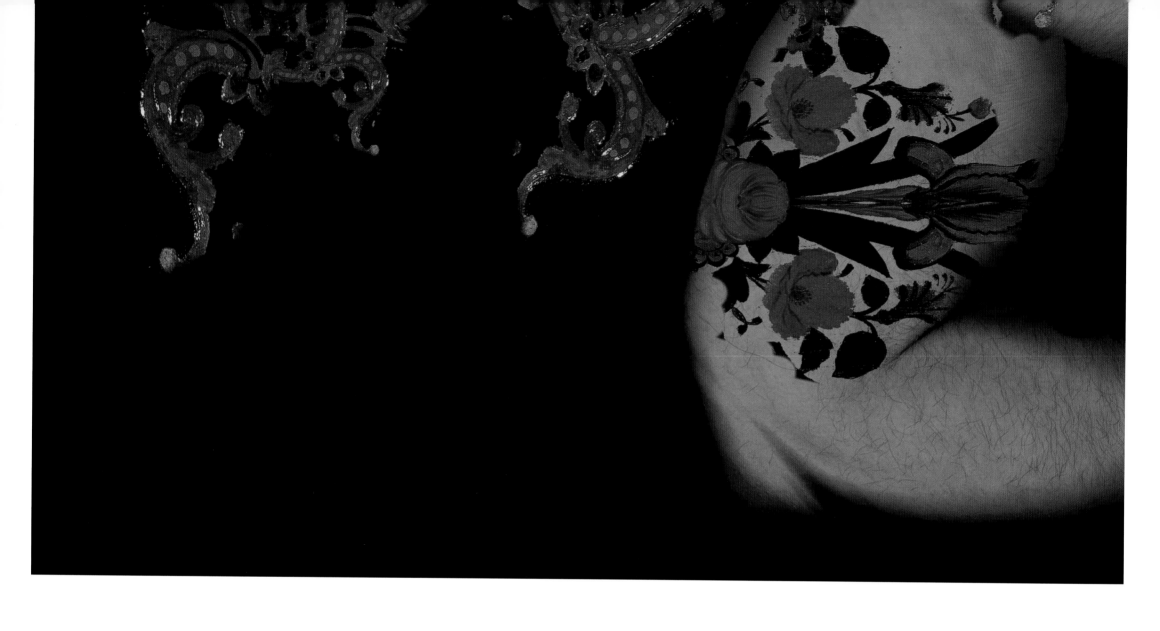

37–41

Ramin Haerizadeh
Men of Allah (01, 03, 05, 04, 08)
2008
C-Prints
Each: 100 × 150 cm

٧٢–٧٨

رامین حائریزاده
مردان الله (٠١، ٠٣، ٠٥، ٠٤، ٠٨)
٢٠٠٨
چاپ سی
كل منها ١٠٠ × ١٥٠ سم

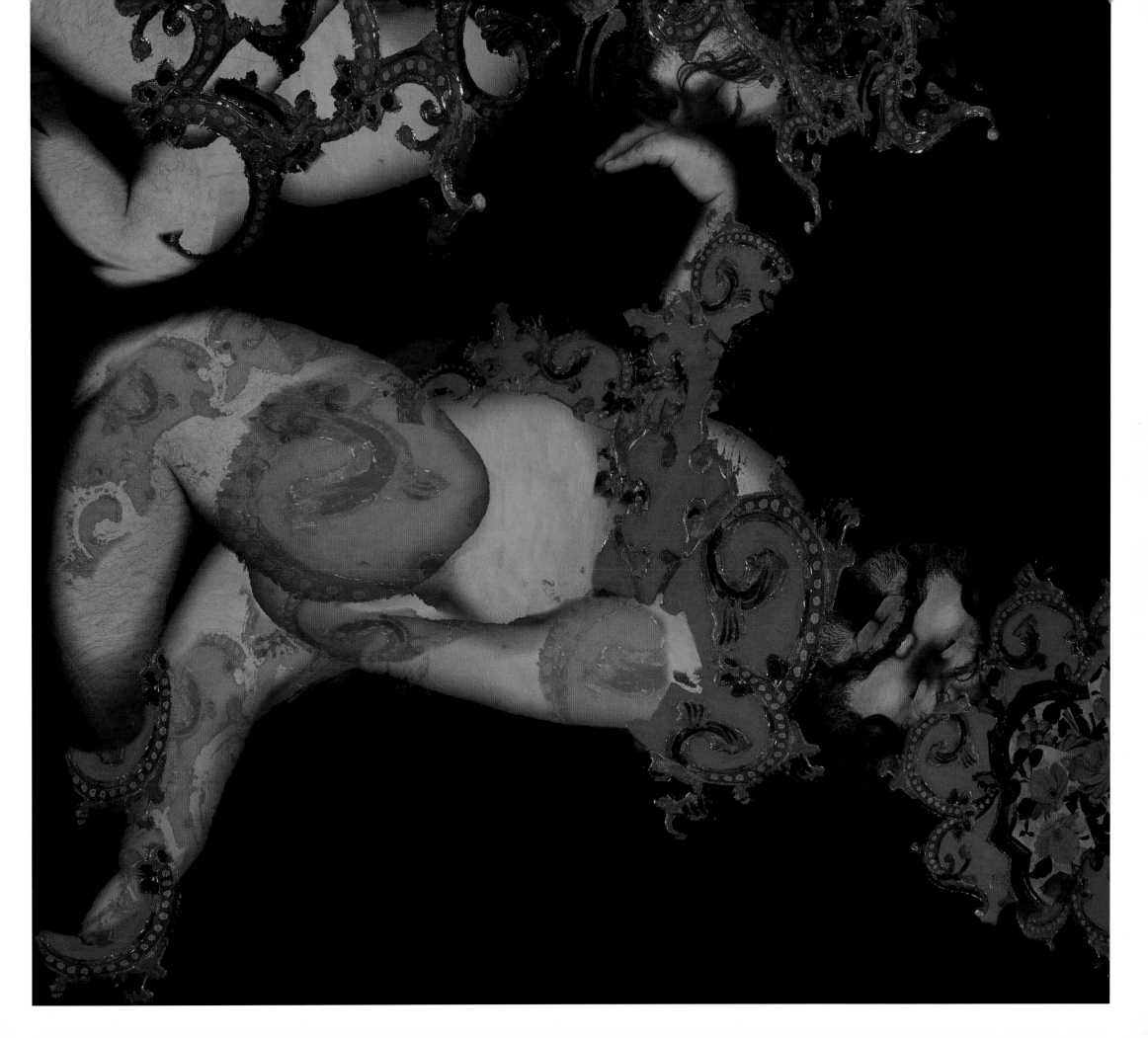

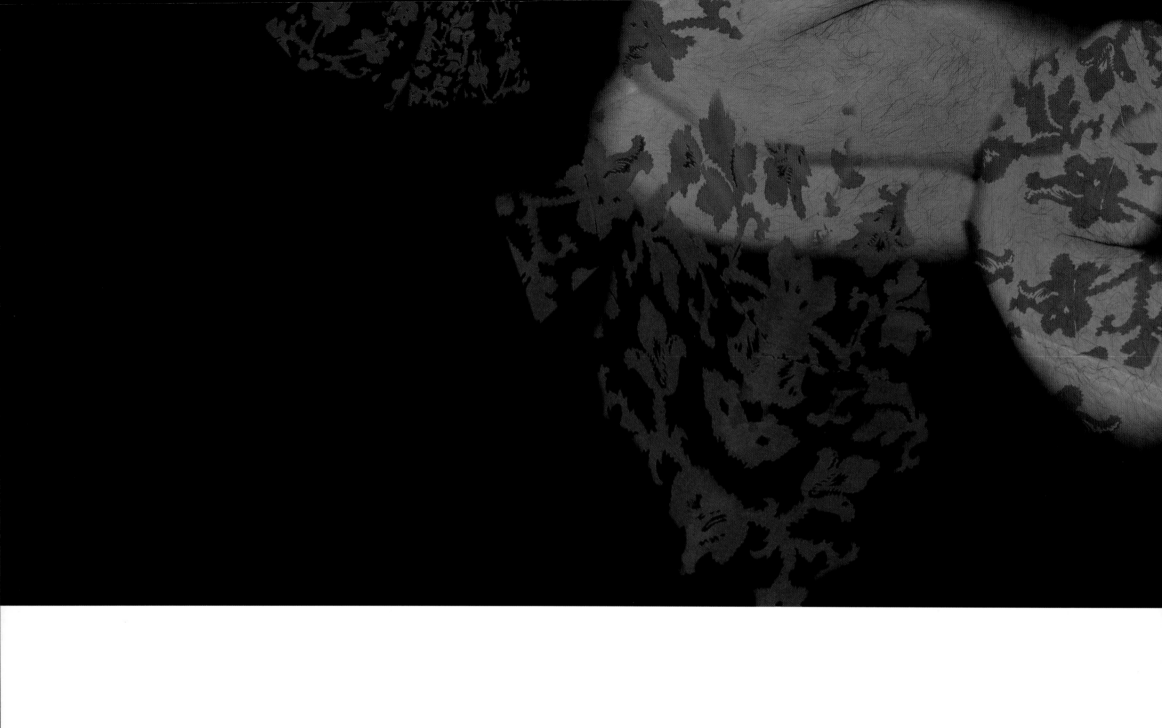

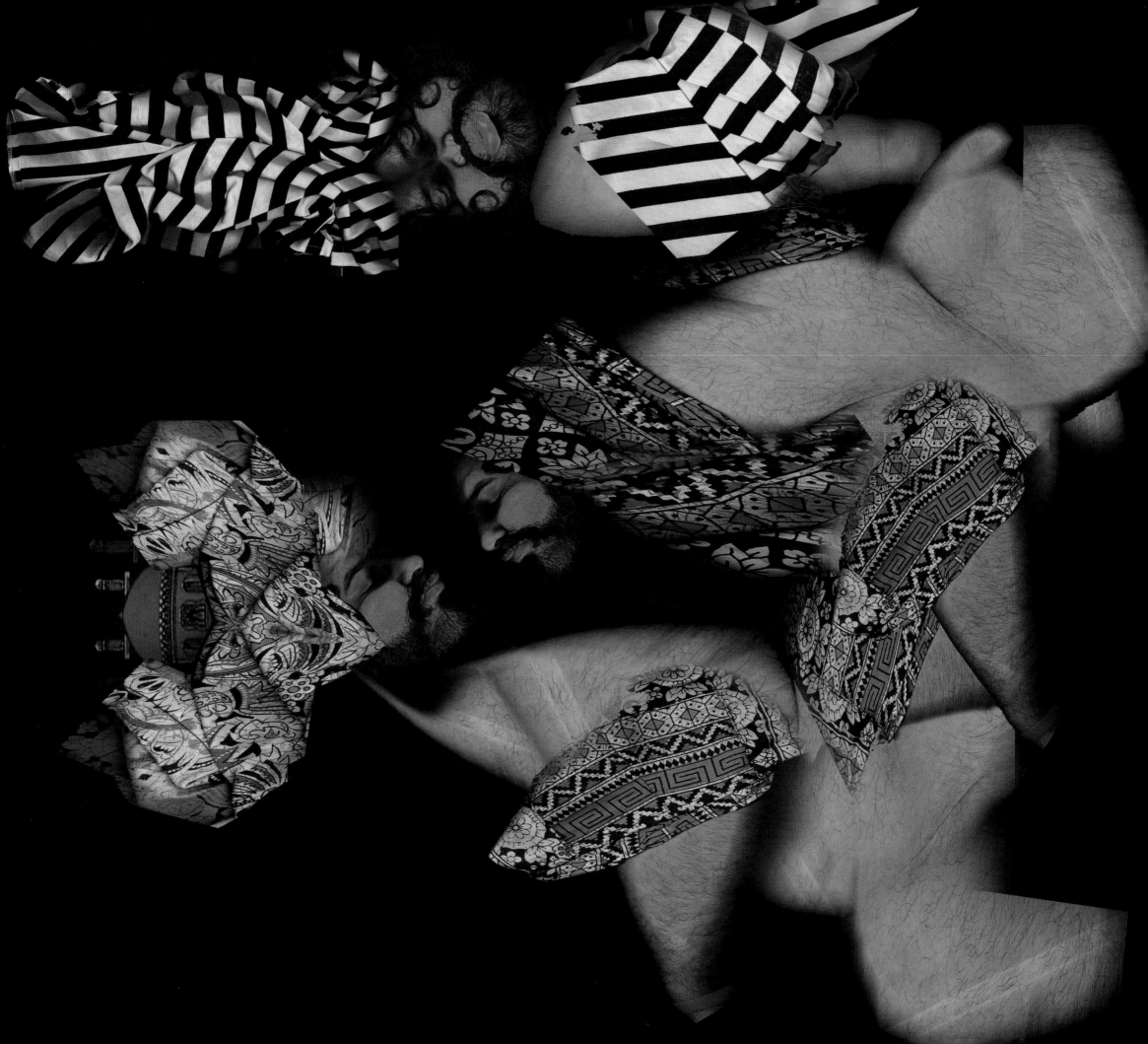

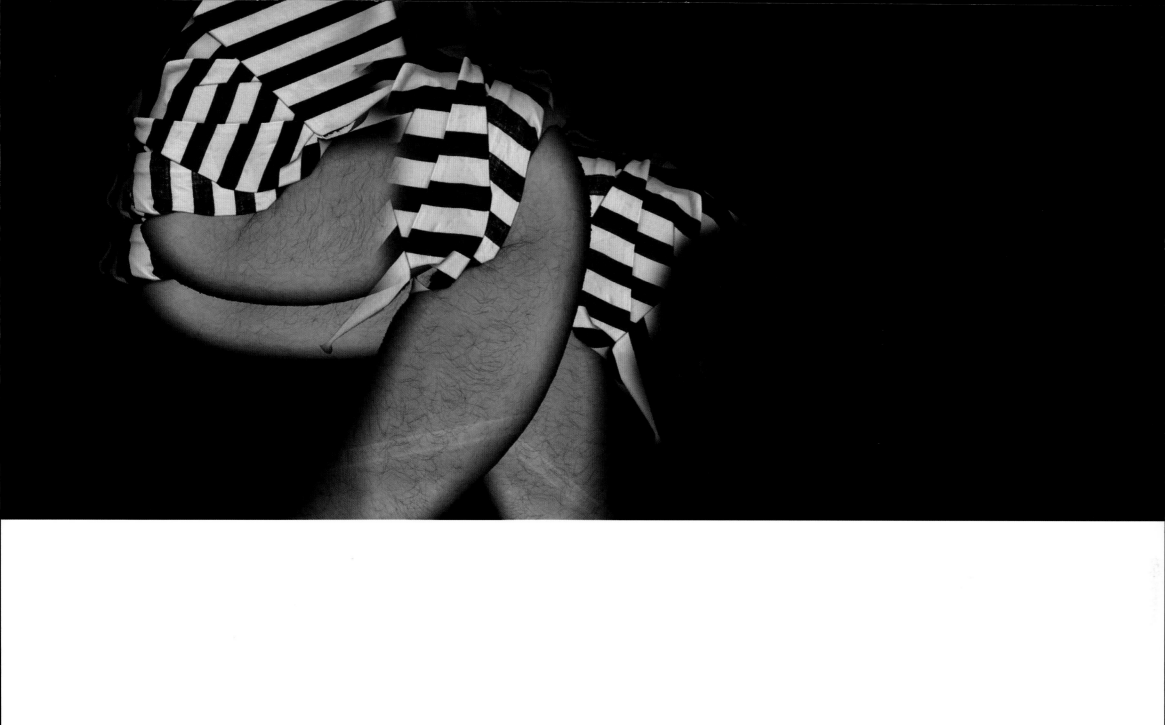

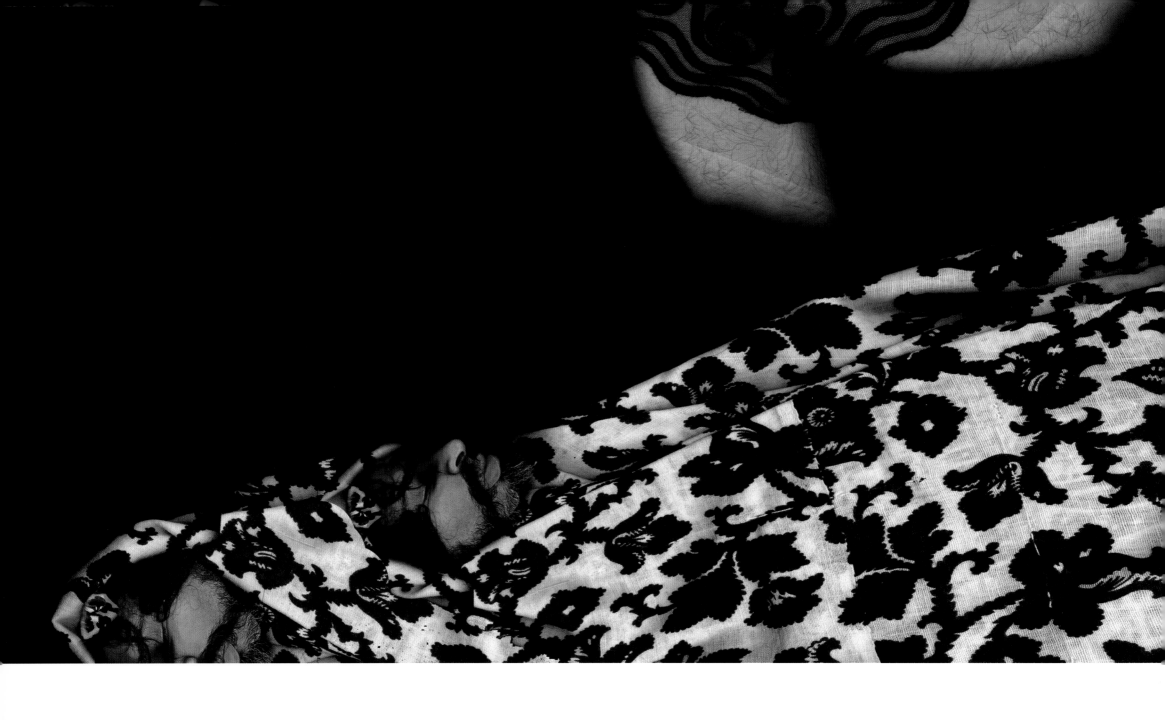

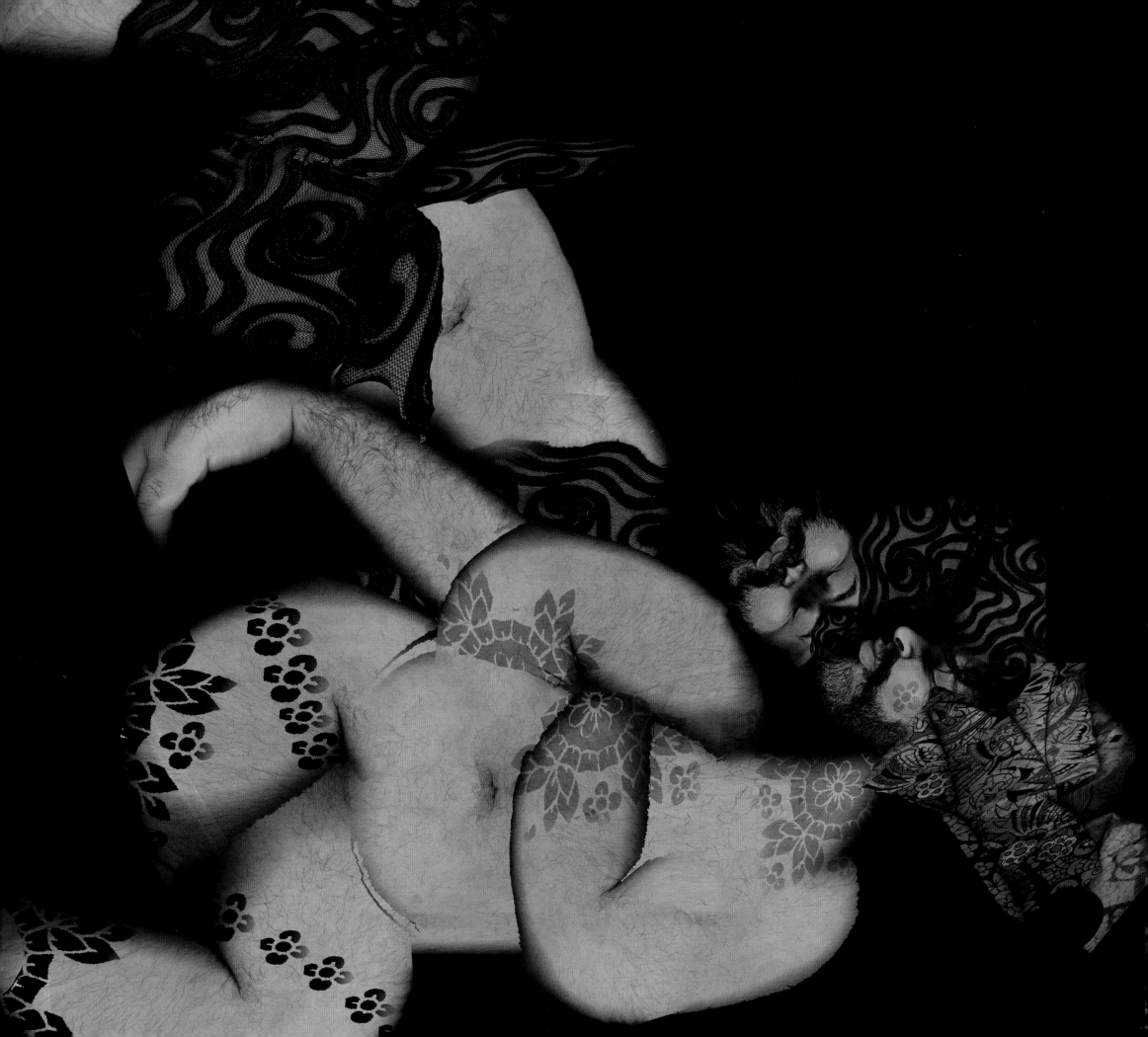

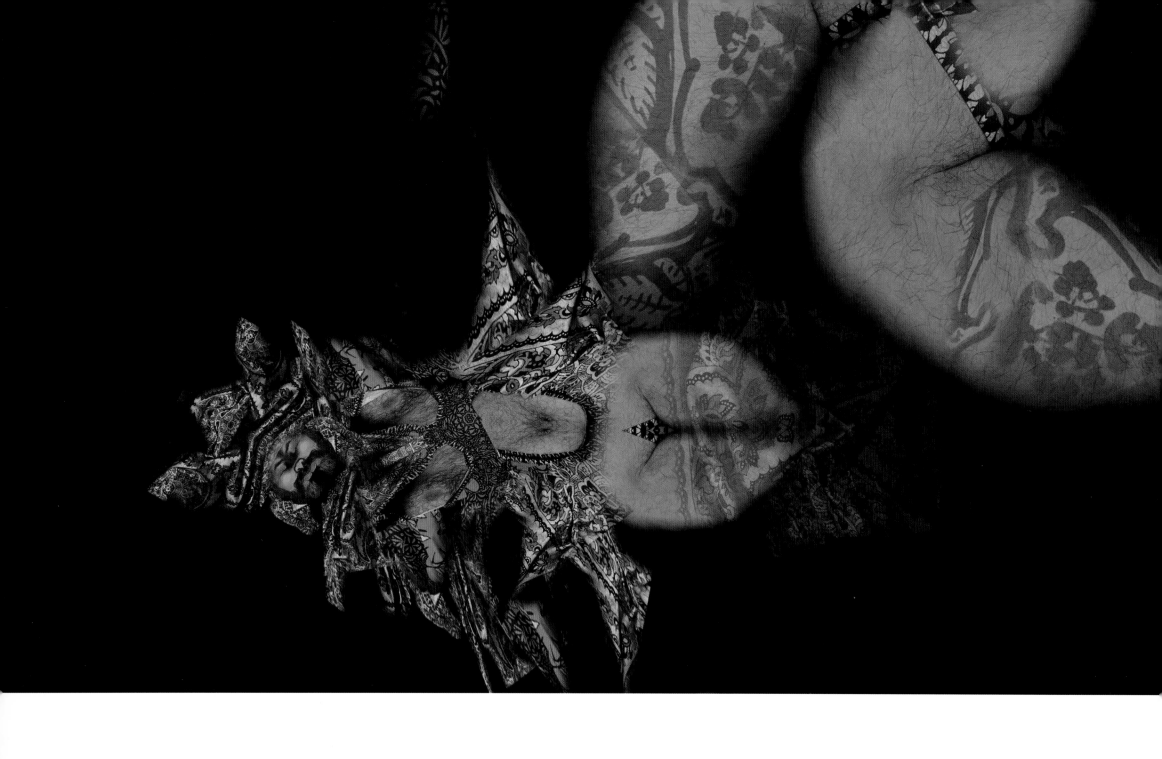

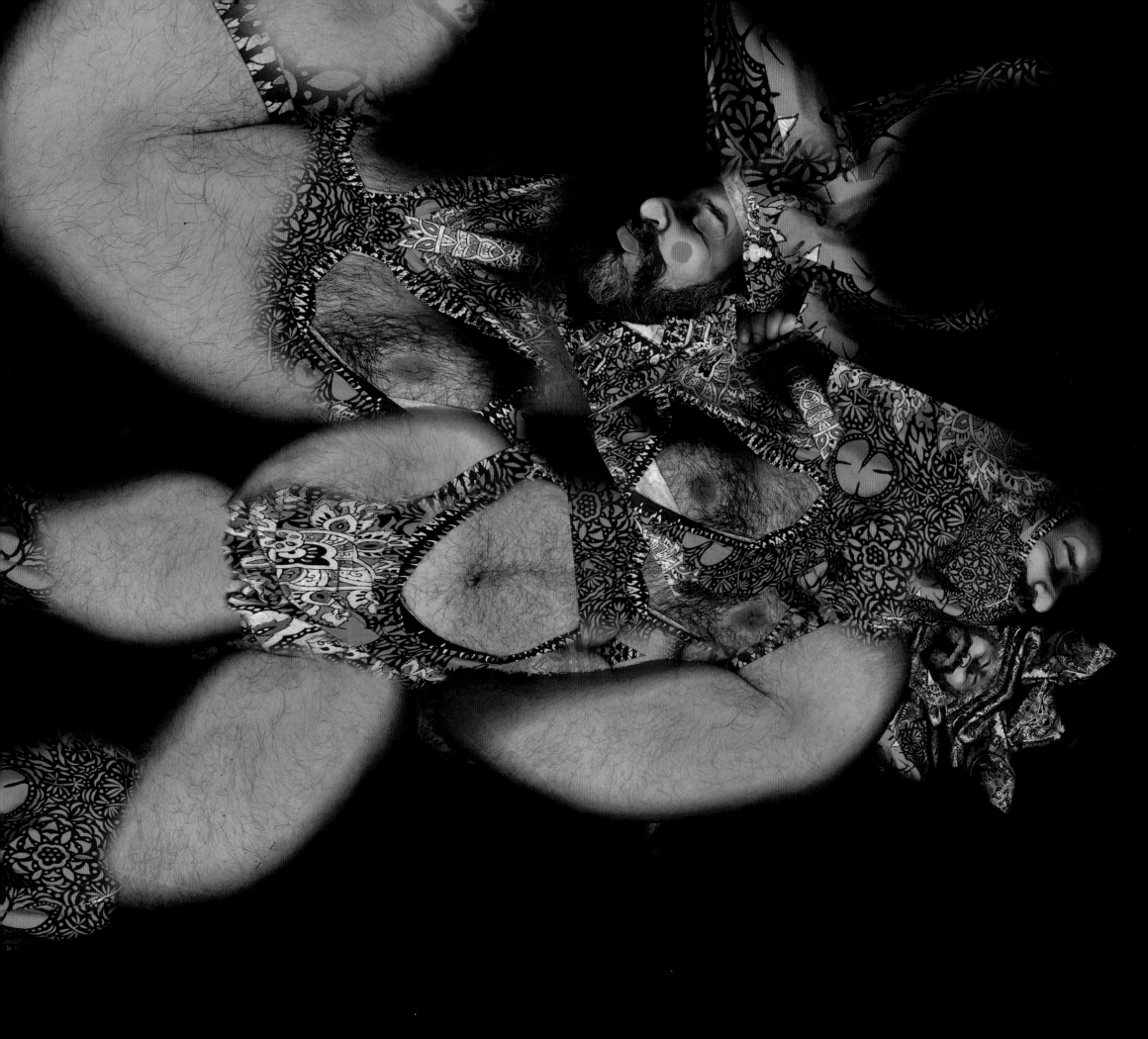

Rokni Haerizadeh
Dagger Dance
2008
Acrylic on canvas
200 × 200 cm

روكني حائرزاده
رقصة الخنجر
٢٠٠٨
اكريليك على قماش فني
سم ٢٠٠ × ٢٠٠

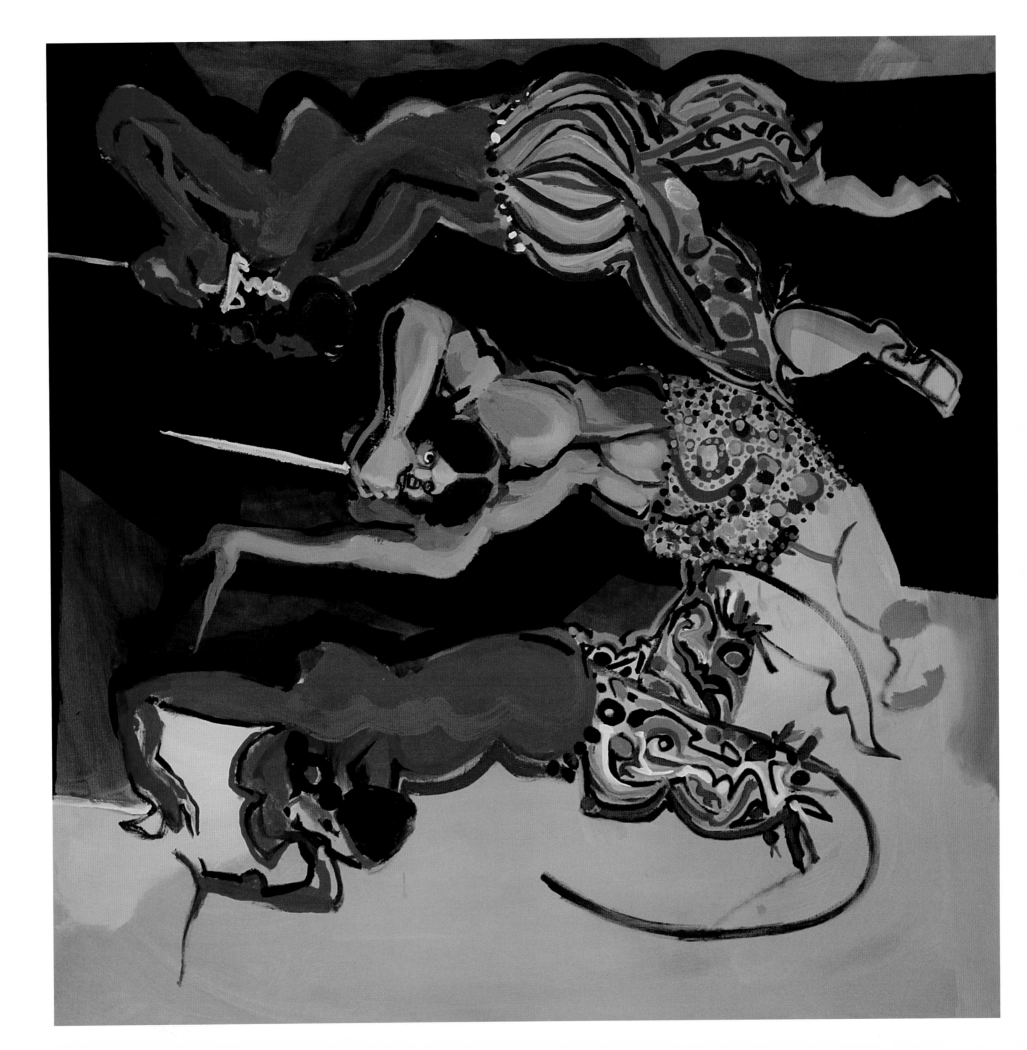

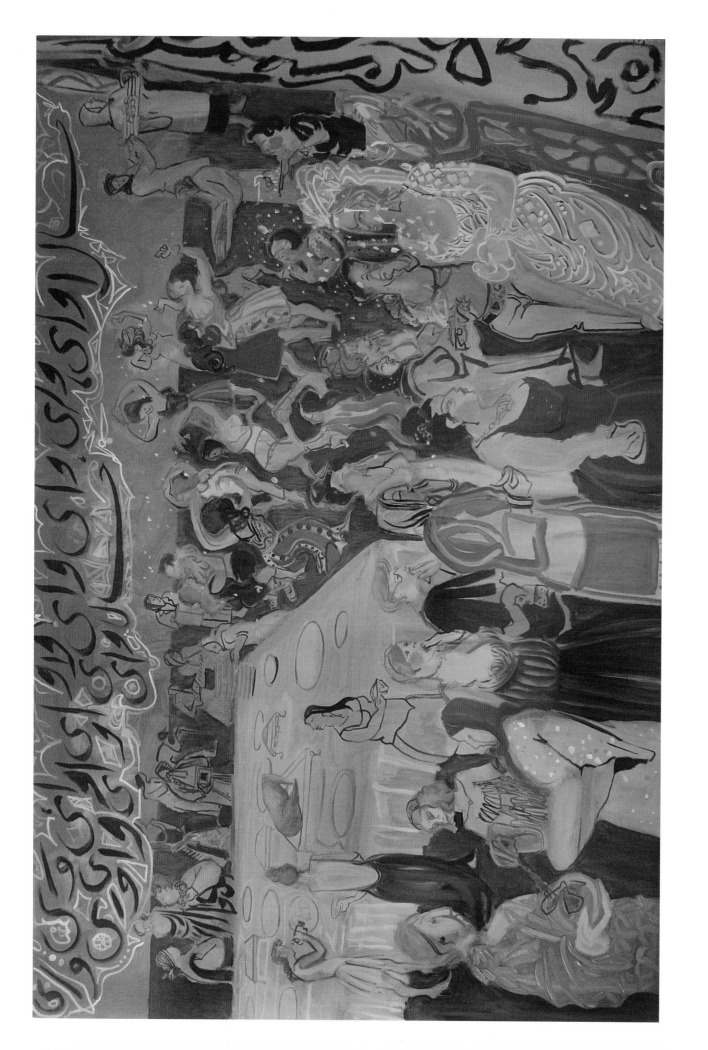

٦٦–٦٣ 43–46
Rokni Haerizadeh
عروسی ایرانی نمونه‌ای Typical Iranian Wedding
٢٠٠٨ 2008
رنگ علی قماش قنیب Oil on canvas
۳۰۰ × ۲۰۰ سانتیمتر (هر لنگه) 200 × 300 cm (each panel)
۶۰۰ × ۲۰۰ سانتیمتر (احتمالی) 200 × 600 cm (overall)

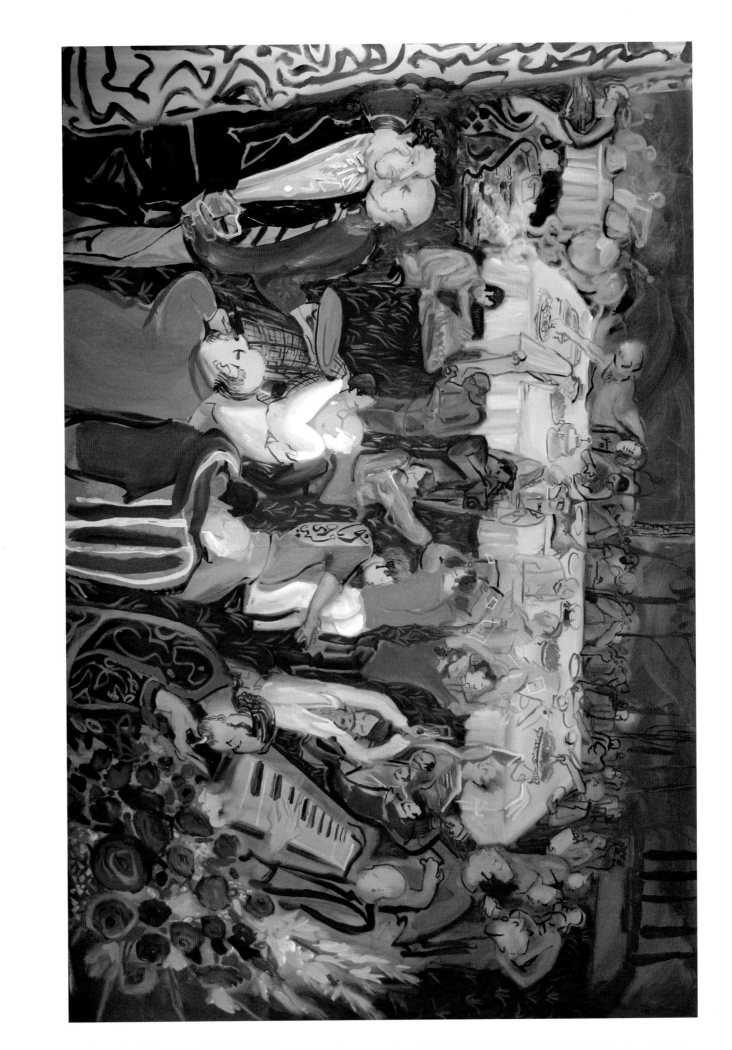

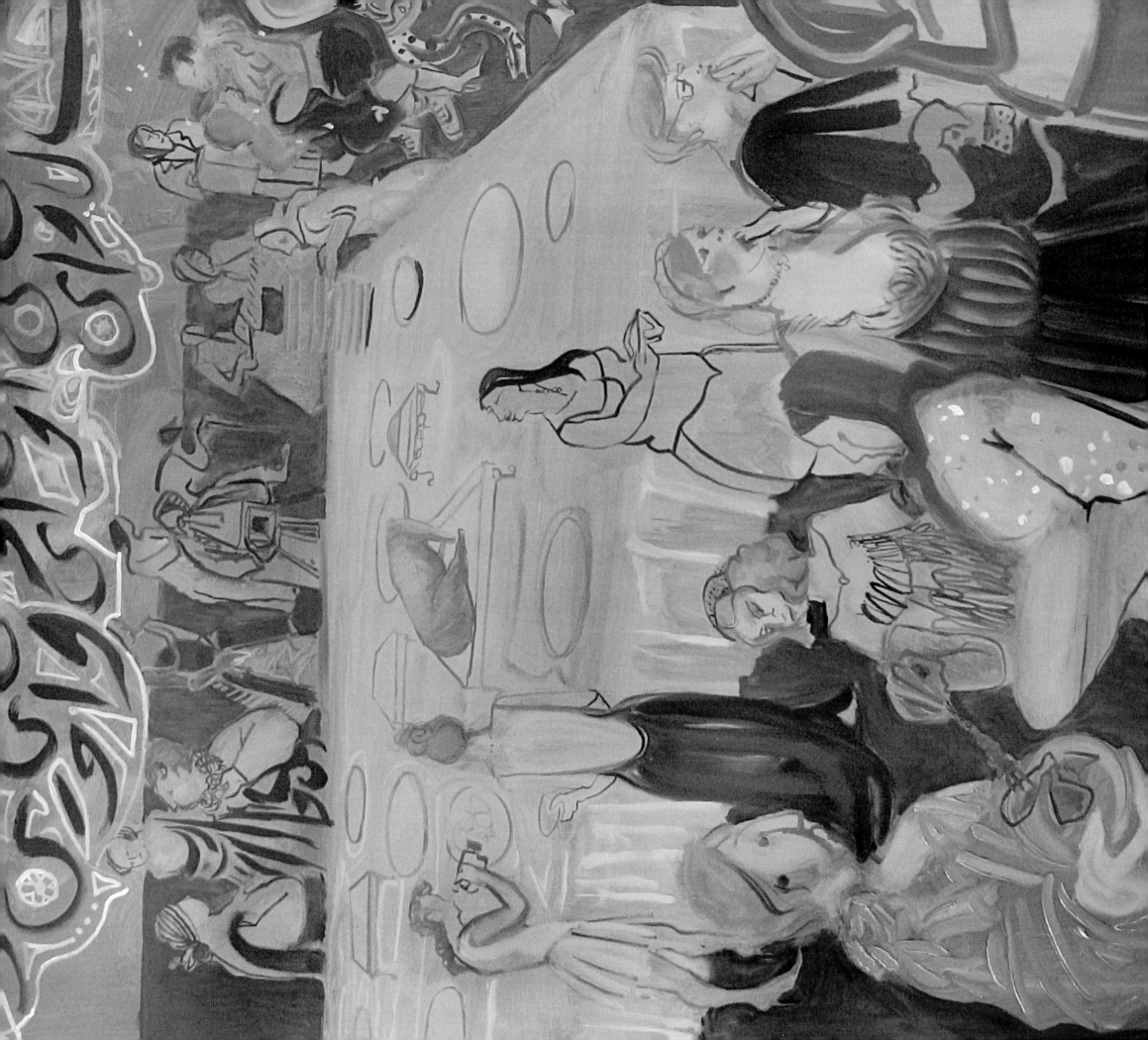

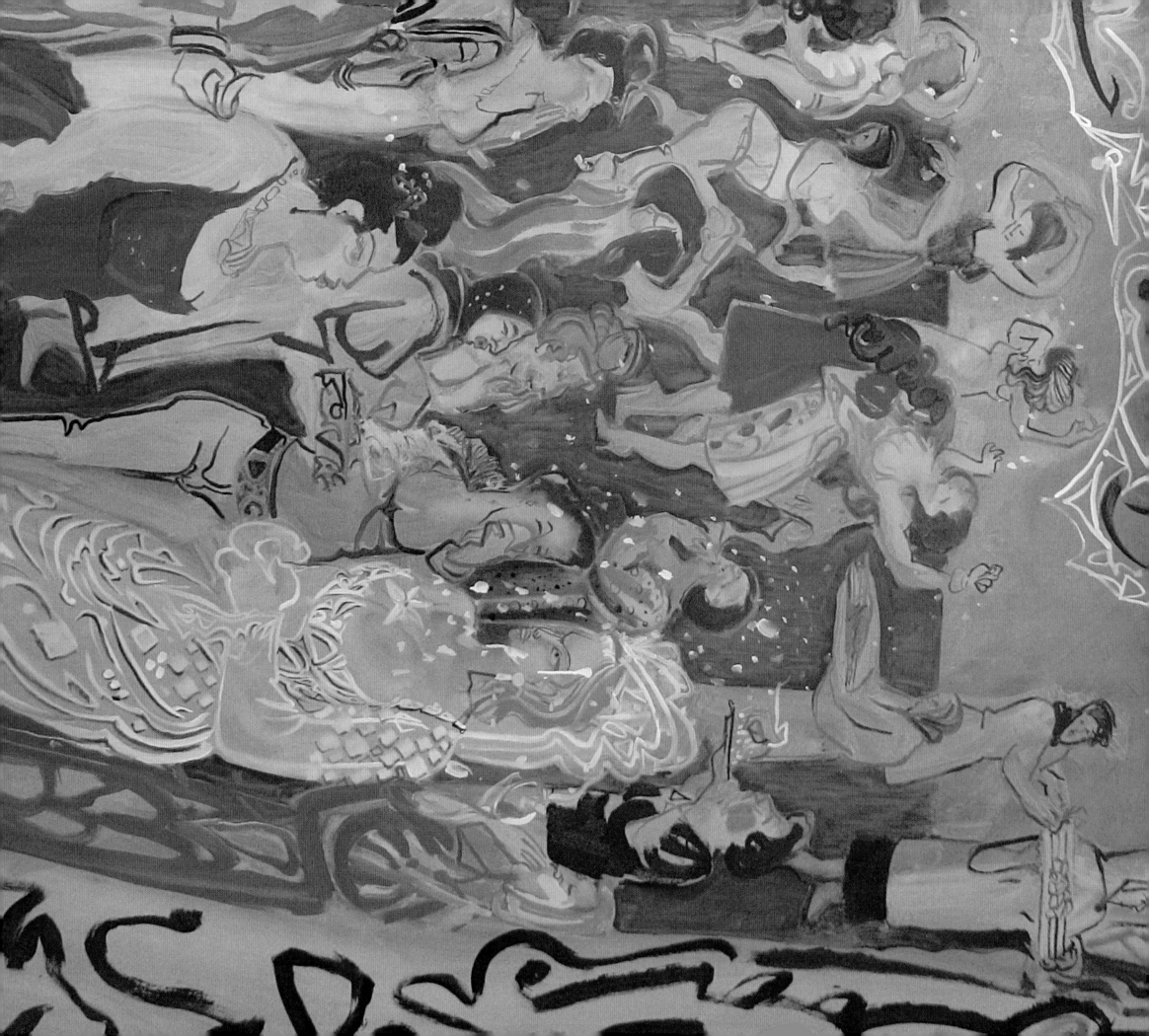

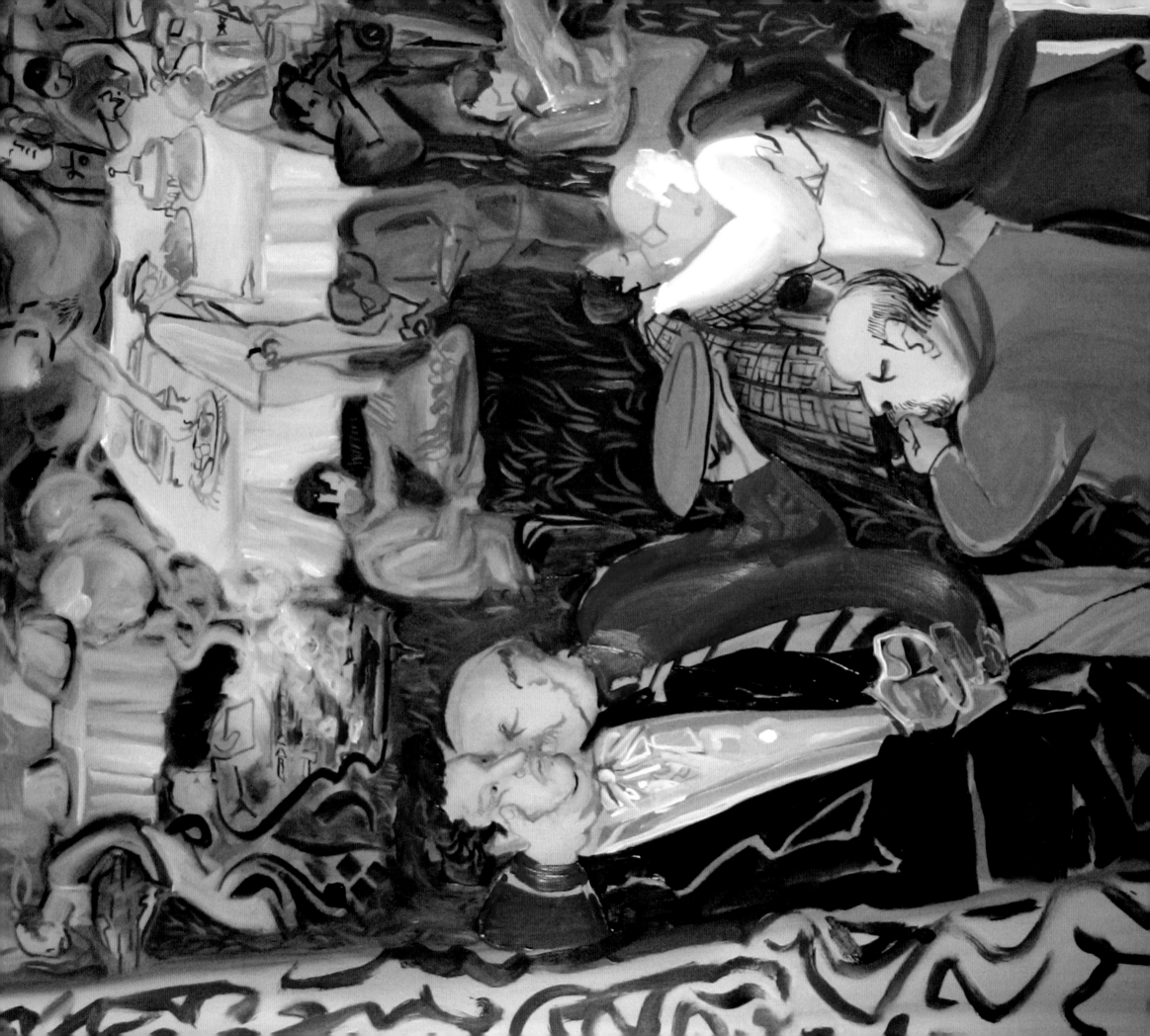

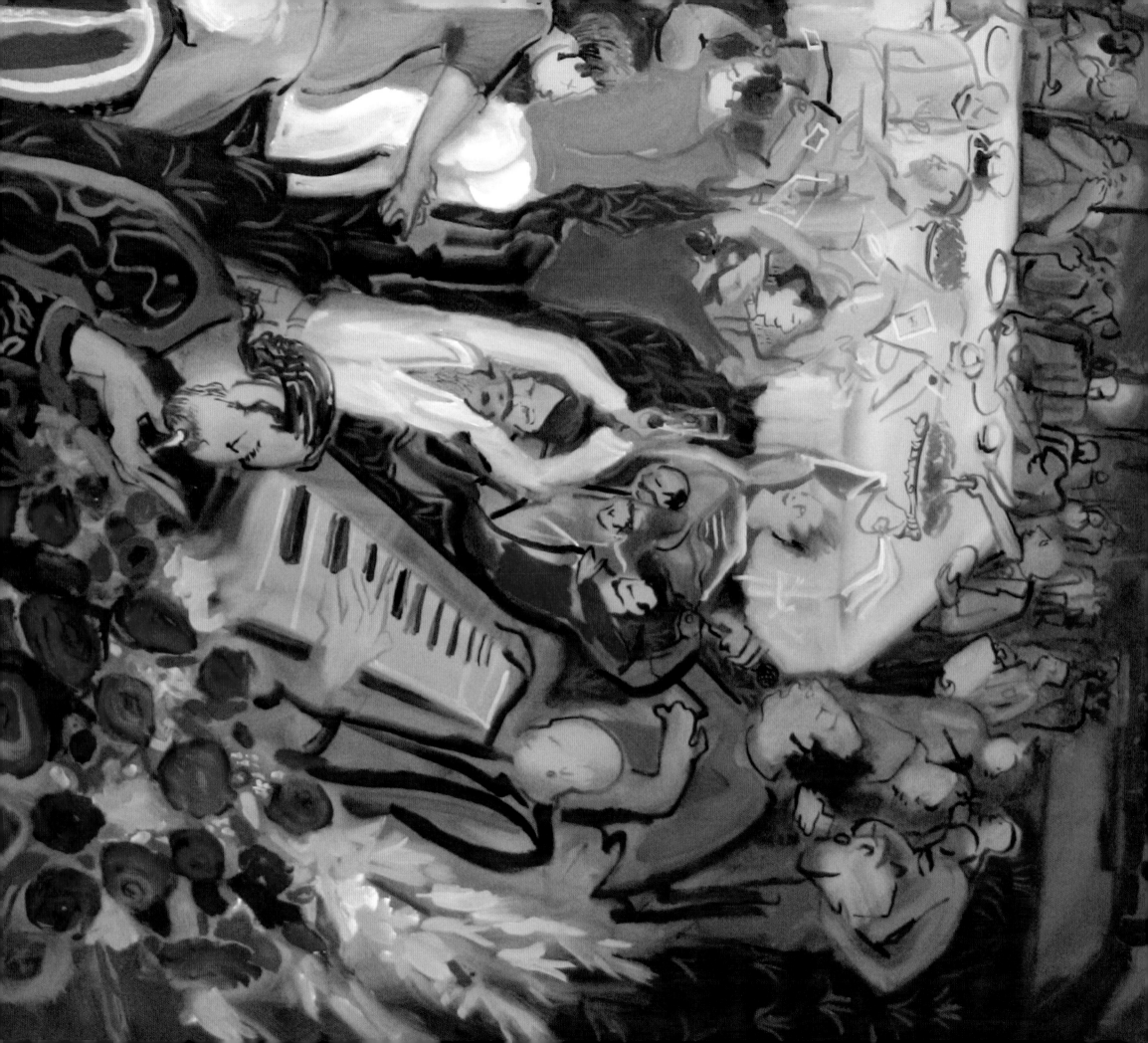

47

Rokni Haerizadeh
Razm
2006
Acrylic on canvas
200 × 200 cm

٤٧

روكنى حائرزاده
رزم
٢٠٠٦
اكريليك على قماش قنب
سم ٢٠٠ × ٢٠٠

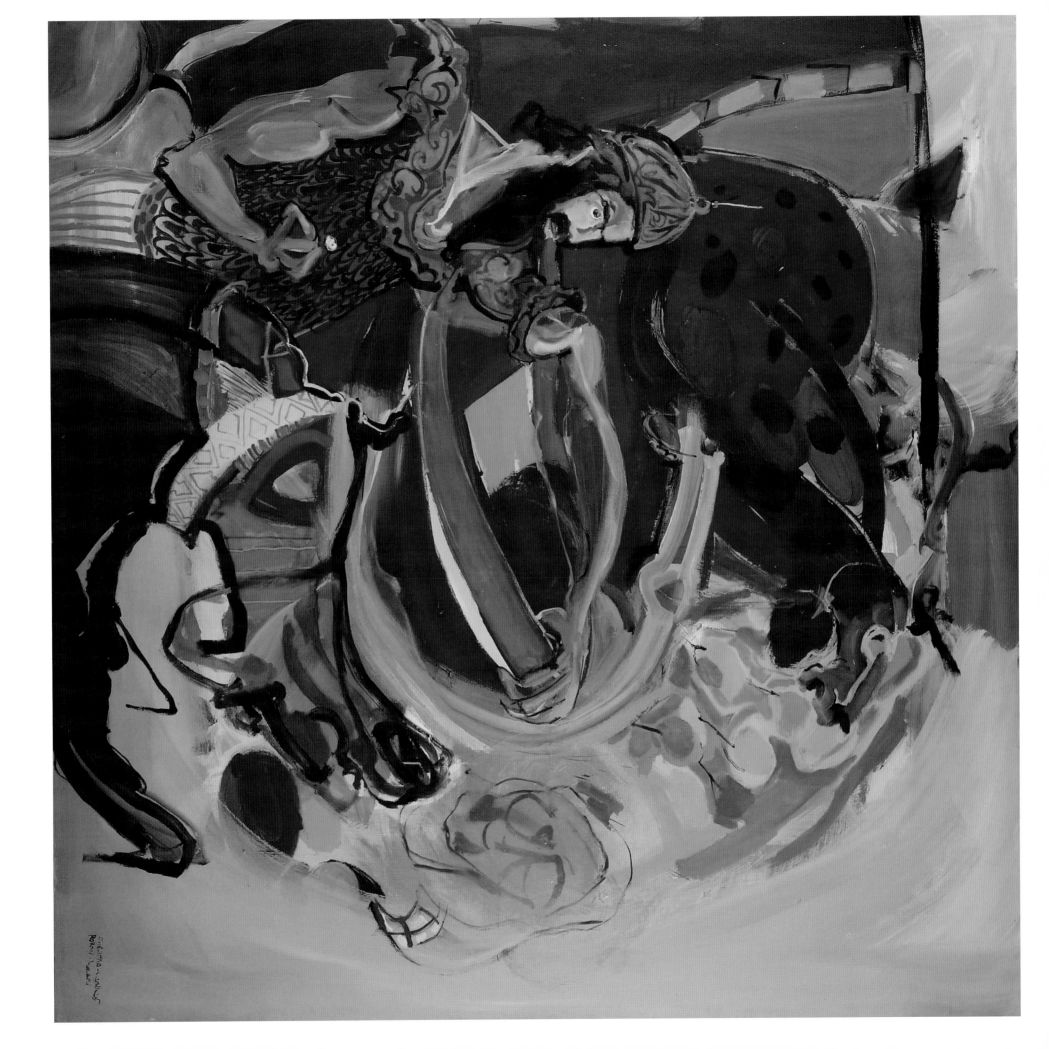

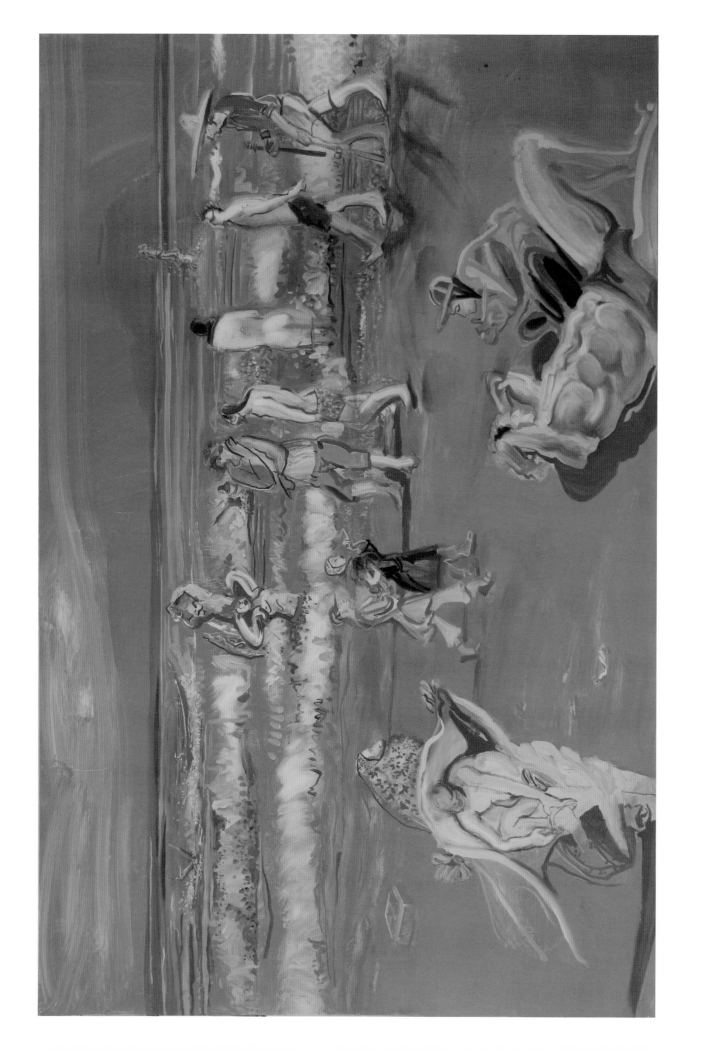

71–70. 48–49

رکنی حائری‌زاده

شومال (شاطئ علی بحر قزوین)

۲۰۰۸

زیت علی قماش قنب

سم ۳۰۰ × ۲۰۰ (کل اللاح)

سم ۶۰۰ × ۲۰۰ (اجمالی)

Rokni Haerizadeh
Shomal (Beach at the Caspian)
2008
Oil on canvas
200 × 300 cm (each panel)
200 × 600 cm (overall)

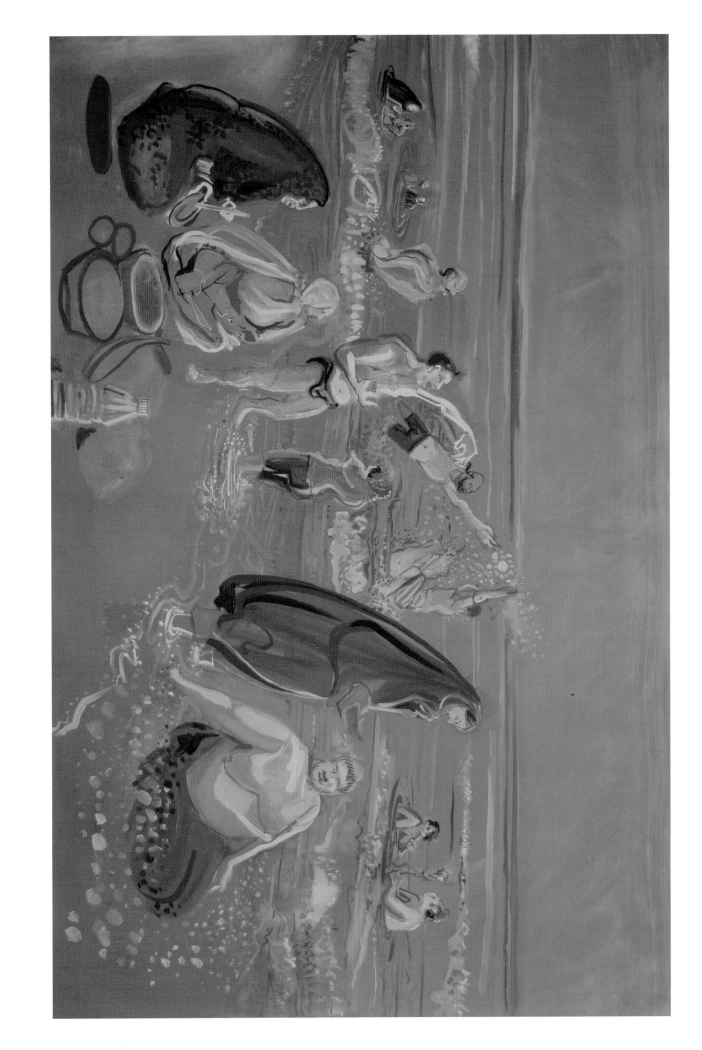

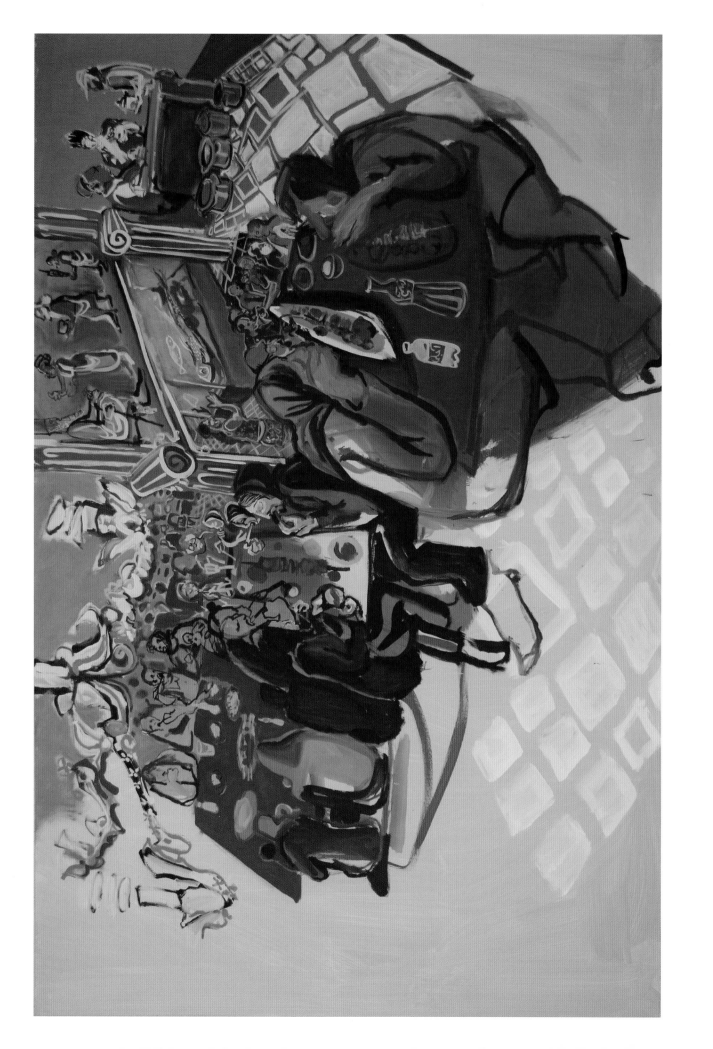

50–53 Rokni Haerizadeh
Typical Iranian Funeral
2008
Oil on canvas
200 × 300 cm (each panel)
200 × 600 cm (overall)

روكني حائريزاده
جنائز ايرانية نموذجية
٢٠٠٨
زيت على قماش قنب
كل لوحة ٢٠٠ × ٣٠٠ سم
إجمالي ٢٠٠ × ٦٠٠ سم

٥٣–٥٠

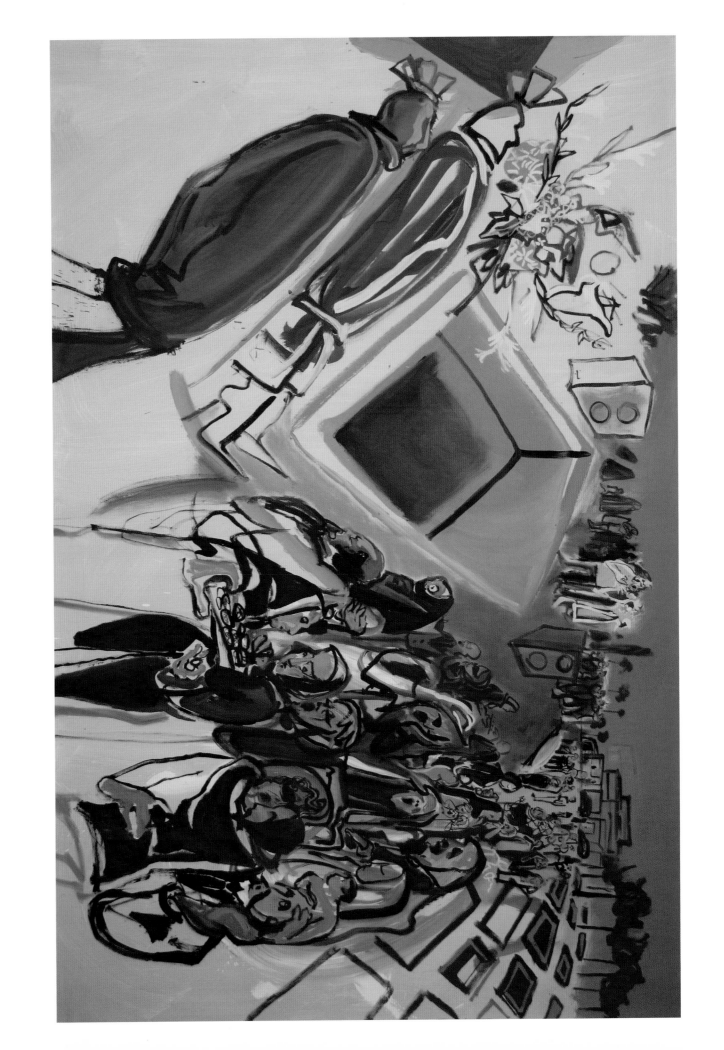

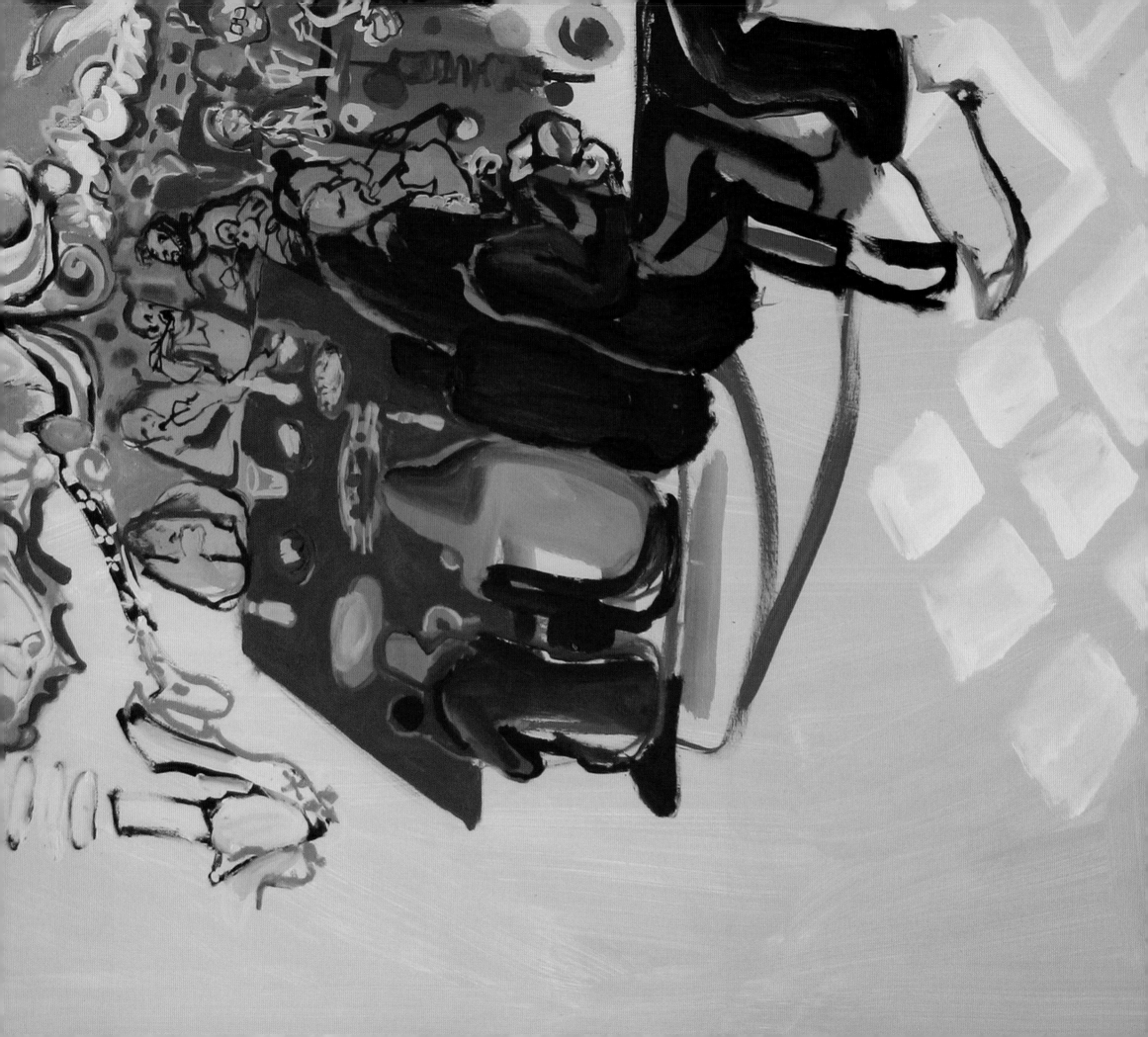

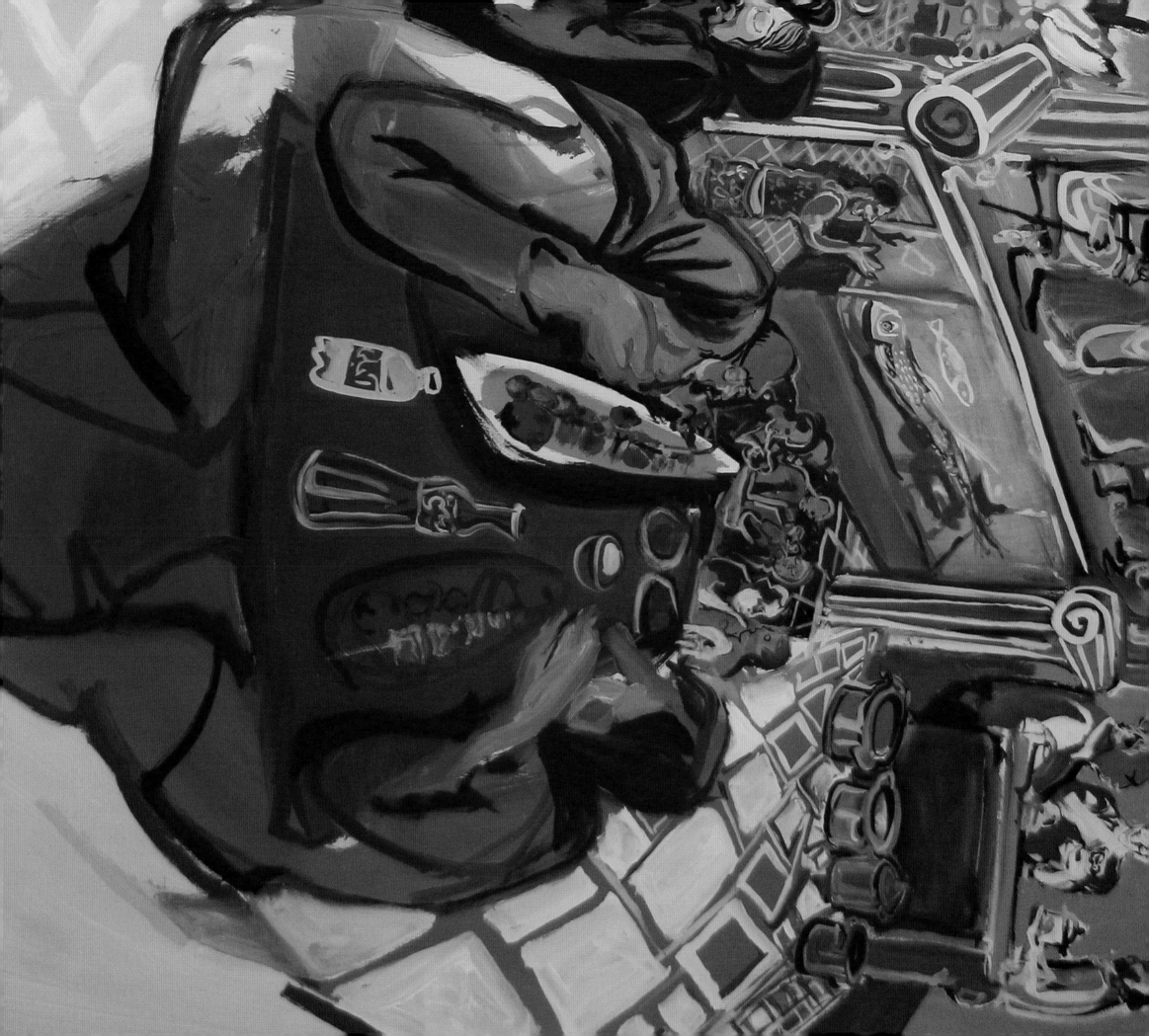

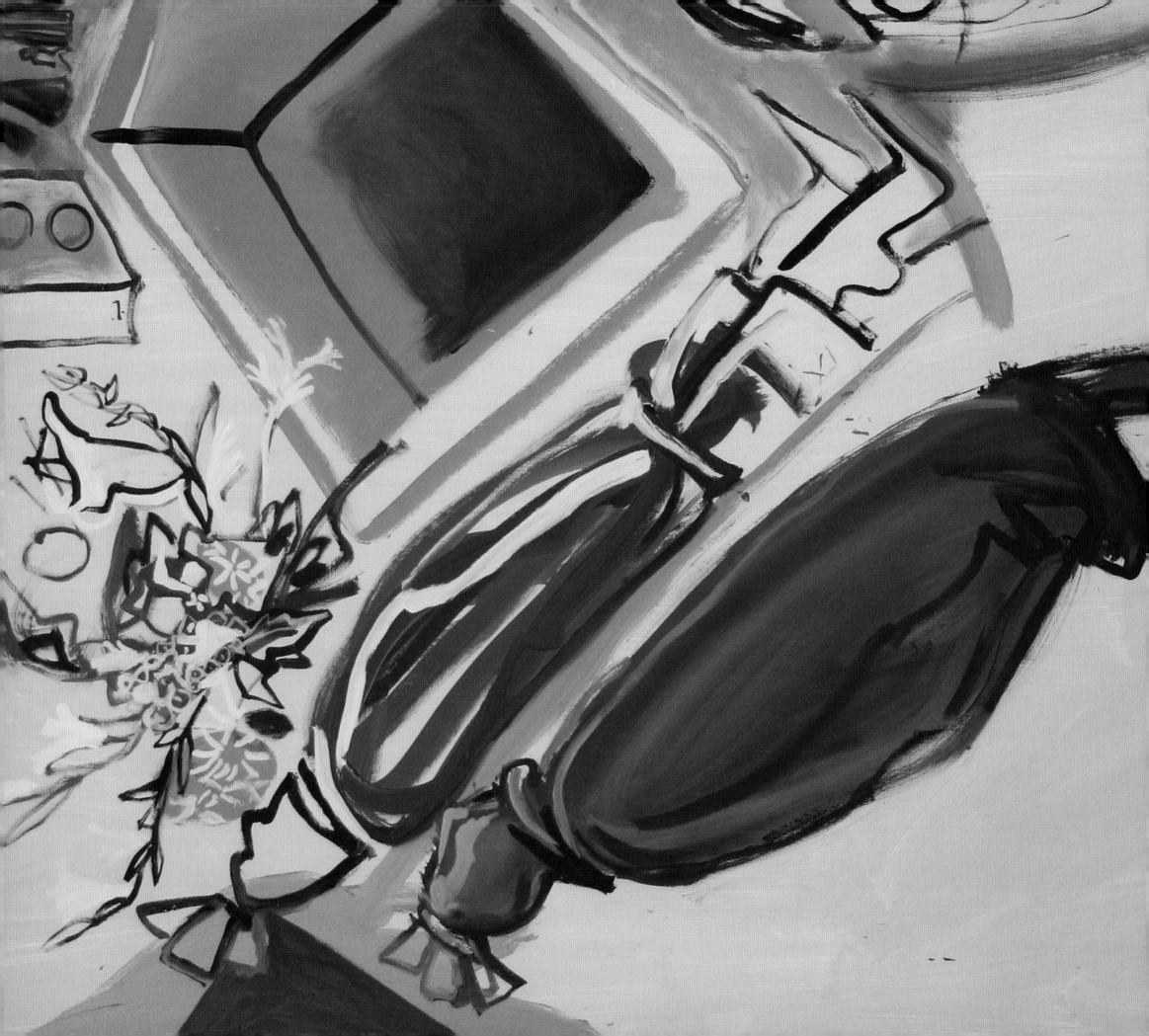

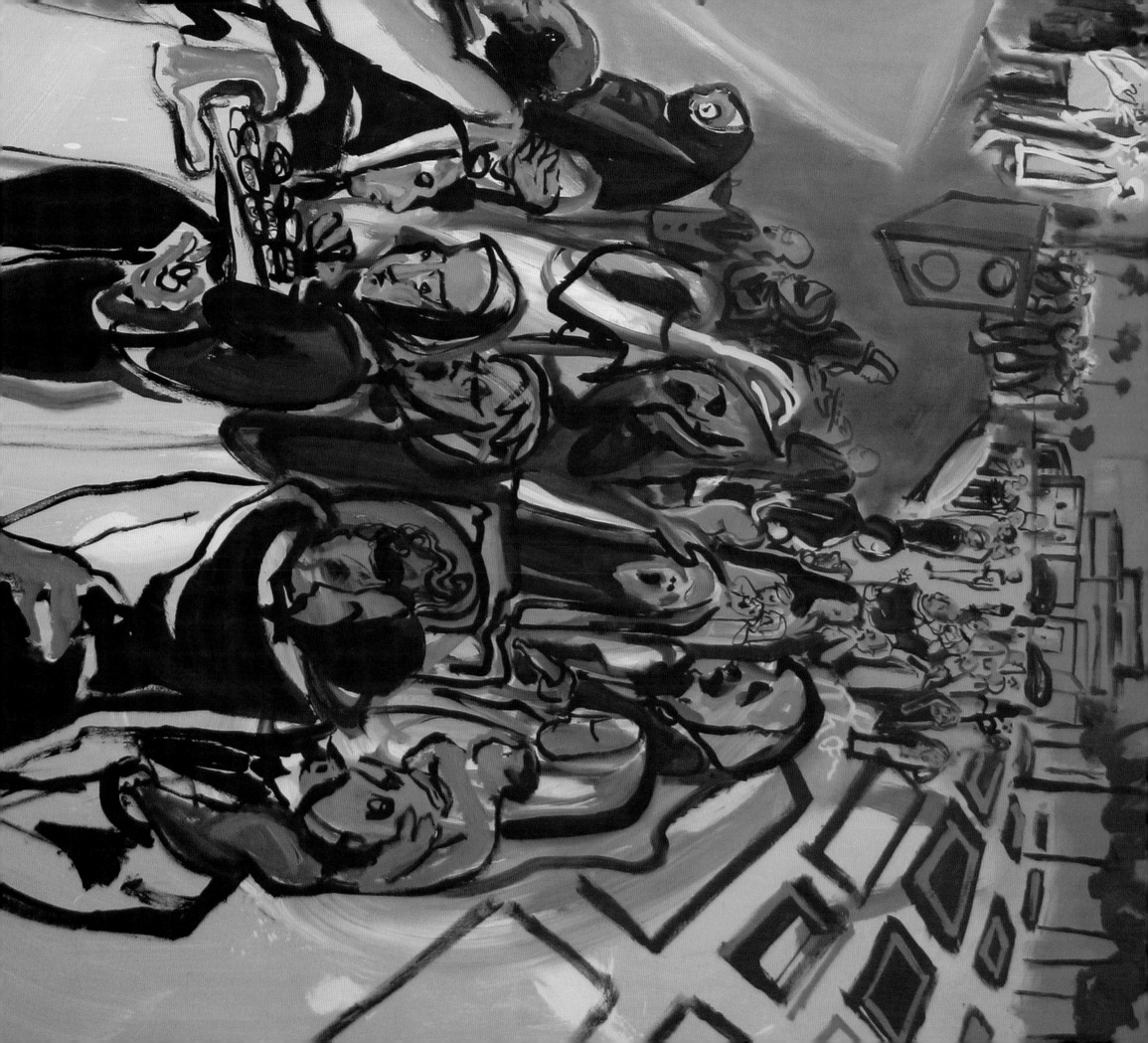

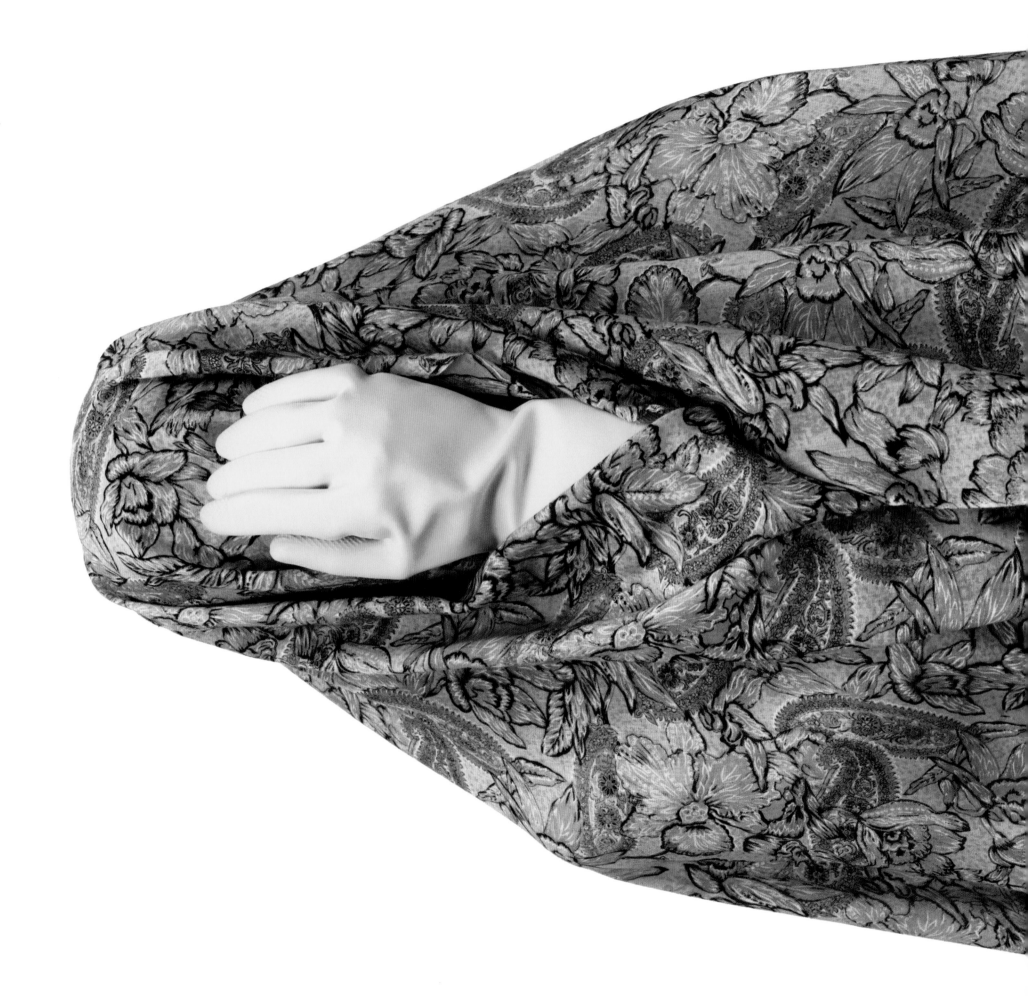

54–60

Shadi Ghadirian
Untitled from the Like EveryDay Series
All: 2000–2001
All: C-print
Each: 183 × 183cm

٥٥-٤٩

شادي قديريان
بلا عنوان من سلسلة مثل كل يوم
٢٠٠١-٢٠٠٠
المطبوعة: سي برنت
كل صورة: ١٨٣ × ١٨٣ سم

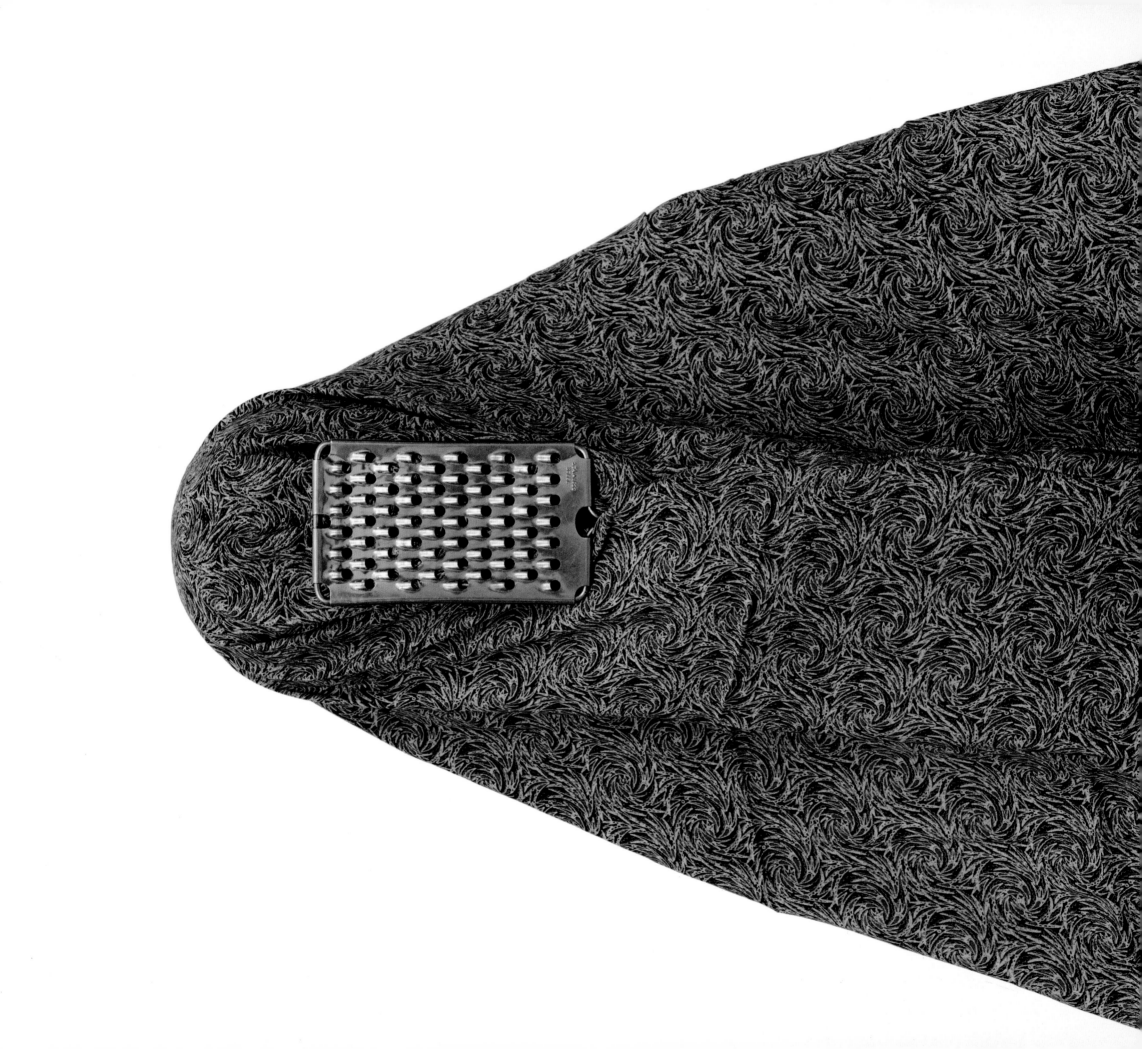

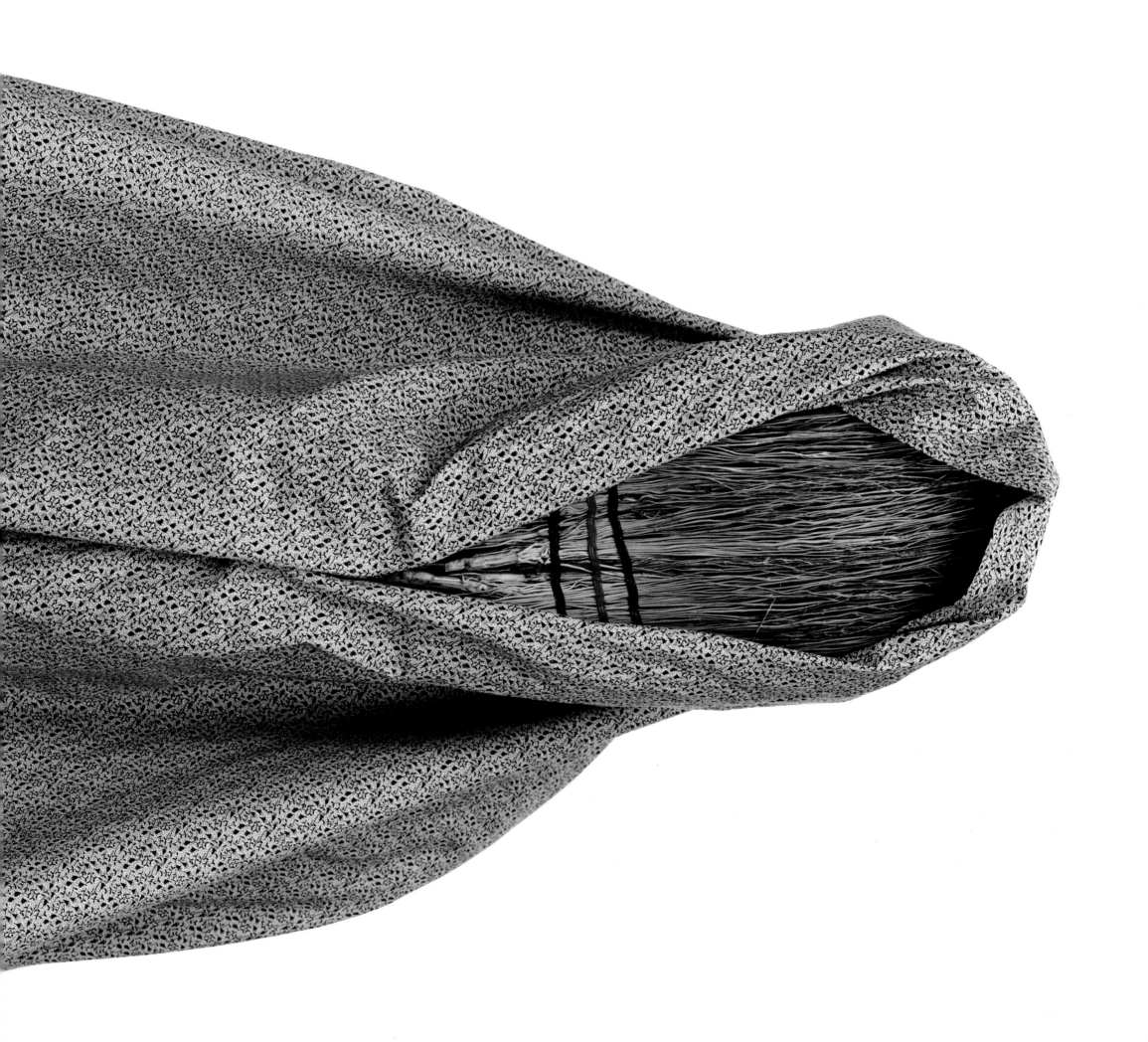

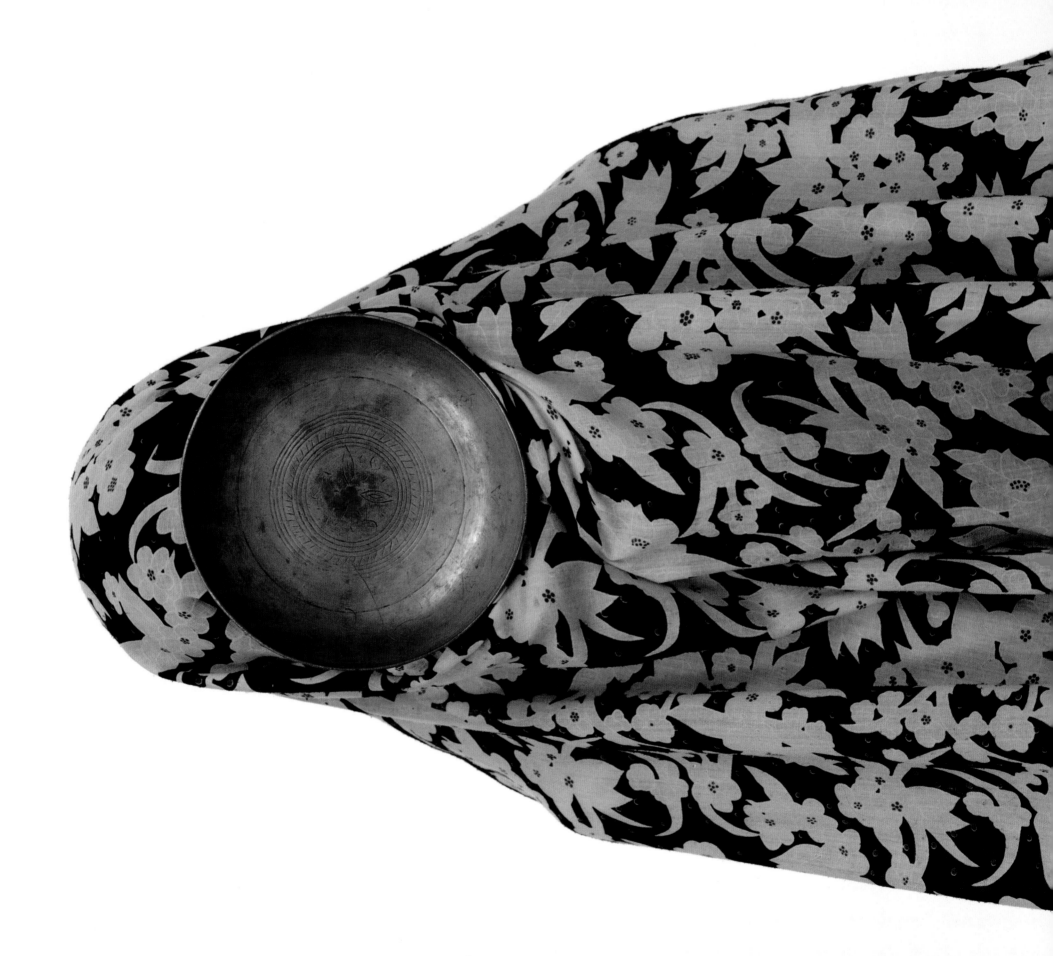

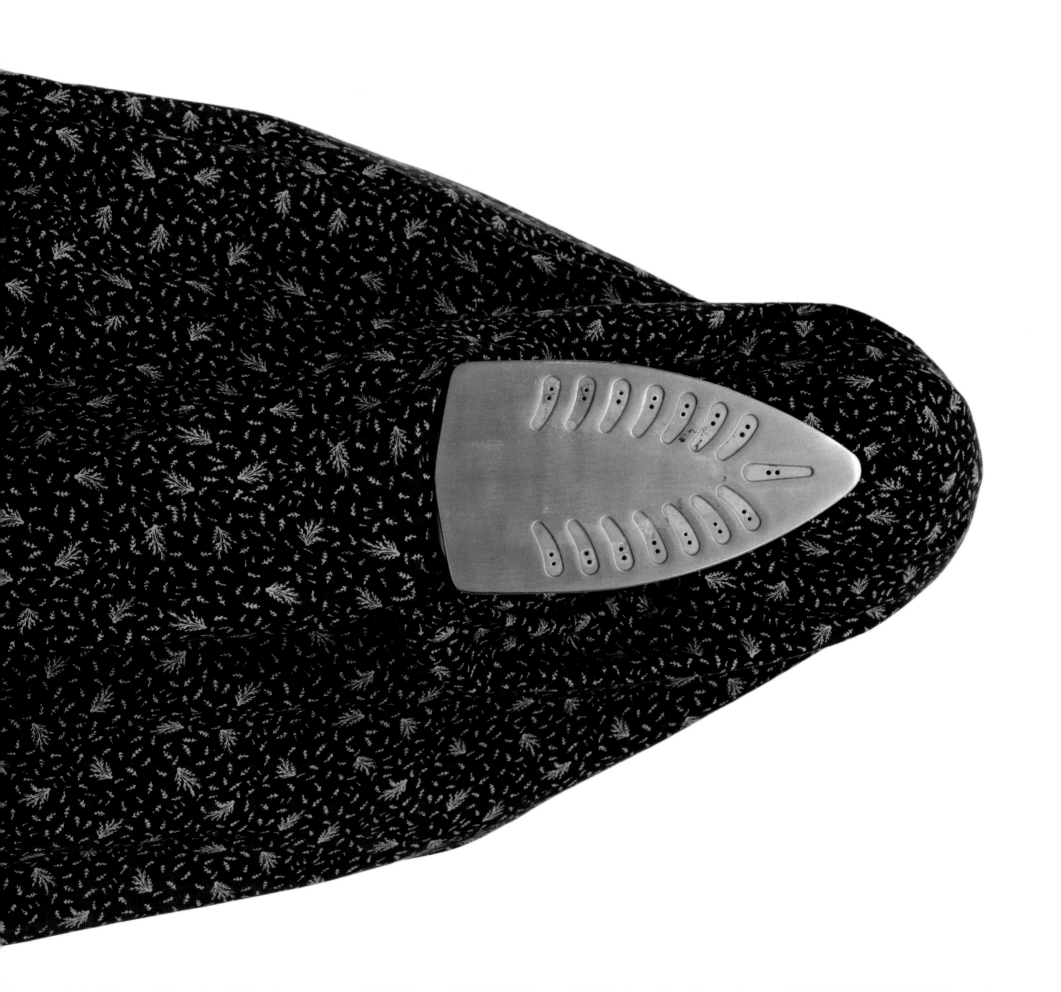

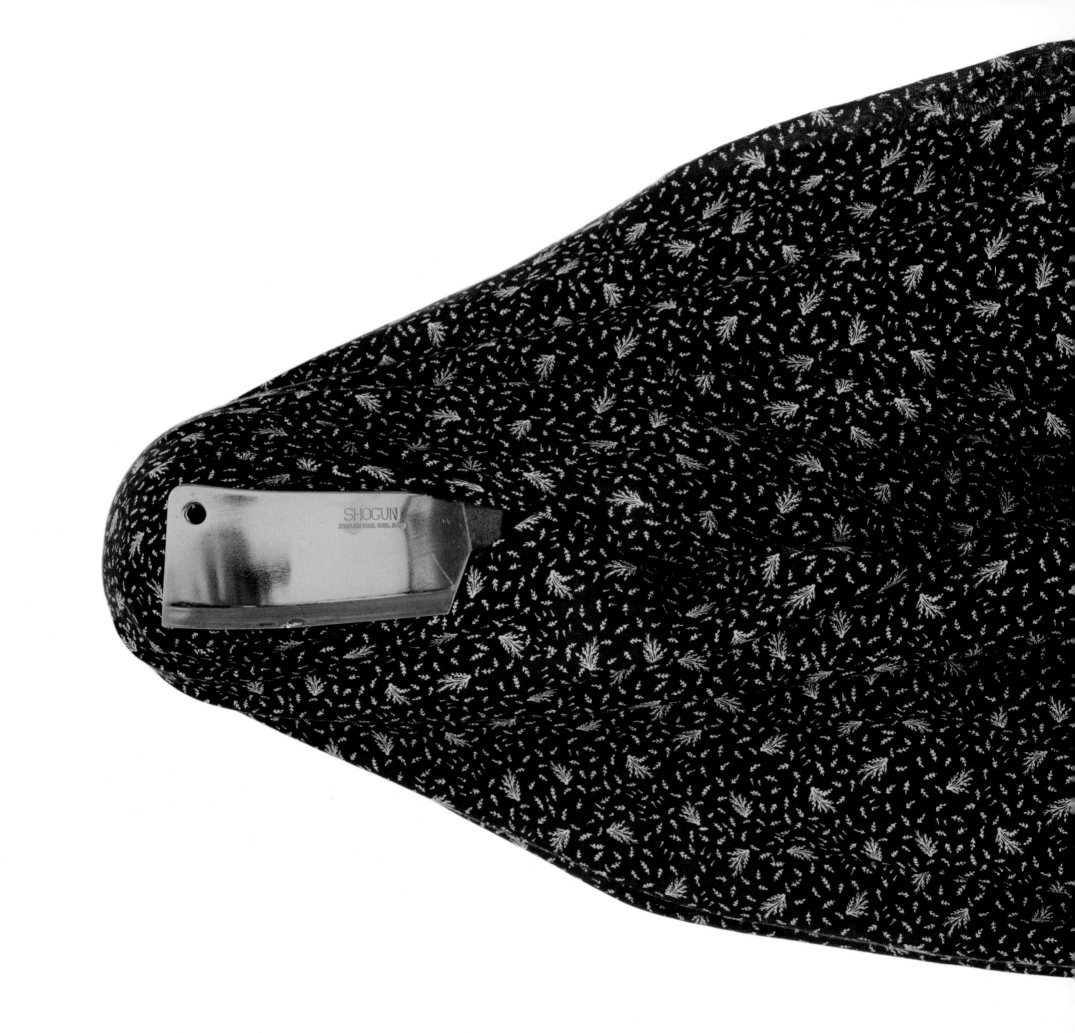

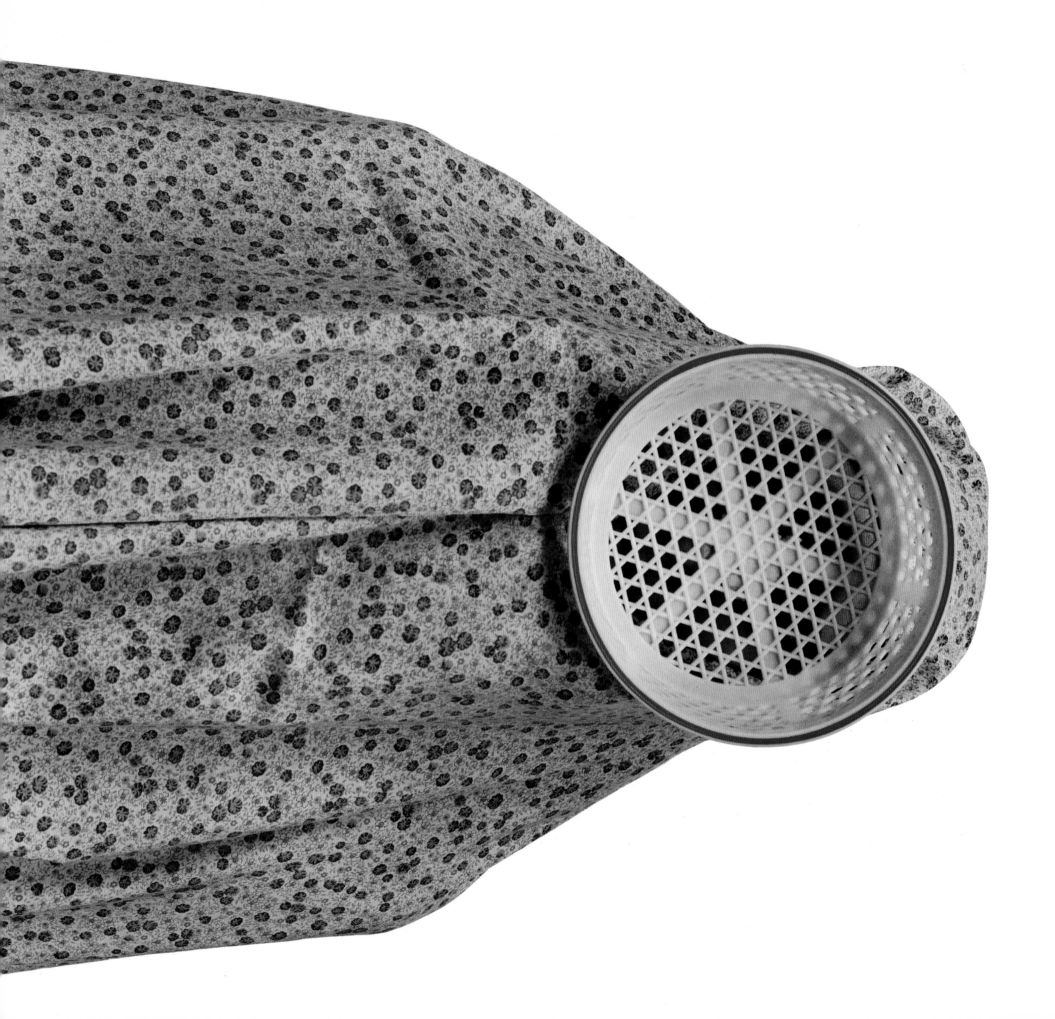

٤٨ 61

خالد حافظ Khaled Hafez
أيدي بحيرة الجني Mighty Hands of Gemmis
٢٠٠٨ 2008
أكريليك وكولاج على قماش Acrylic and collage on canvas
٢٠٠ × ٢٥٠ سم 200 × 250cm

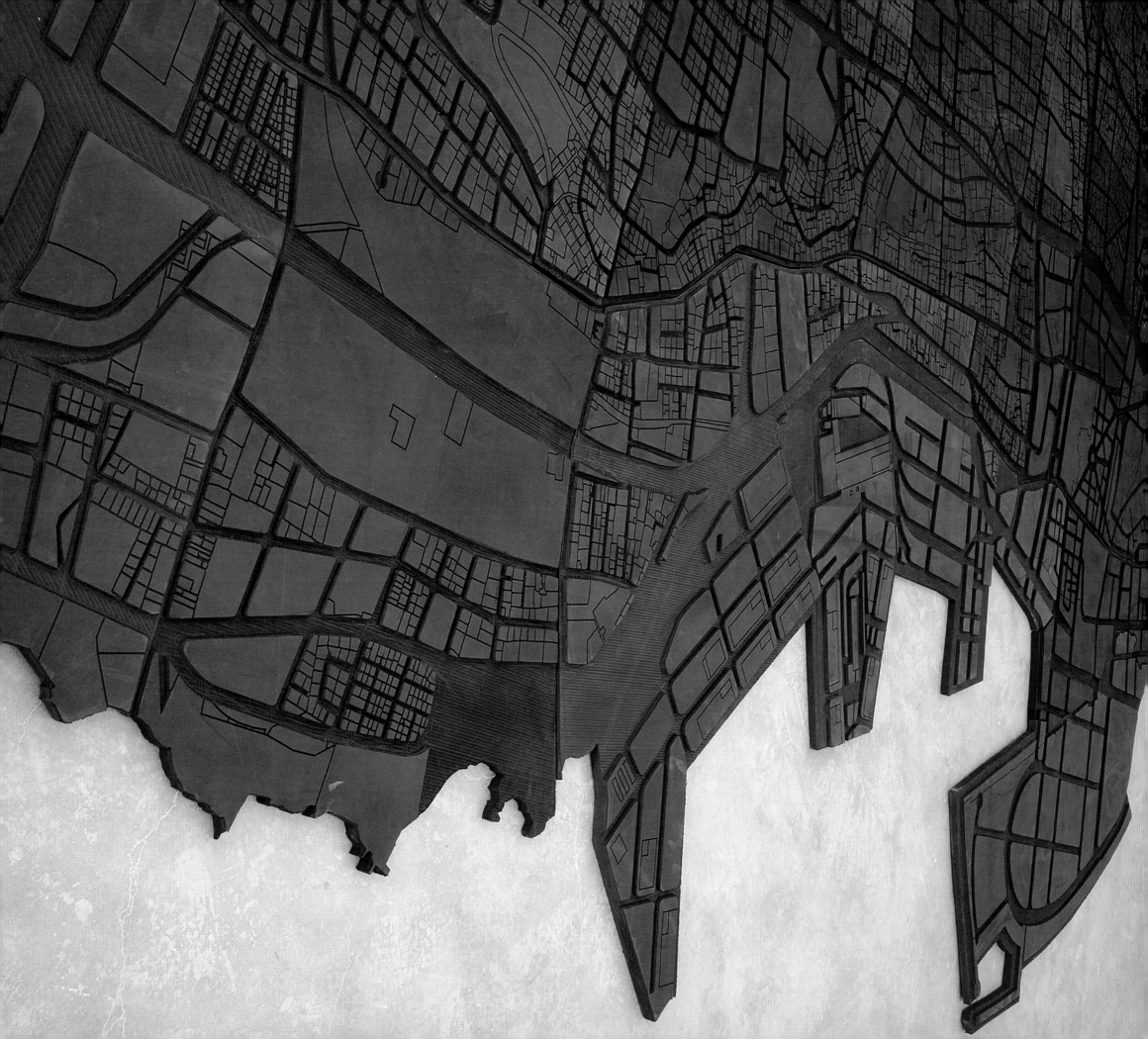

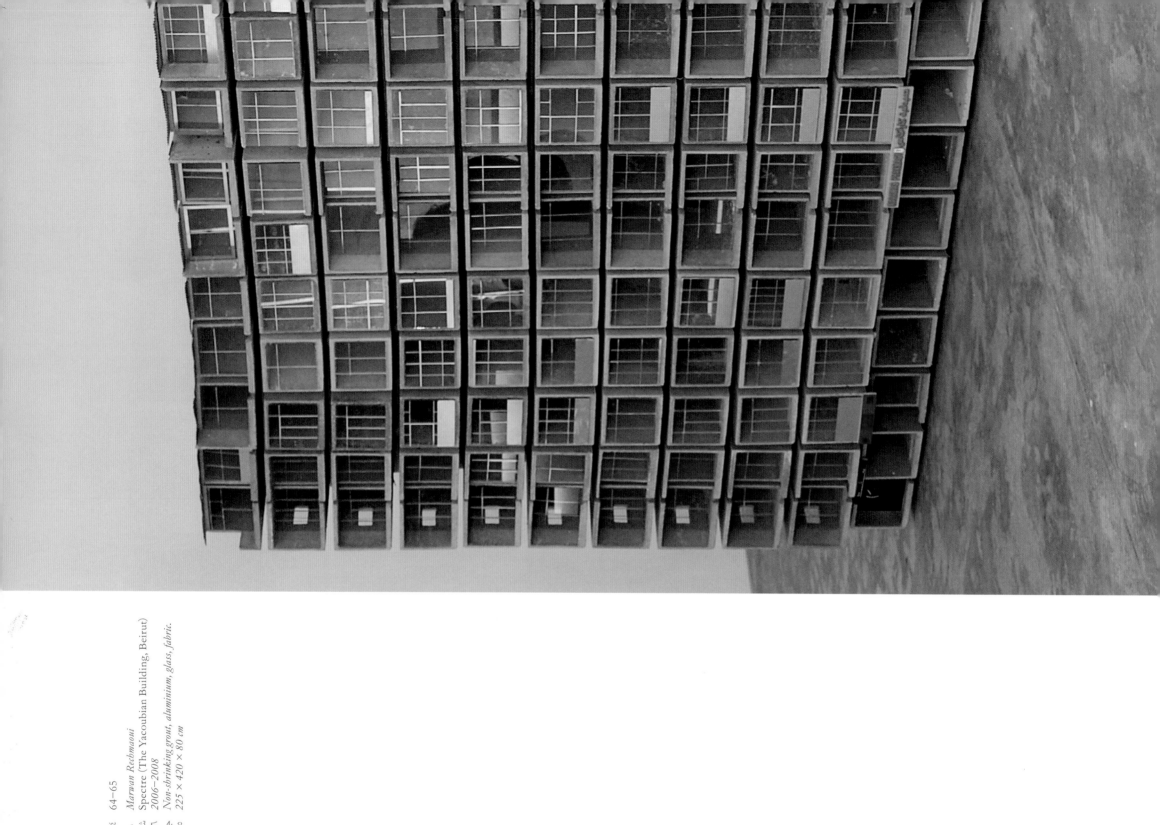

Marwan Rechmaoui
Spectre (The Yacoubian Building, Beirut)
2006–2008
Non-shrinking grout, aluminium, glass, fabric.
225 × 420 × 80 cm

مروان رشماوي ٦٥-٦٤
شبح (بناية يعقوبيان بيروت)
٢٠٠٨ - ٢٠٠٦
جفش غير قابل للتكماش، المنيوم، زجاج، قماش.
سم ٨٠ × ٤٢٠ × ٢٢٥

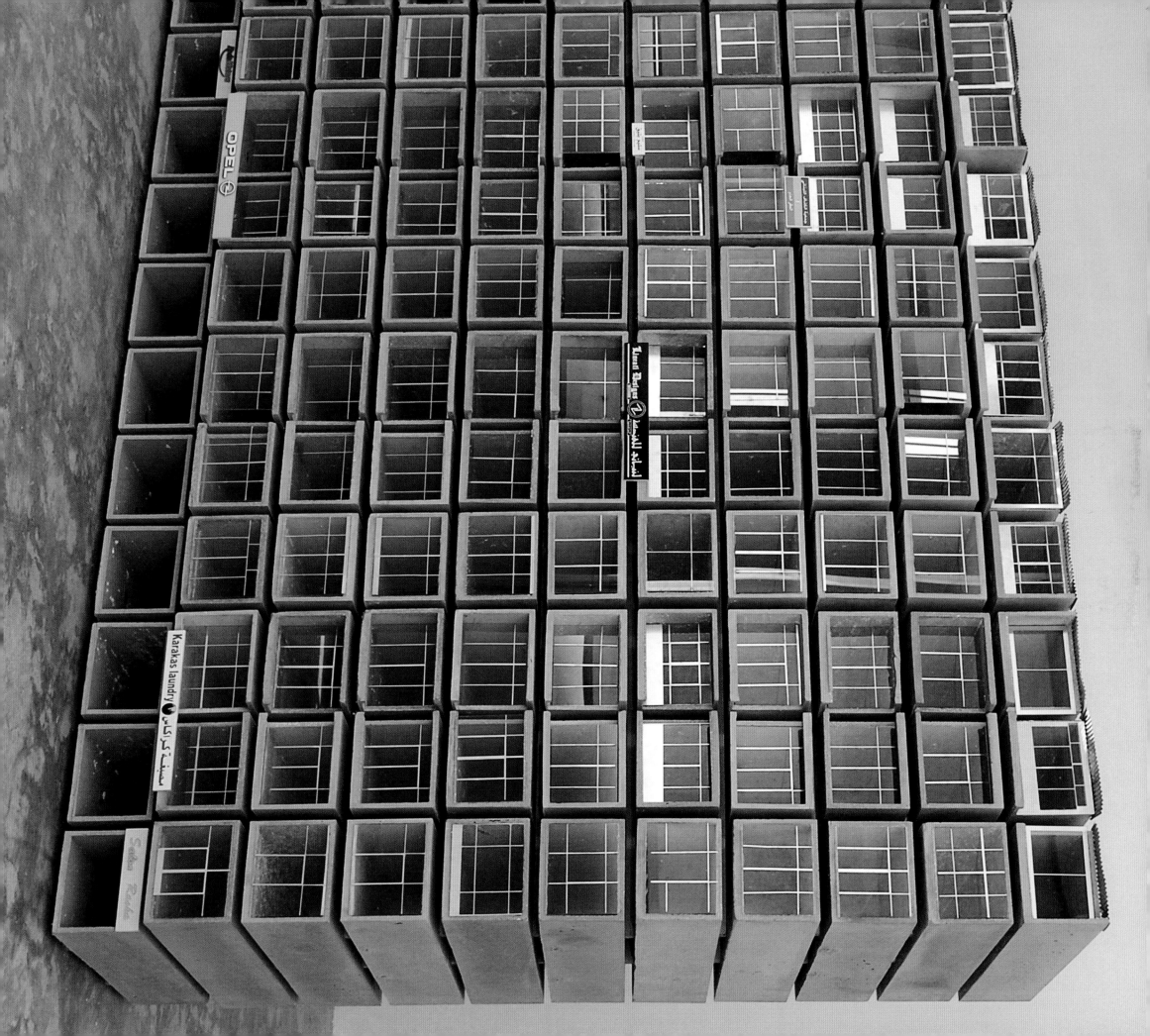

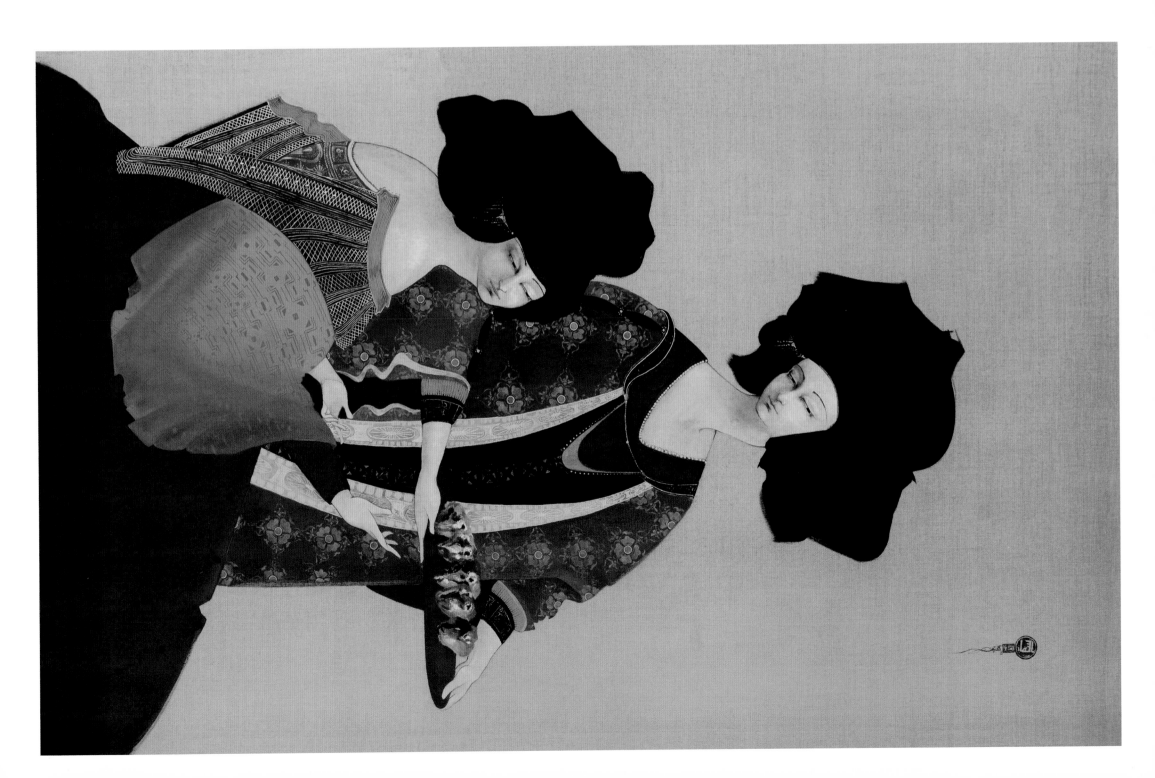

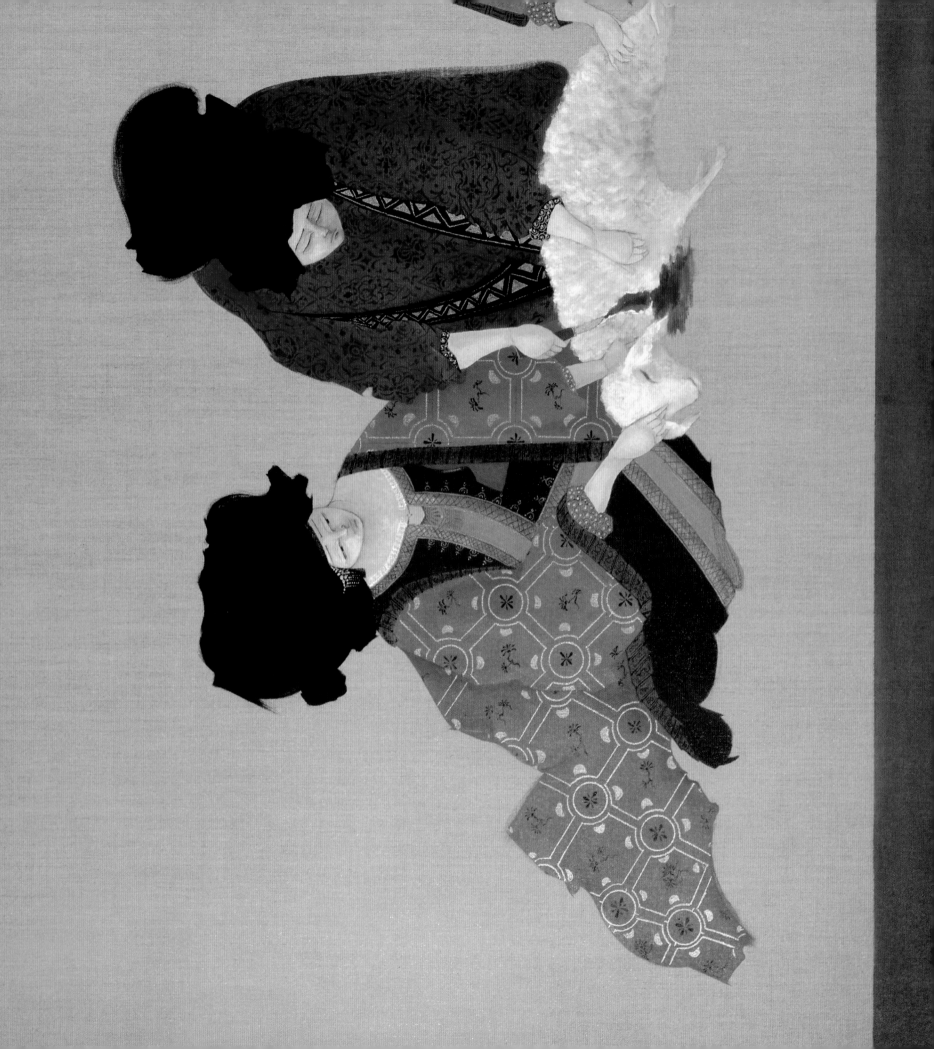

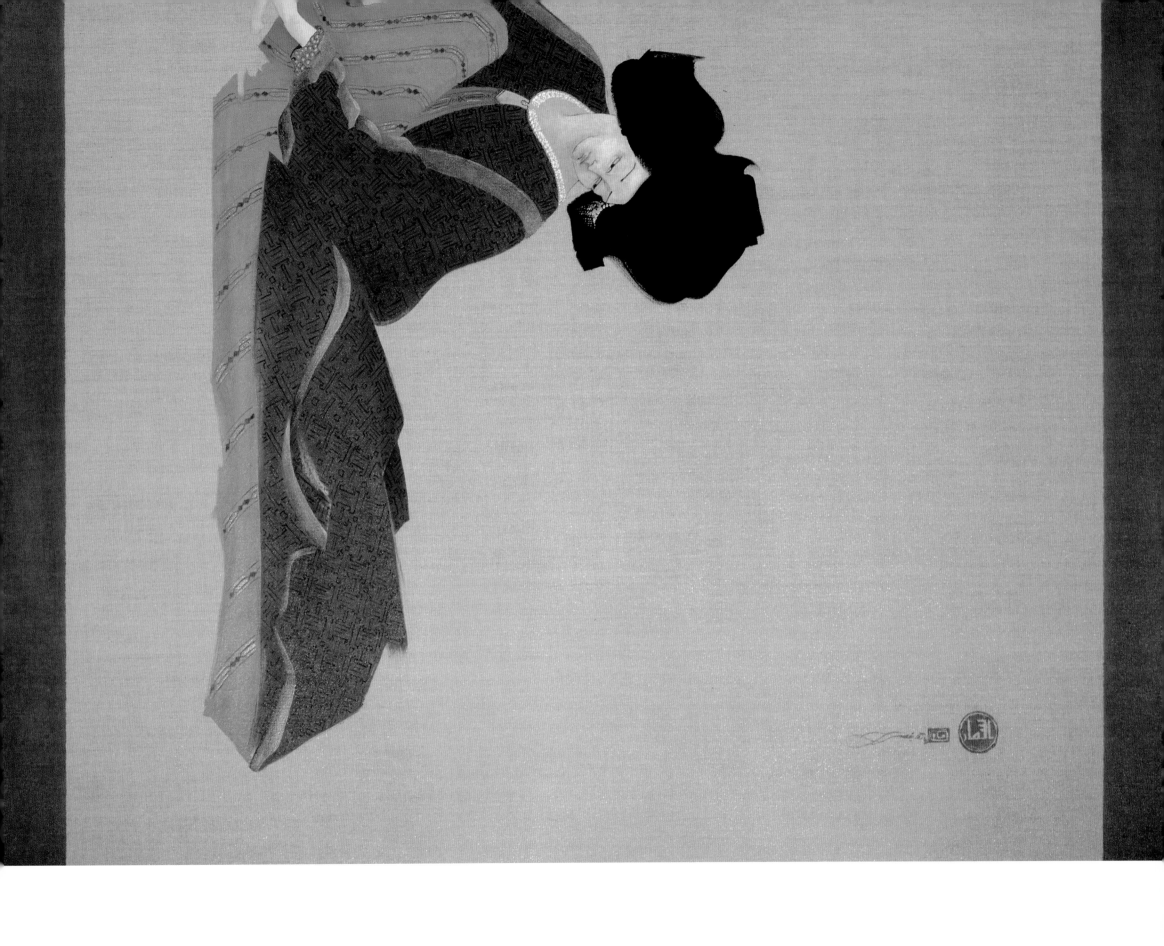

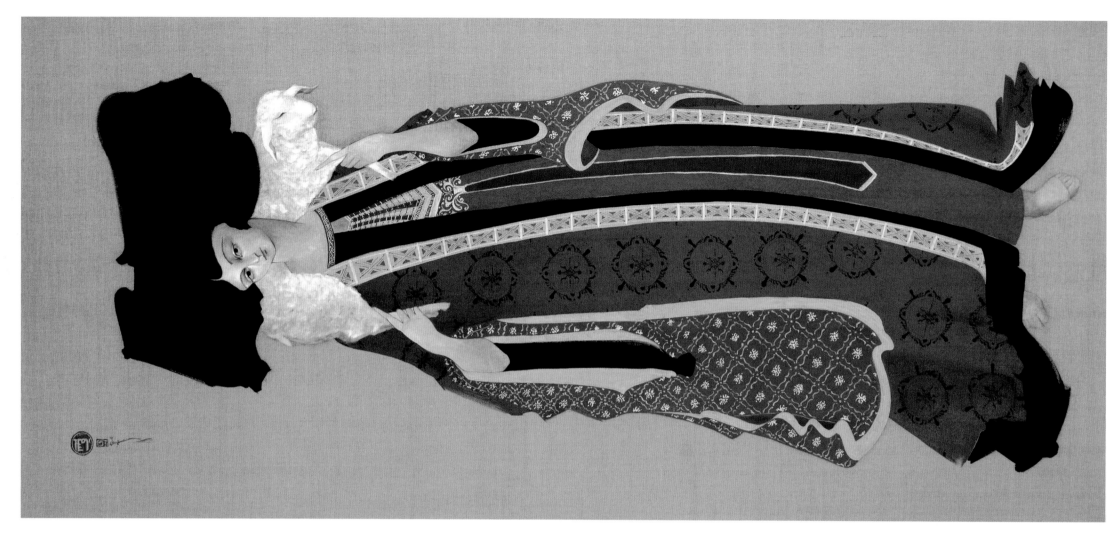

68–69

Hajr Kahraman
Carrying On Shoulder 1 & Carrying On Shoulder 2
2008
Oil on linen
Each panel: 173 × 76.3 cm

٦٩–٦٨

هجر قهرمان
يحمل على الأكتاف ١ و يحمل على الأكتاف ٢
٢٠٠٨
زيت على قماش كتان
كل لطان: ١٧٣ × ٧٦٫٣ سم

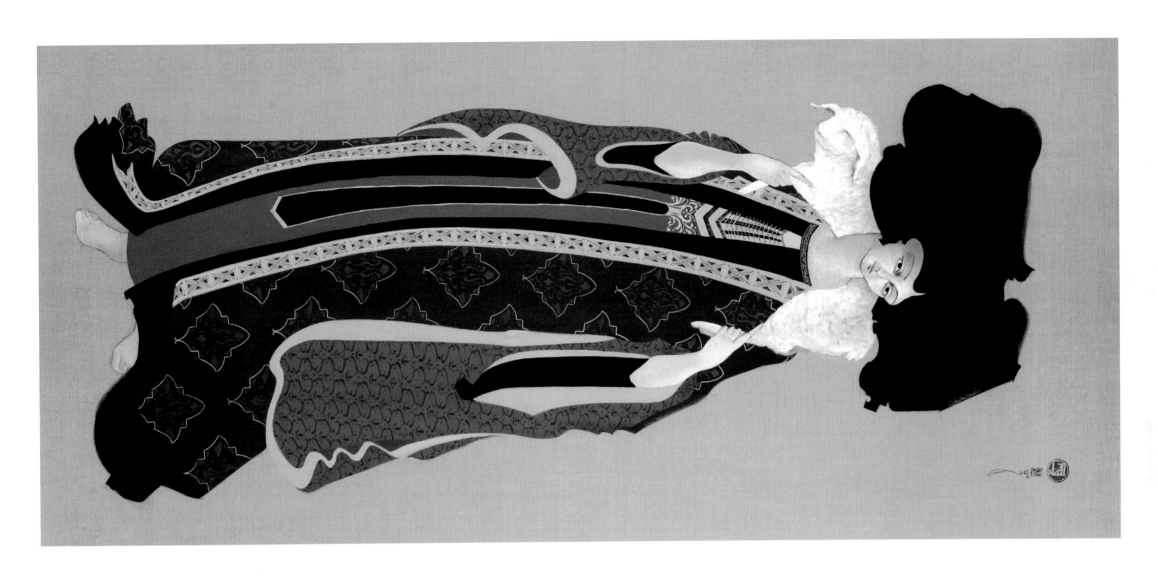

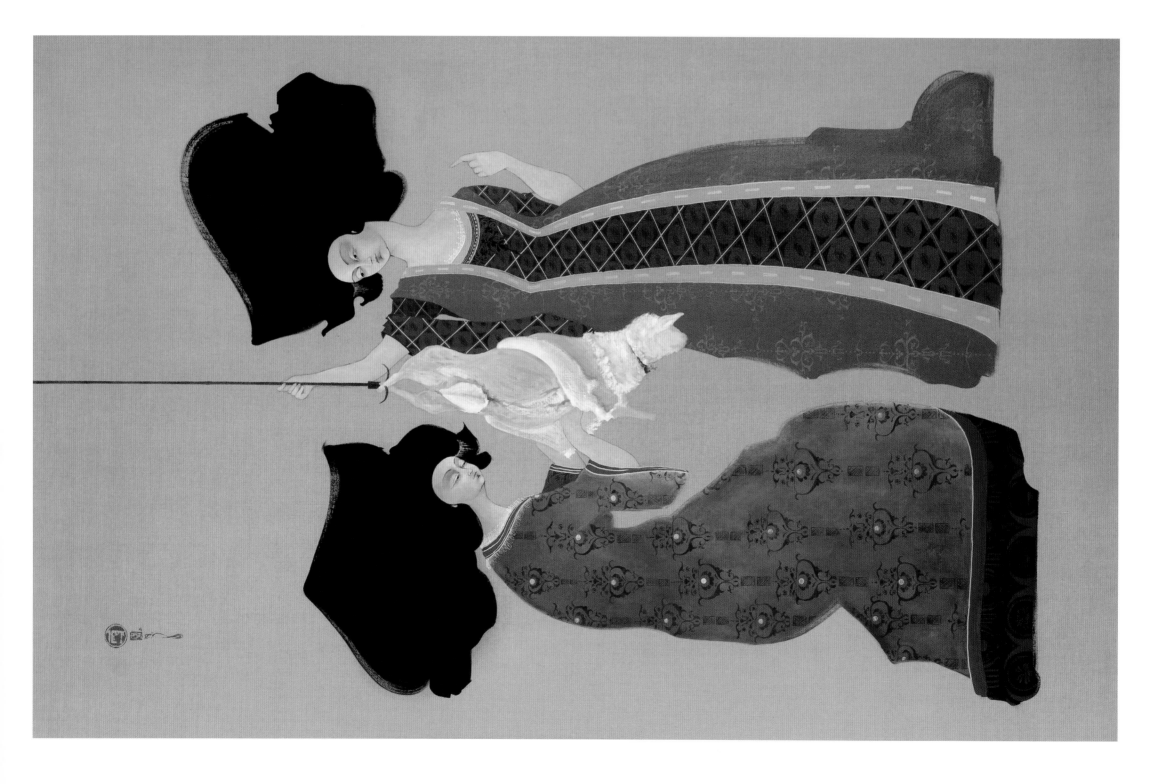

٣٩
هيو قهرمان
سلخ الحمل
٢٠٠٨
زيت على قماش كتان
١٧٣ × ١٠٦٫٥ سم

70

Hayv Kahraman
Flaying the Lamb
2008
Oil on linen
173 × 106.5 cm

جعفر خالدى
اللانهاية وما يليها
٢٠٠٨
زيت على قماش قنب
سم ٢٠٠ × ٢٢٠

Jeffar Khaldi
The Infinite and Beyond
2008
Oil on canvas
220 × 200 cm

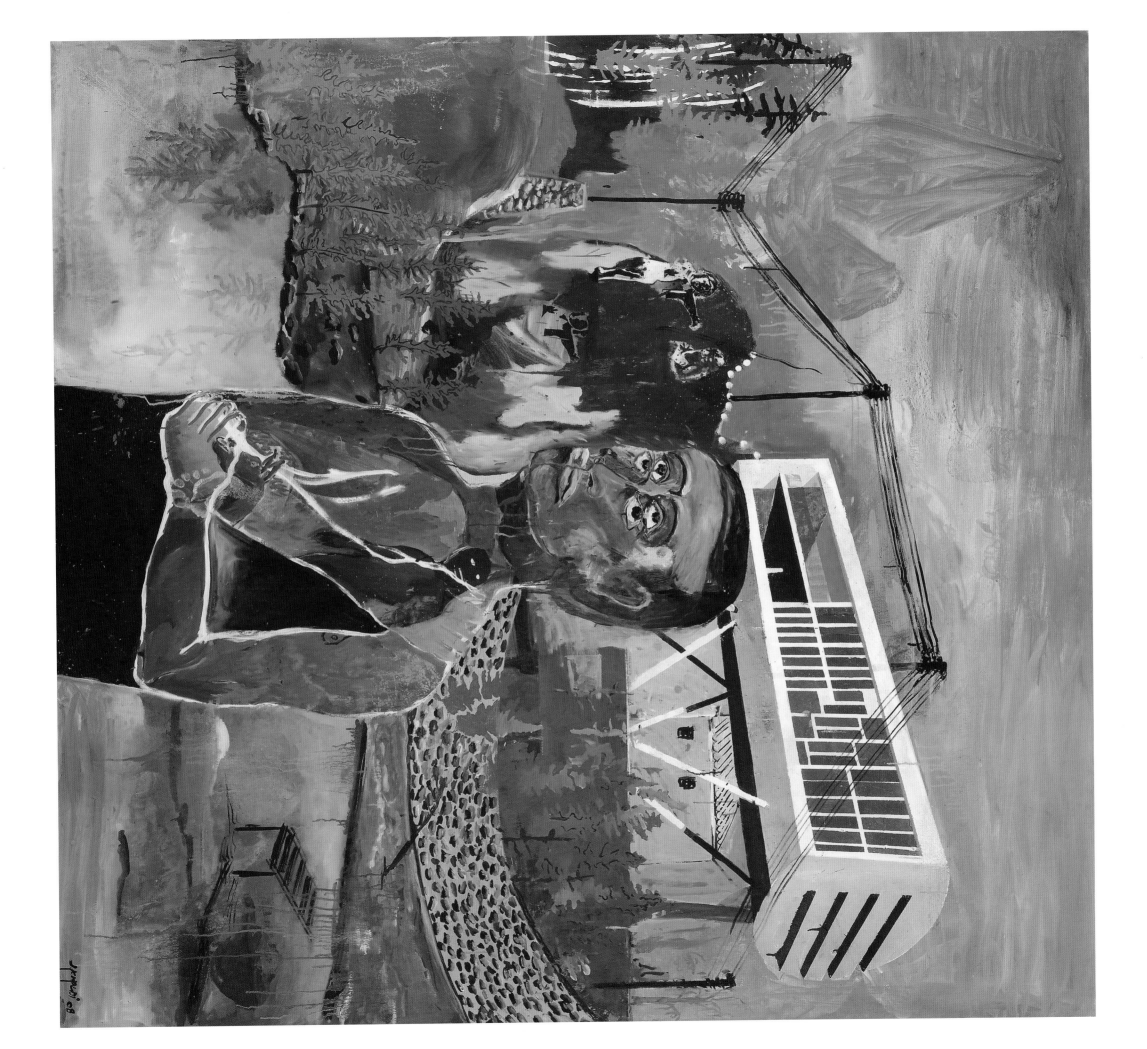

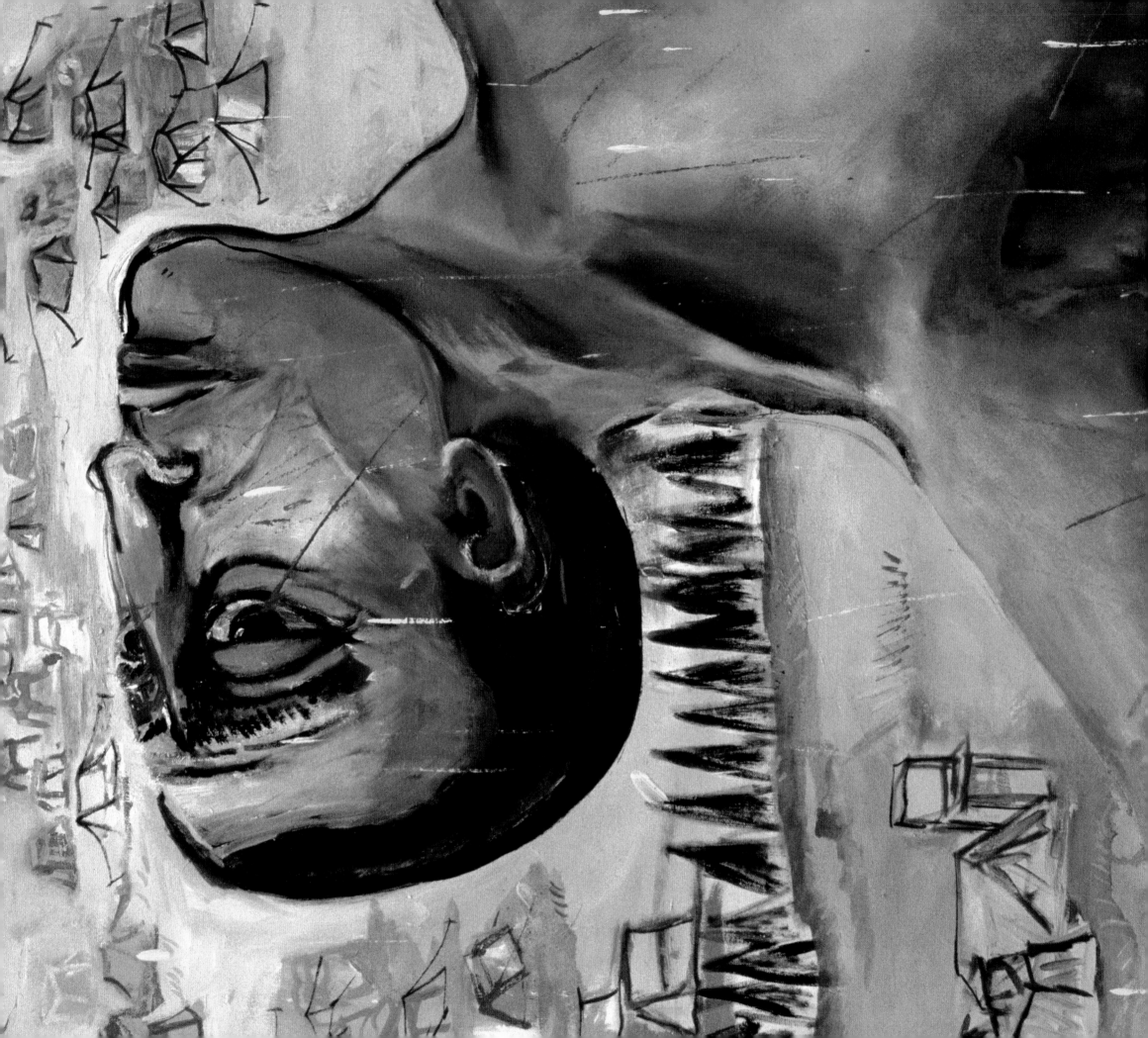

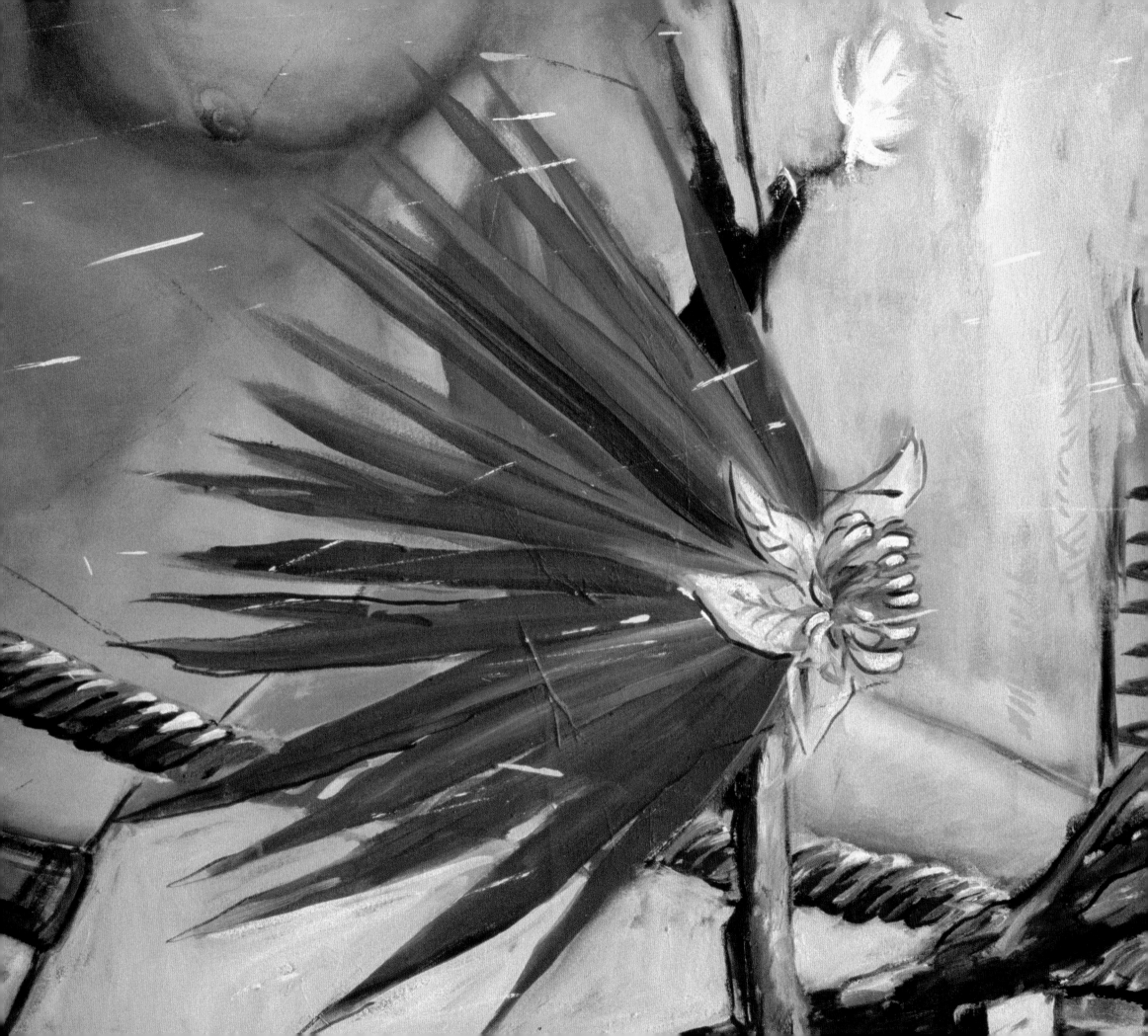

جعفر خالدي *Jeffar Khaldi*

مجمّد Frozen

٢٠٠٧ 2007

زيت على قماش قنب *Oil on canvas*

سم ٢٦٠ × ٢٣٠ *230 × 260 cm*

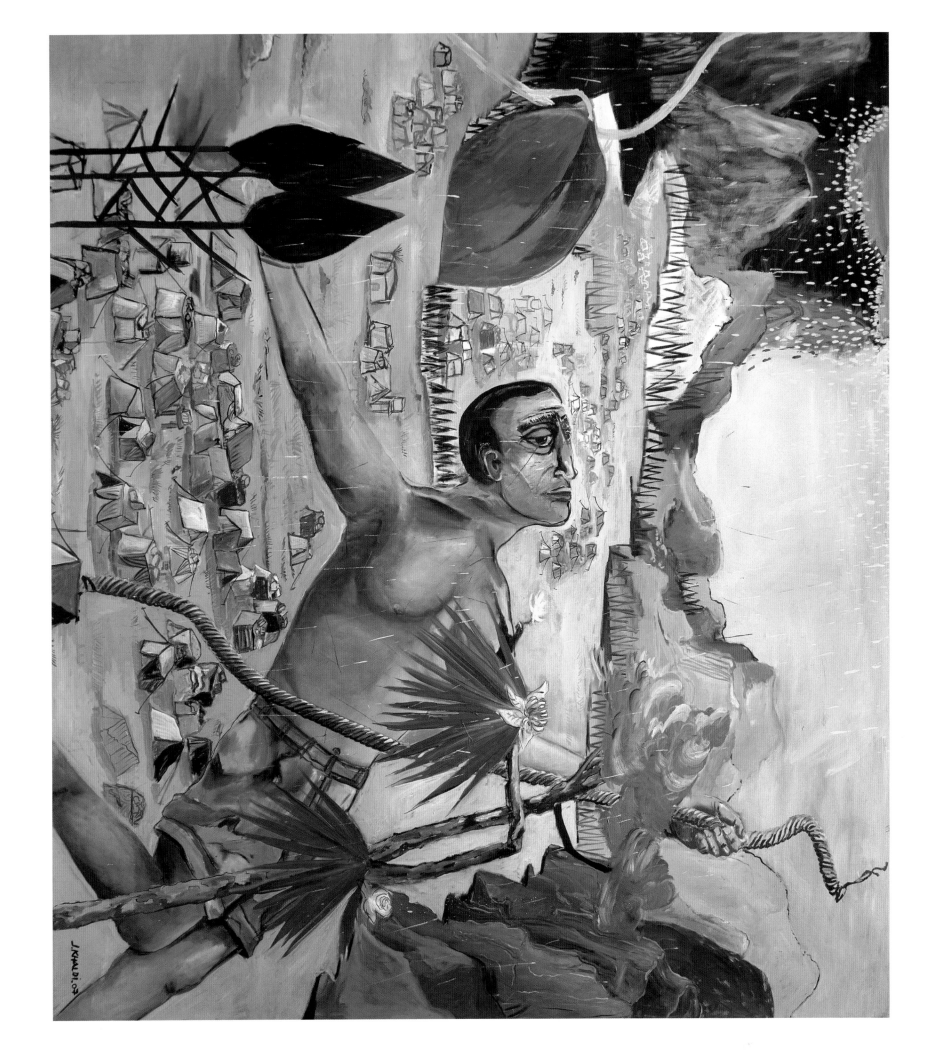

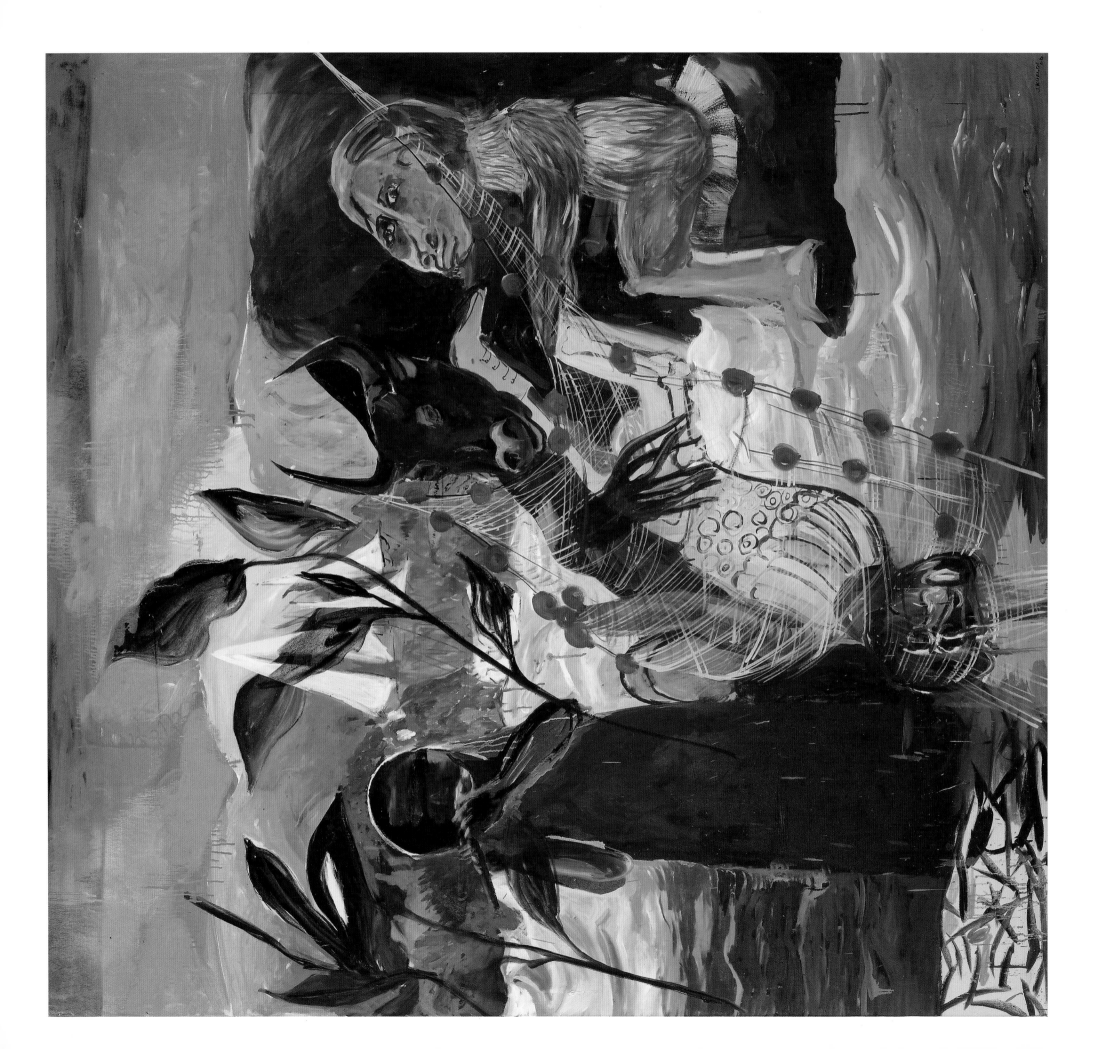

جعفر خالدي Jeffar Khaldi
أحلام سوشي Sushi Dreams
٢٠٠٨ 2008
زيت على قماش Oil on canvas
٢٢٠ × ٢٠٠ سم 220 × 200 cm

٢٤ 75 Laleh Khorramian
لاله خرميان Eden – 1st Generation
الجيل الأول – عدن 2005
٢٠٠٥ Ink and oil on paper
حبر زيت على ورق 223.5 × 355.6 cm
سم ٣٥٥,٦ × ٢٢٣,٥

Laleb Khorramian
Some Comments on Empty and Full
2008
Ink, oil, crayon, and collage on polypropylene
190.5 × 130.7 cm

٢٢
لاله خرميان
تعليق على الفضاء والملا
٢٠٠٥
حبر زيت على ورق
سم ١٢٩٫٧ × ١٩٠٫٥

77 78

Farsad Labbauf
Joseph (Gaze)
2008
Oil on canvas
142.3 × 112 cm

فرساد لباف
جوزف (رمشق)
۲۰۰۸
زیت علی قماش قنی
سم ۱۱۲ × ۱٤۲٫۳

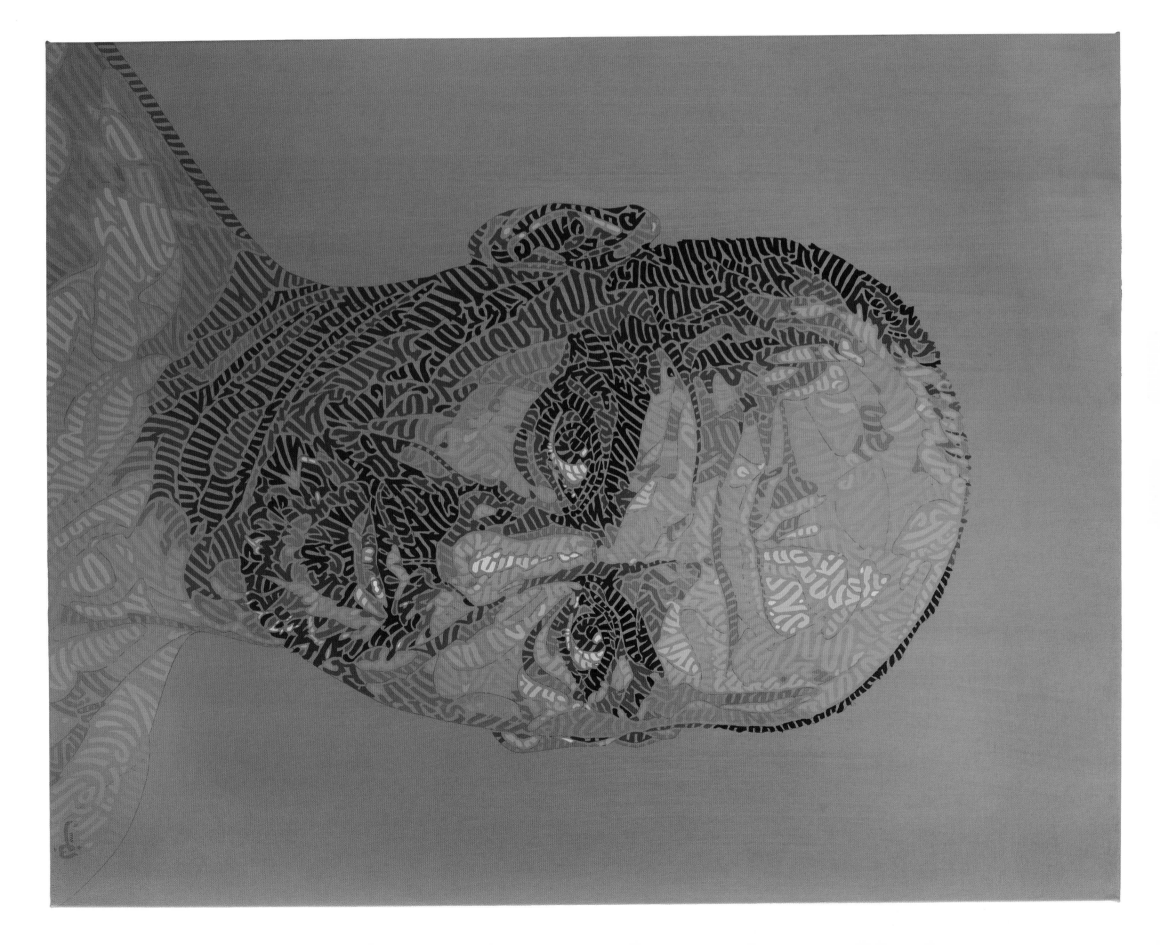

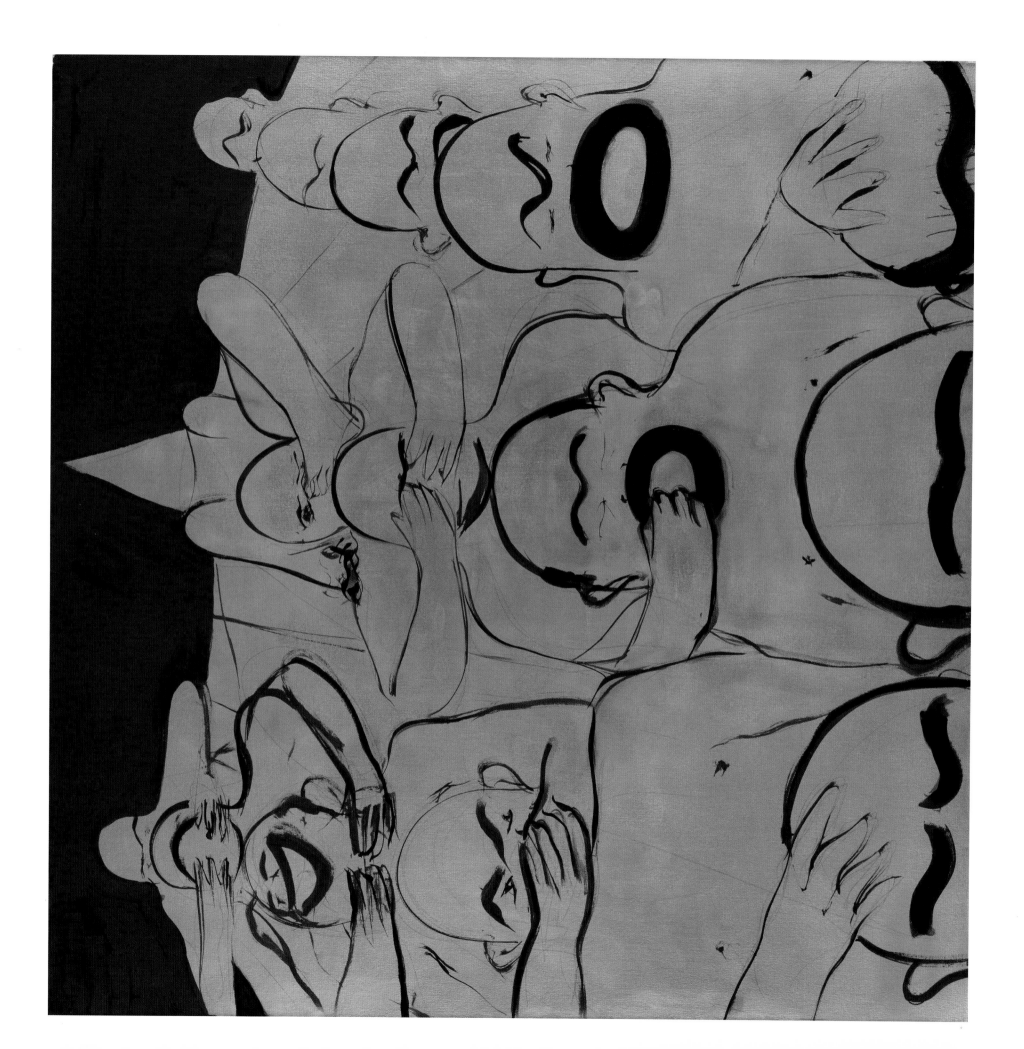

31

٣١ 78

تالا مدني
في الطابور
٢٠٠٦
رش ورنگ روی بوم، رنگ زیتی ...
١٢٢ × ١٢٢ سم

Tala Madani
In Line
2006
Spray paint and oil on canvas
122 × 122 cm

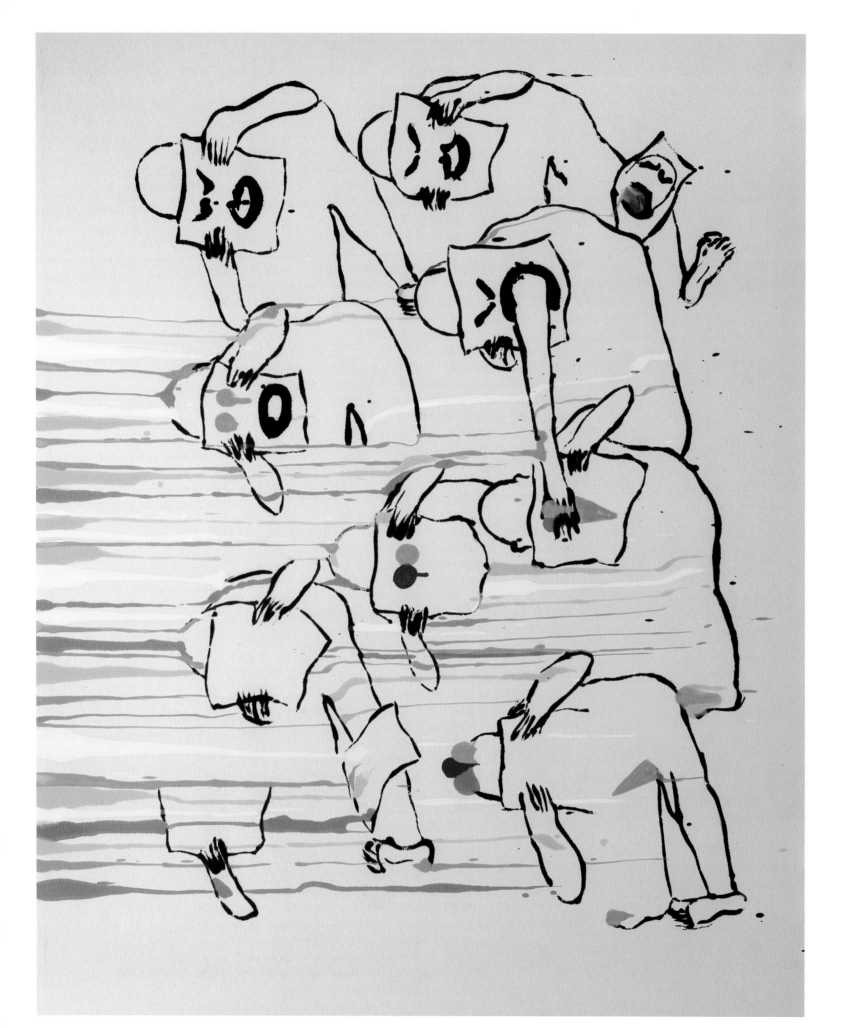

۳۰ 79

طلا مدني
آيس كريم
۲۰۰۸
زيت على قماش
۲٤۰ × ۱۹٥ سم

Tala Madani
Ice Cream
2008
Oil on canvas
195 × 240 cm

طلال مدني
ضوء مقدس
٢٠٠٦
قلم مع زيت على قماش قطن
مسم ١٢٢ × ١٢٢

Tala Madani
Holy Light
2006
Marker and oil on canvas
122 × 122 cm

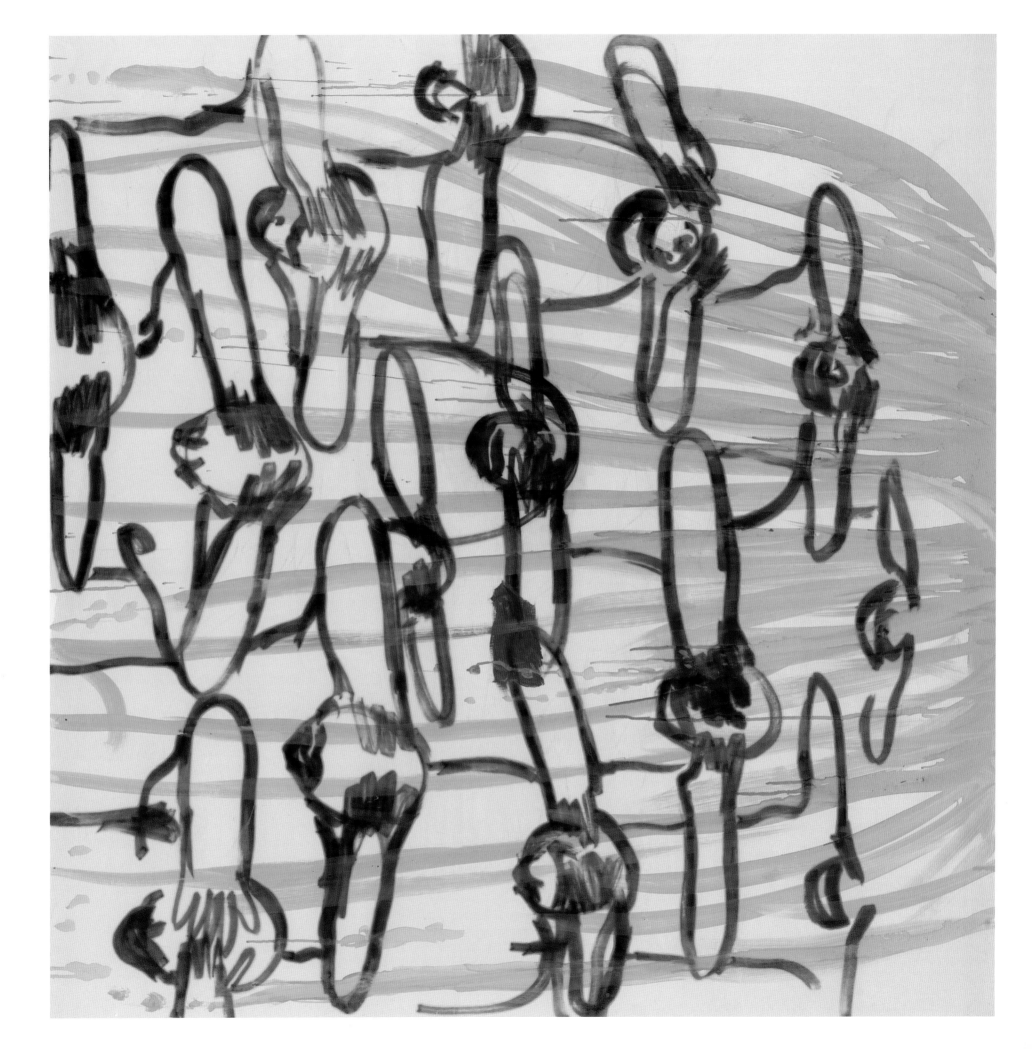

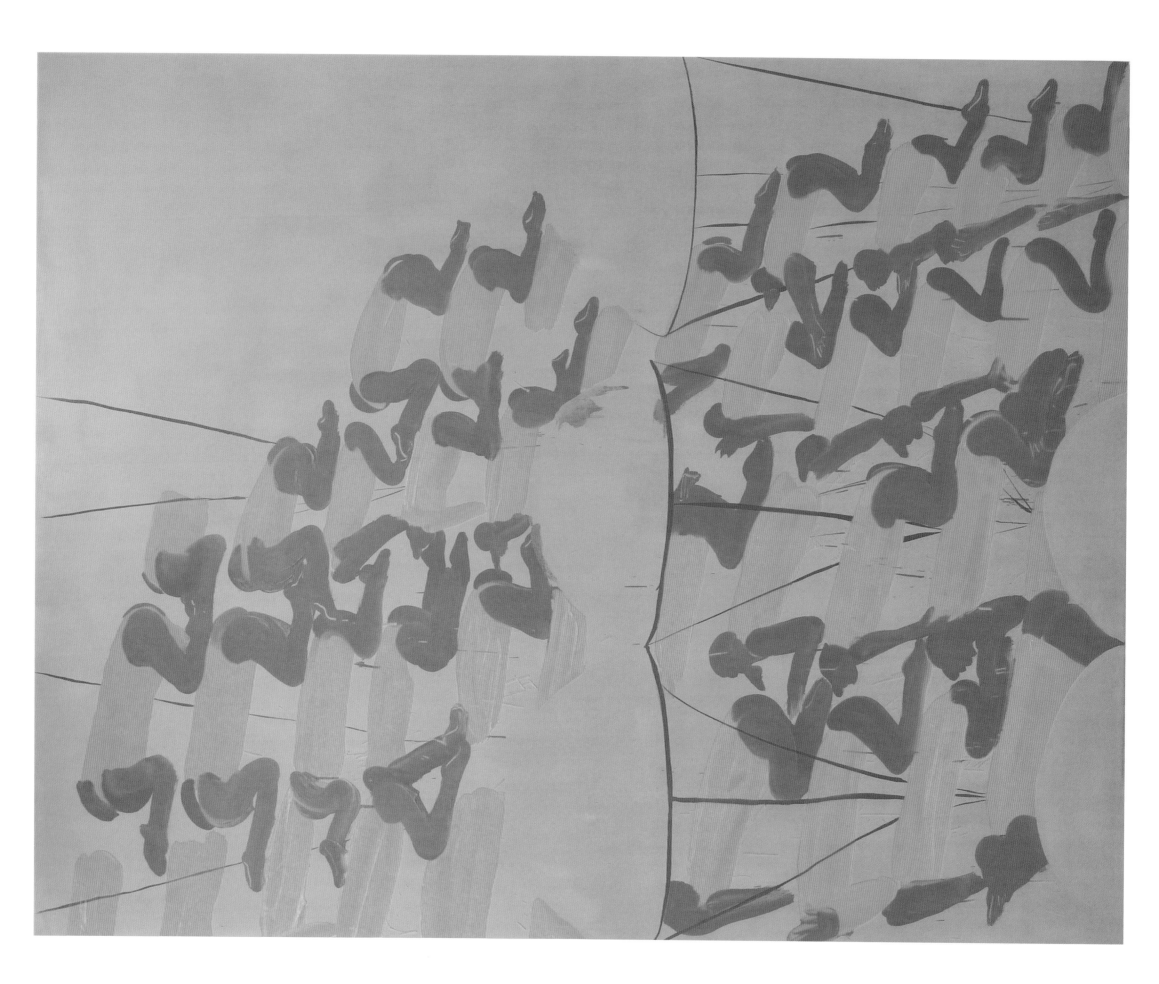

٨١

٨١

طلا مدني
البرصي (مطاط)
٢٠٠٨
زيت على قماش
سم ١٩٥ × ٢٥٠

81
Tala Madani
Elastic Pink
2008
Oil on canvas
250 × 195 cm

٨٢ (السابق)
انعكاس البرج
٢٠٠٦
زيت على قماش
سم ٣٩٦ × ١٨٣

82 (overleaf)
Tower Reflection
2006
Oil on canvas
183 × 396 cm

83 ٣٦

Tala Madani طلا مدني
Nosefall سقوط الأنف
2007 ٢٠٠٧
Oil on linen زيت على قماش كتان:
210 × 190 cm سم ١٩٠ × ٢١٠

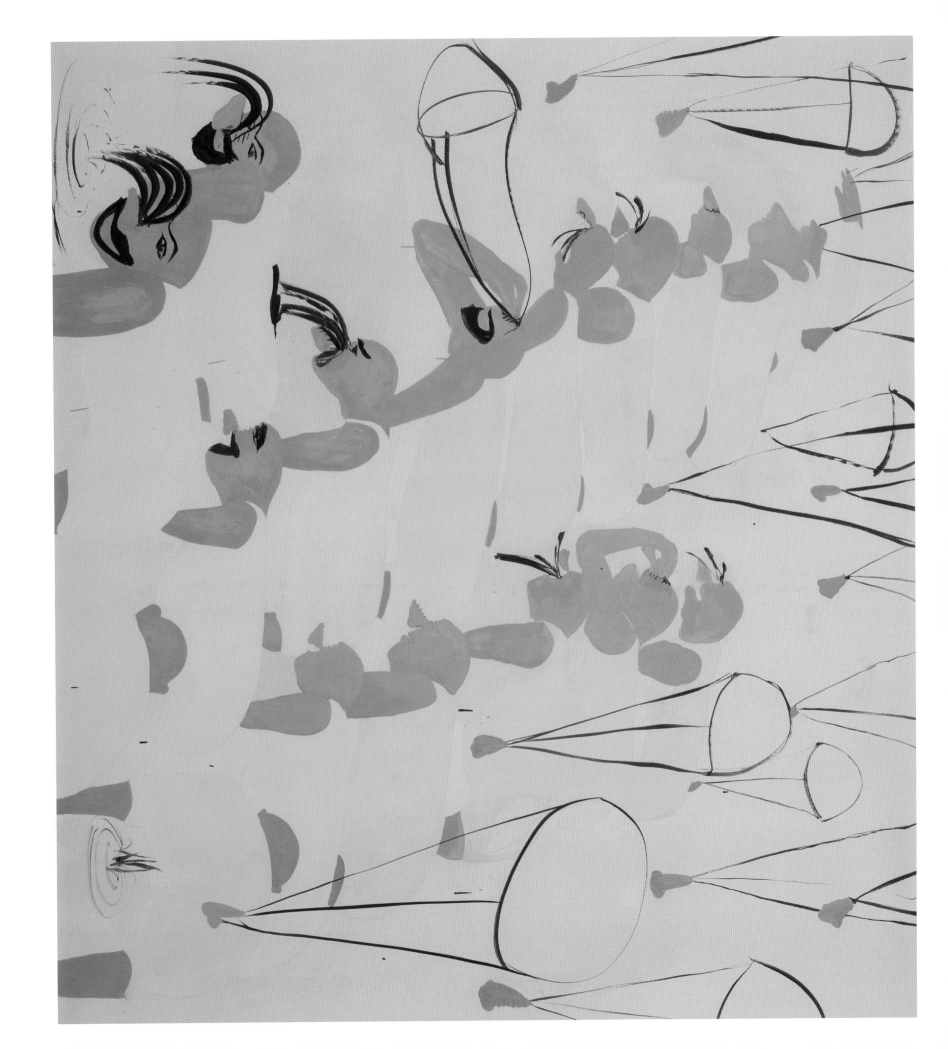

Tala Madani
Seeking Cake Inside
2006
Oil on canvas
24 × 31 cm

طلال مدني
البحث عن التورتة في الداخل
٢٠٠٦
زيت على قماش قنب
٢١ × ٢٤ سم

٢٤ (السابق) 85 (overleaf)
Diving in Cake
2006
Oil on canvas
31 × 24 cm

قيادة في التورتة
٢٠٠٦
زيت على قماش قنب
٢٤ × ٢١ سم

٢٣ (السابق) 86 (overleaf)
Pink Cake
2008
Oil on canvas
40 × 30 cm

التورتة الوردية
٢٠٠٨
زيت على قماش قنب
٣٠ × ٤٠ سم

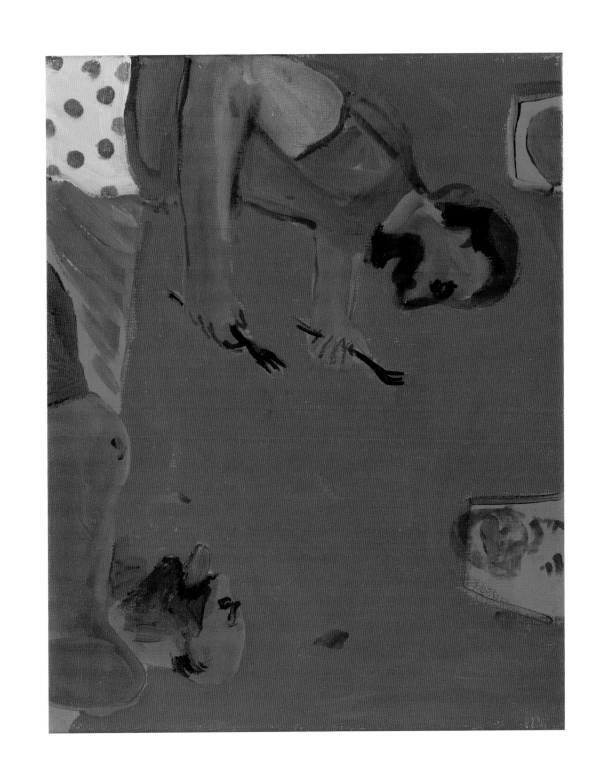

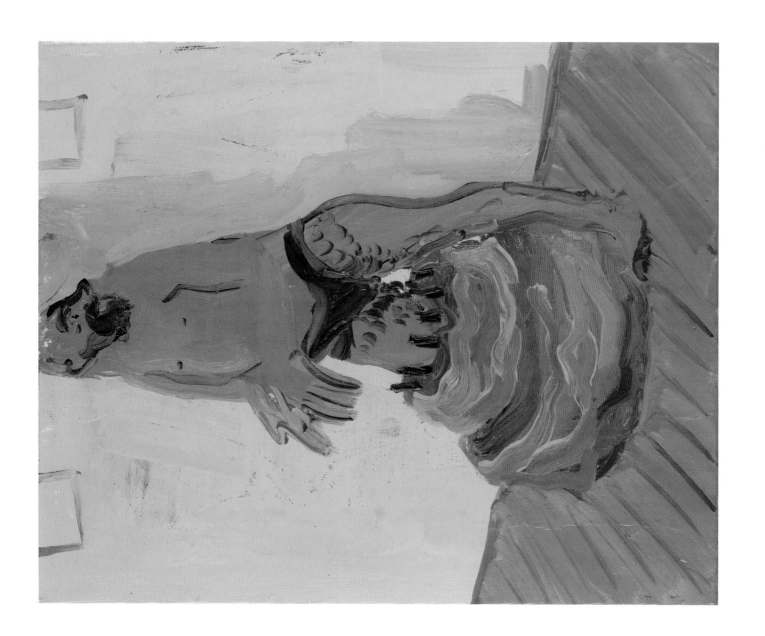

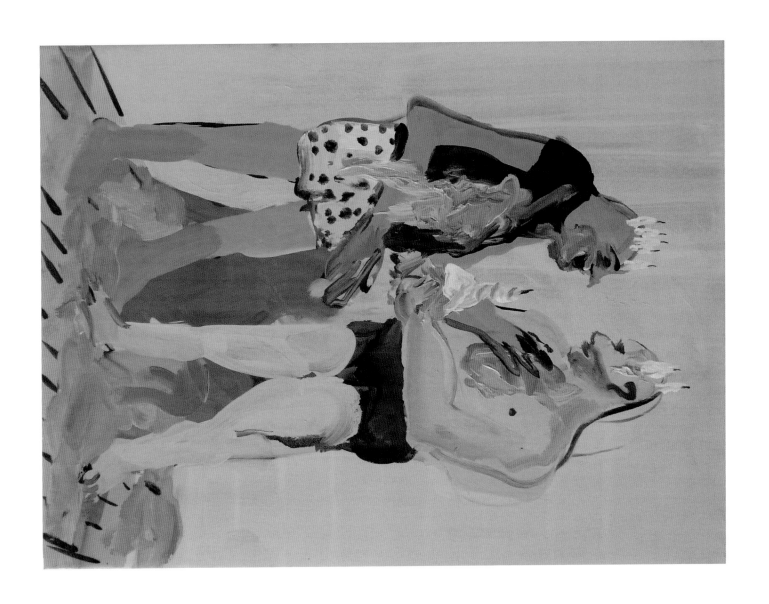

Tala Madani
Fork in Tattoo
2006
Oil on canvas
31 × 23 cm

٣٢

طلال مدني
شوكة في الوشم
٢٠٠٦
زيت على قماش قنب
سم ٢٣ × ٣١

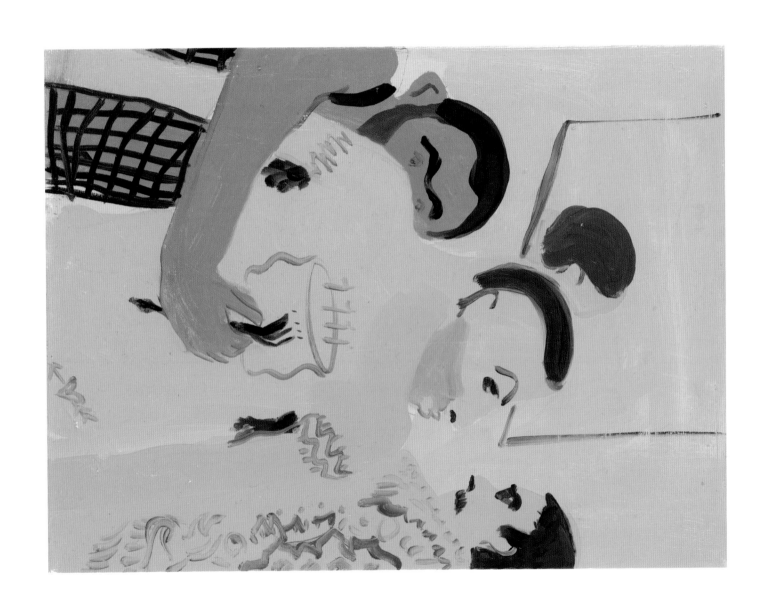

88 *Tala Madani*
Braided Beard
2007
Oil on canvas
36 × 28 cm

89 (overleaf)
Withered
2006
Oil on canvas
26 × 20 cm

90 (overleaf)
Two Pillows and a Bolster
2007
Oil on linen
30 × 40 cm

٨٨ طالا مدني
اللحية المجدولة
٢٠٠٧
زيت على قماش قنب
٣٦ × ٢٨ سم

٨٩ (السابق)
الذبول
٢٠٠٦
زيت على قماش قنب
٢٦ × ٢٠ سم

٩٠ (السابق)
الوسادة والمسند
٢٠٠٧
زيت على قماش كتان
٣٠ × ٤٠ سم

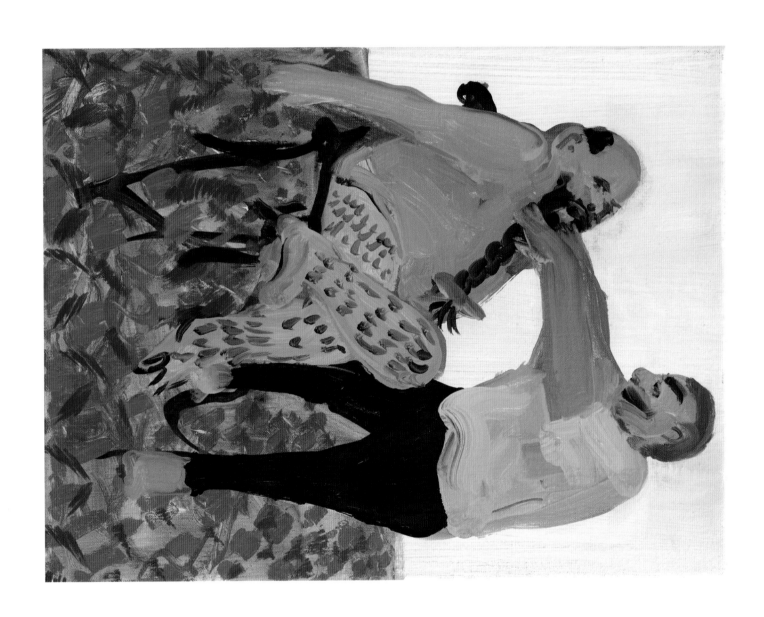

91 ۱۸

Tala Madani
Pose
2006
Oil on canvas
31 × 31 cm

طلال مدني
الوضع
۲۰۰٦
زيت على قماش قنب
سم ۳۱ × ۳۱

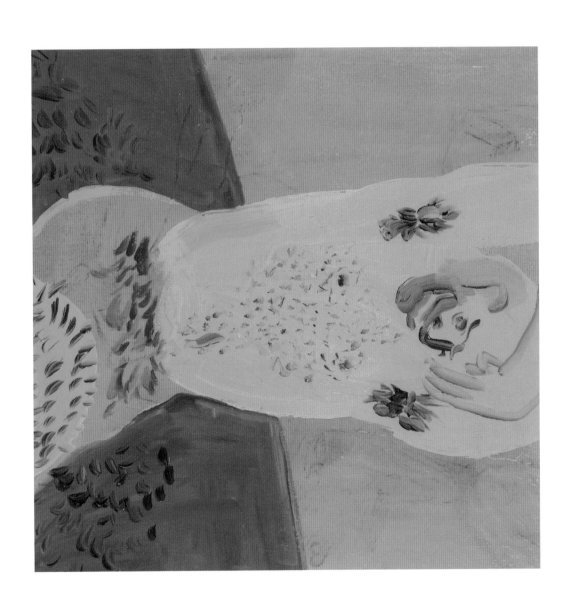

17–13 92–96

شیرین فخیم Shirin Fakhim
عاهرات طهران Tehran Prostitutes
۲۰۰۸ 2008
اعلام مختلط Mixed media
حجم طبیعی Life size

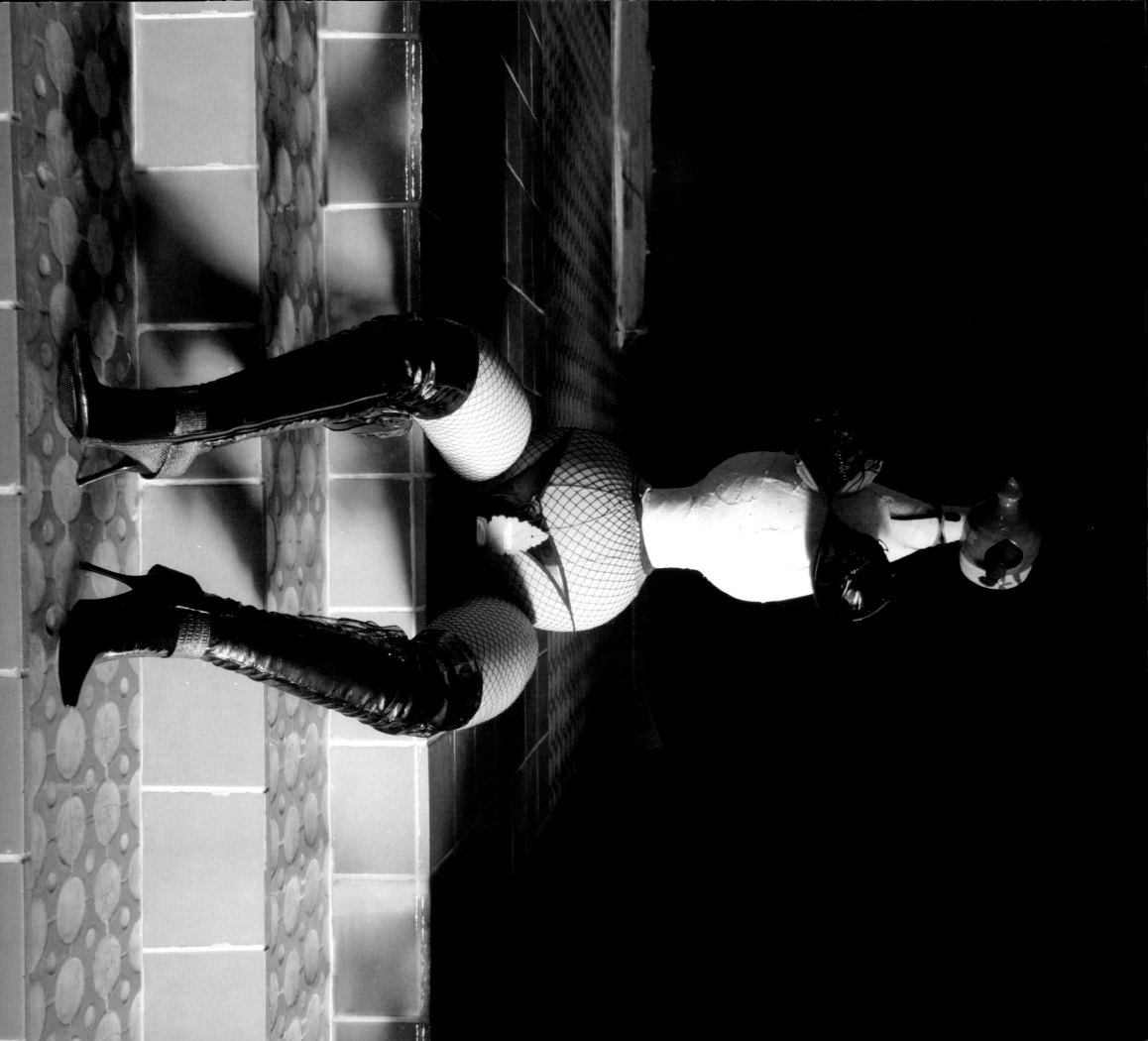

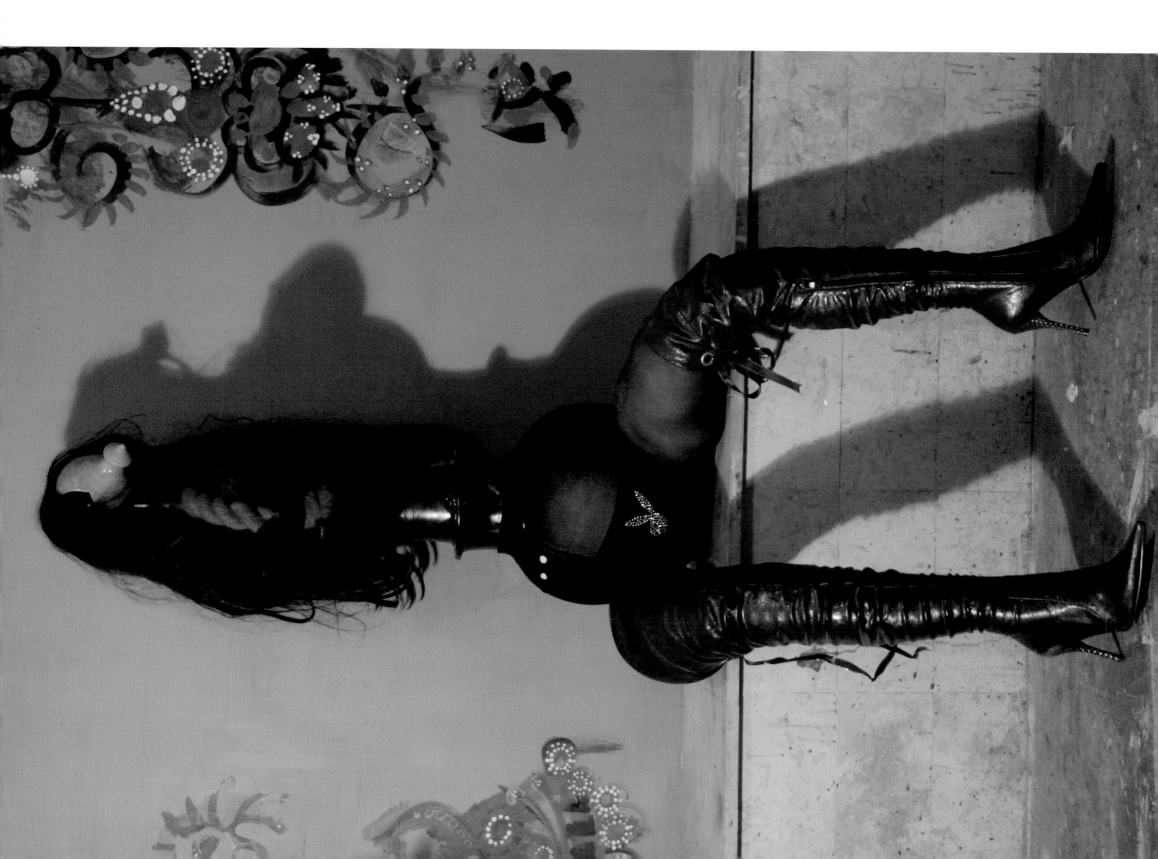

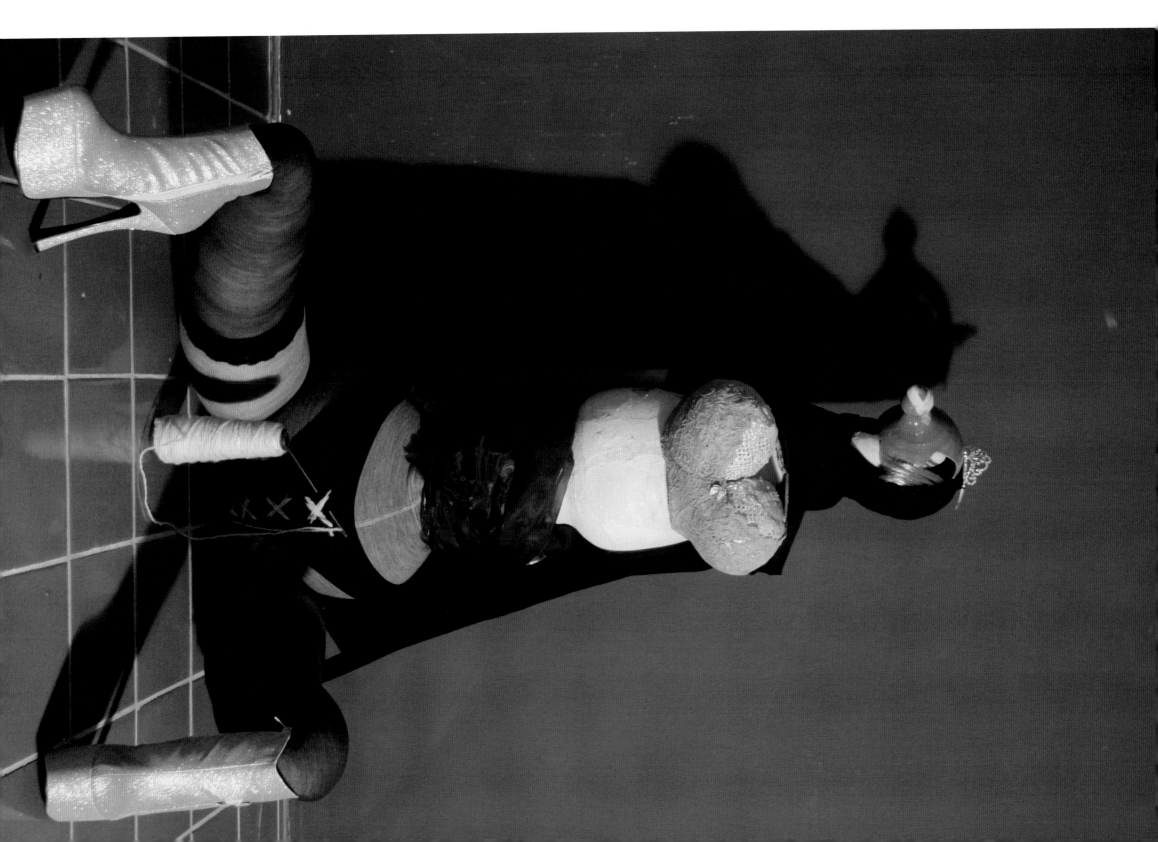

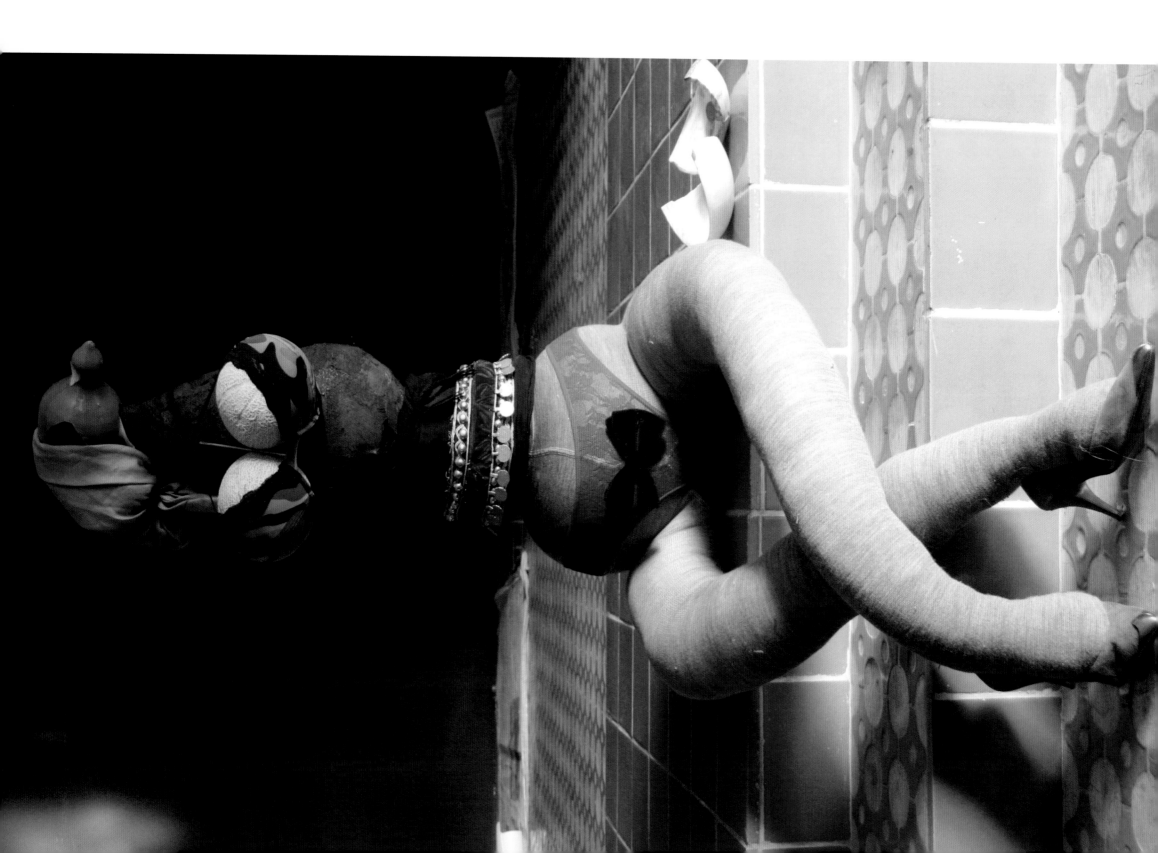

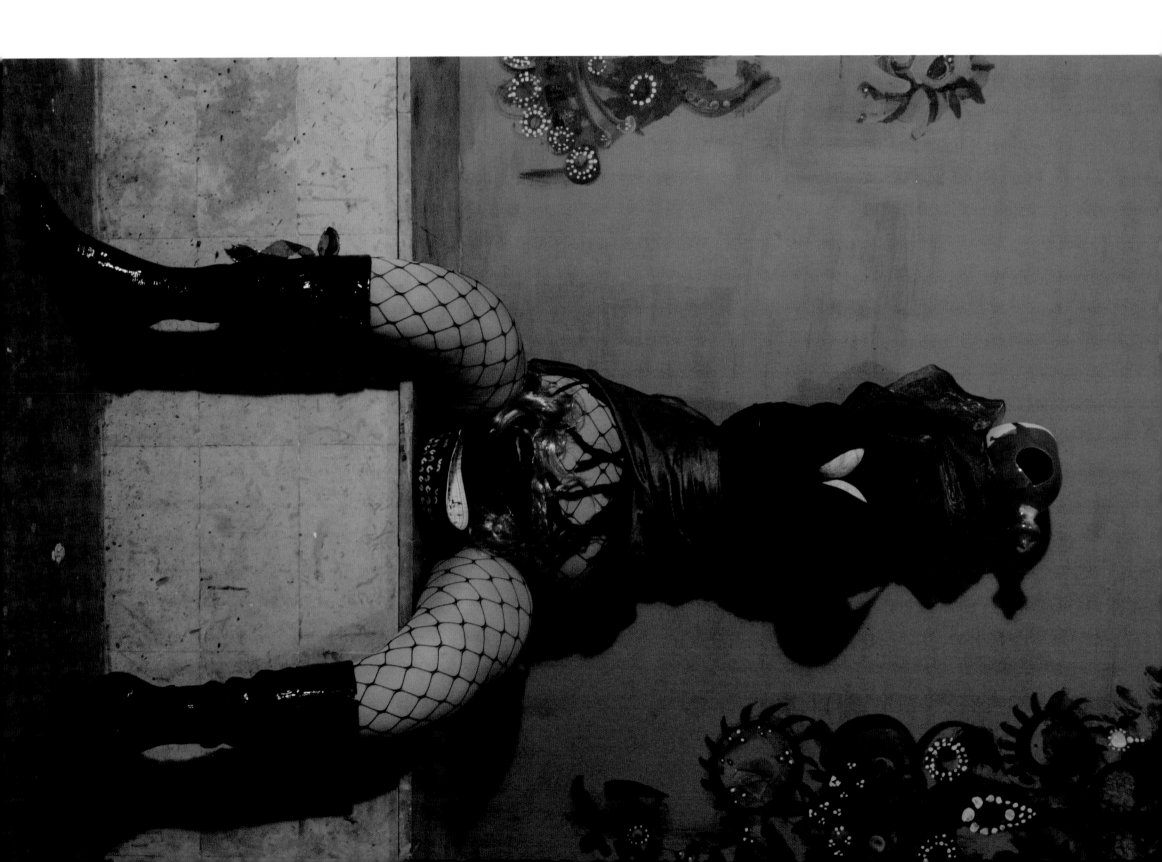

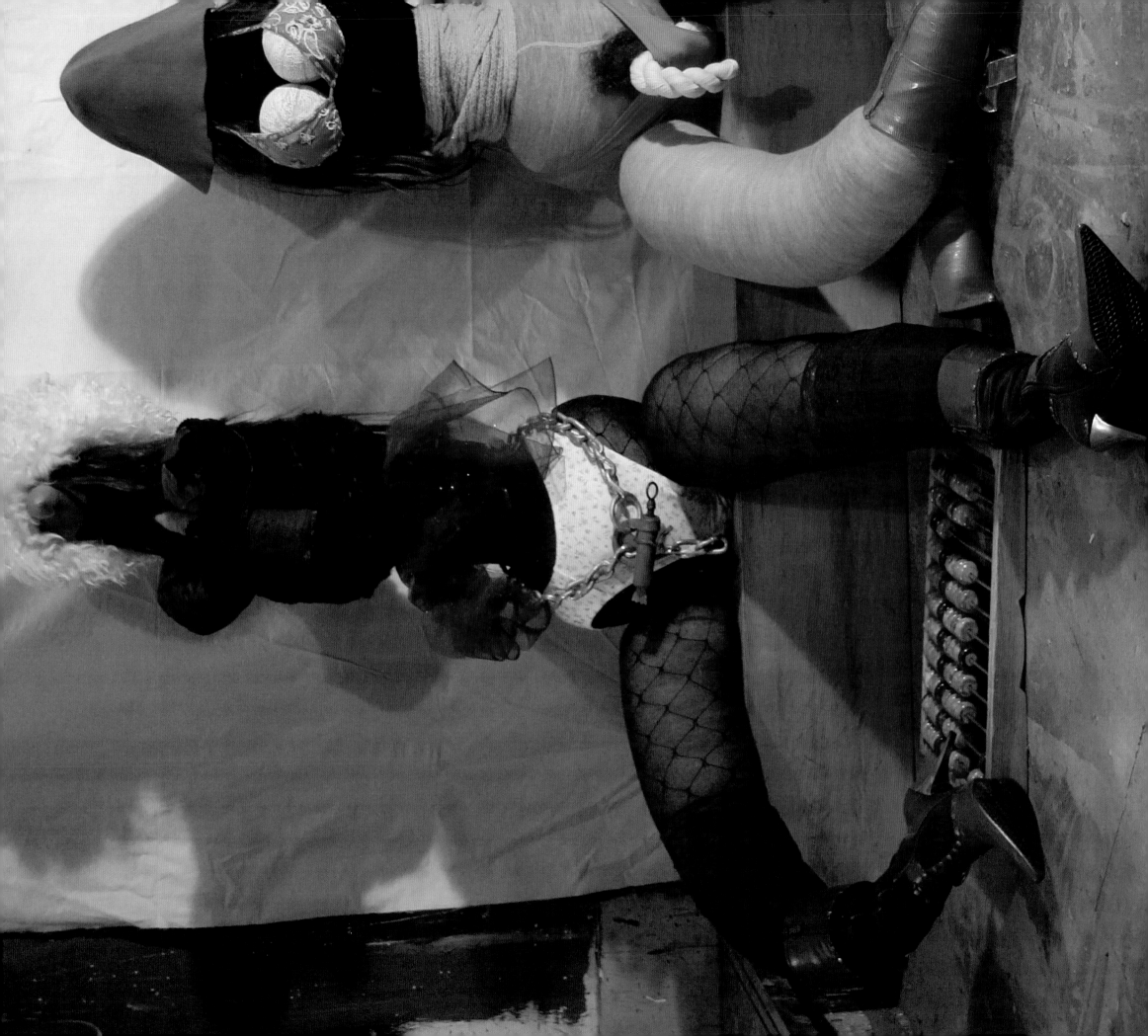

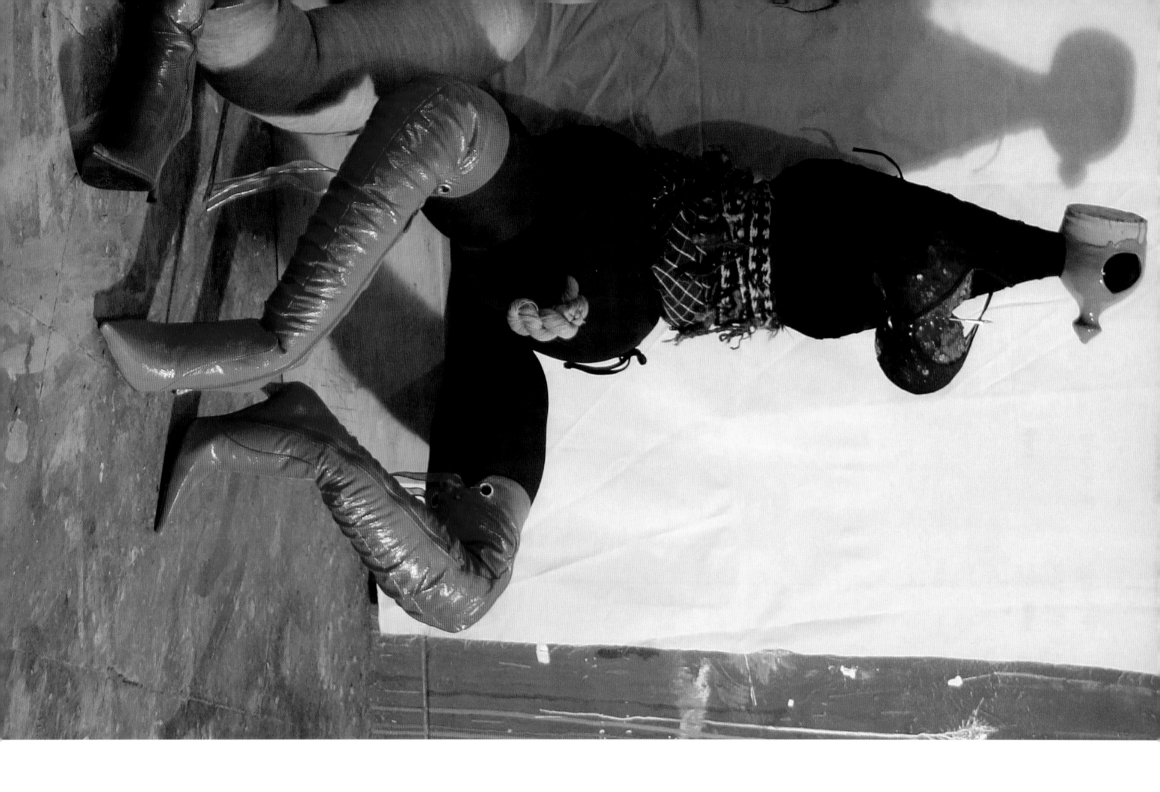

۱۷ 97

قطعه ترکیبی Shirin Fakhim
عابره‌های طهران Tehran Prostitutes
۲۰۰۸ 2008
تکنیک مخلوط Mixed media
اندازه طبیعی Life size

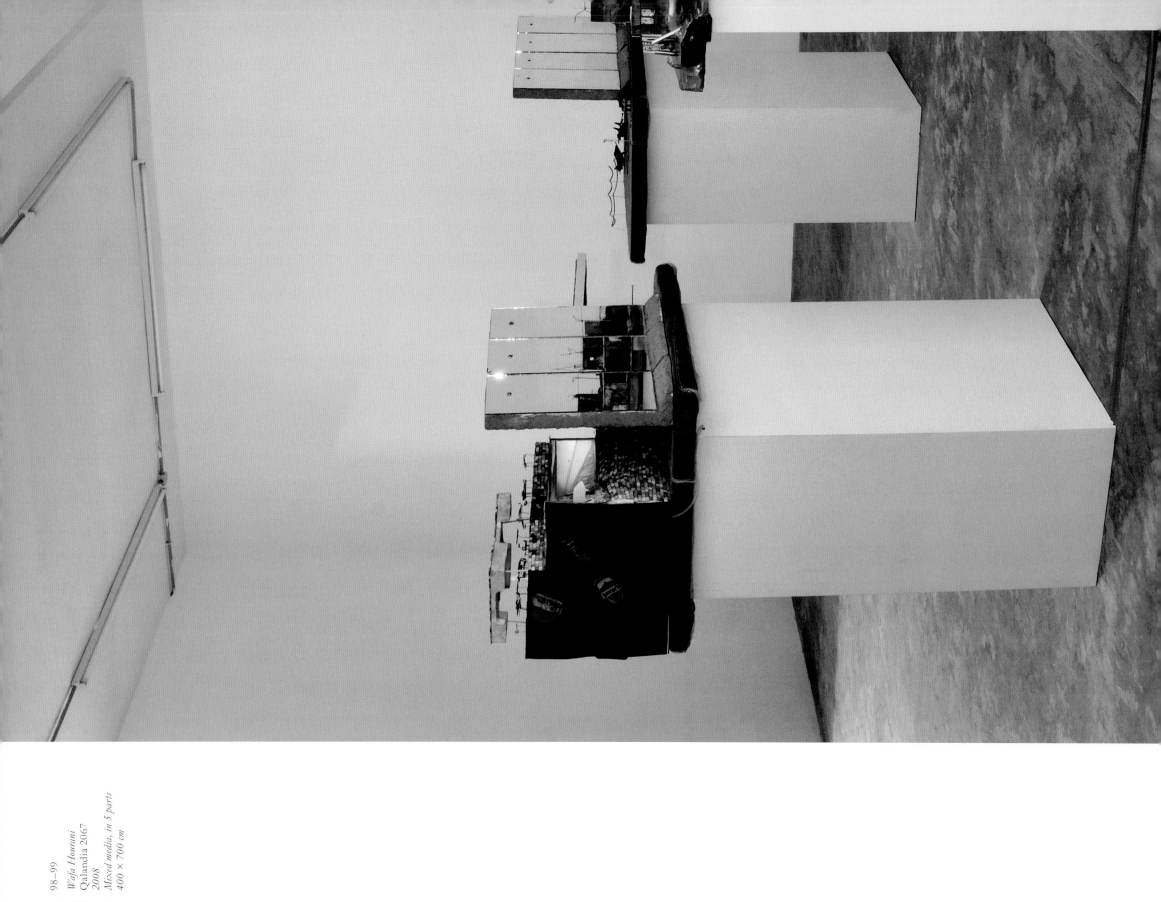

٩–٨ 98–99

وفا حوراني Wafa Hourani
٢٠٦٧ قلنديا Qalandia 2067
٢٠٠٨ 2008
مواد مختلطة، بخمسة أجزاء Mixed media, in 5 parts
سم ٧٠٠ × ٤٠٠ 400 × 700 cm

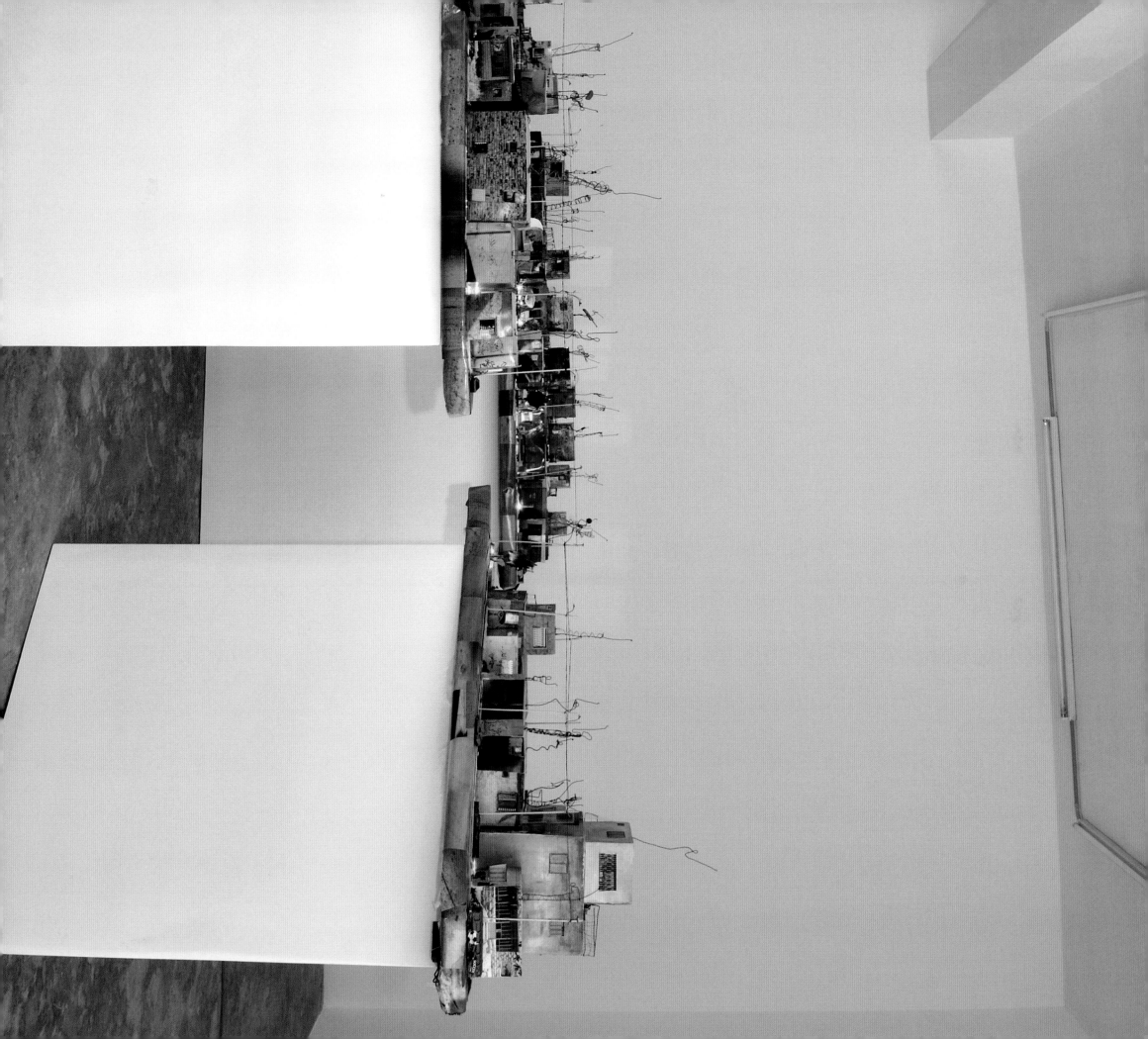

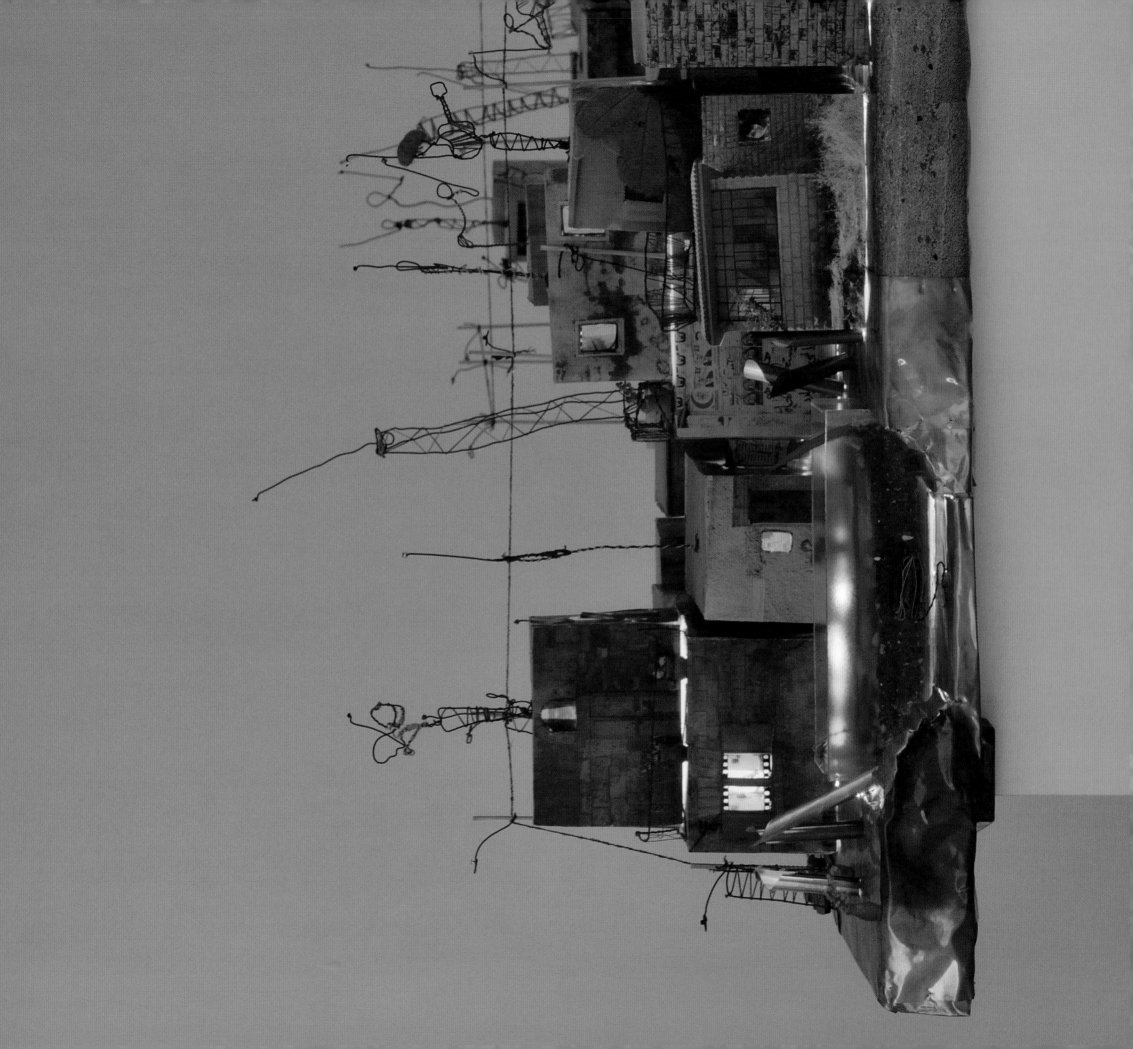

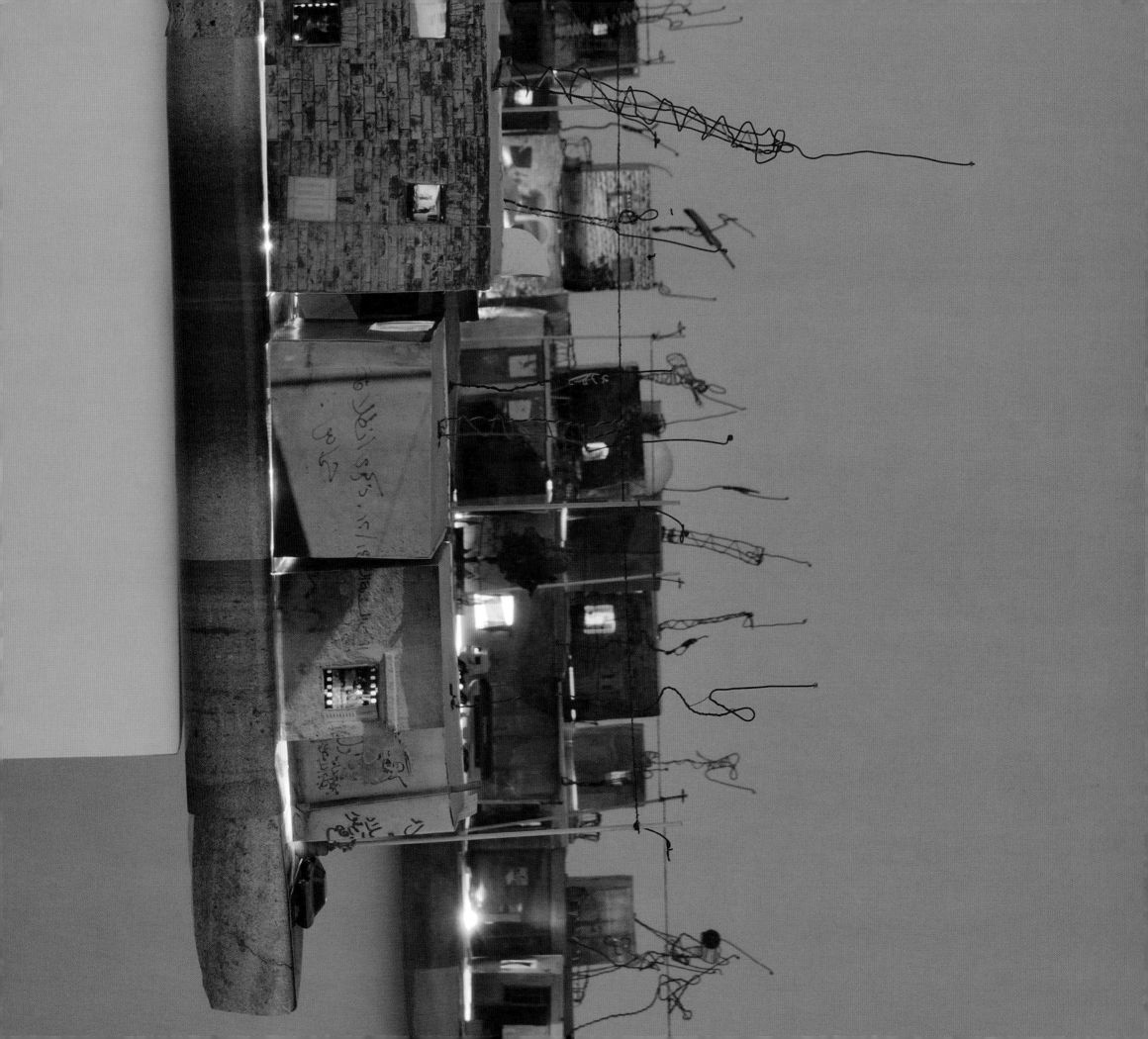

100 ∨

Ahmad Morshedloo
Untitled
2008
Acrylic and pen on board
90 × 120 cm

أحمد مورشيدلو
بدون عنوان
٢٠٠٨
اكريليك وقلم على لوح
سم ١٢٠ × ٩٠

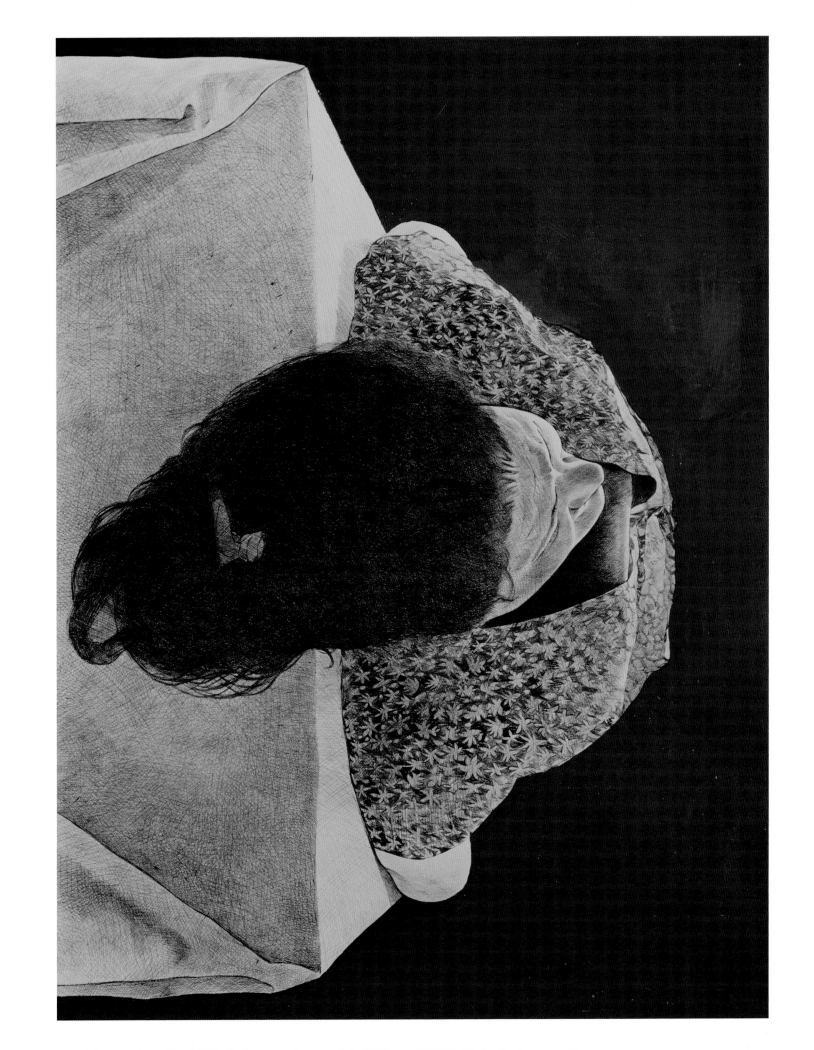

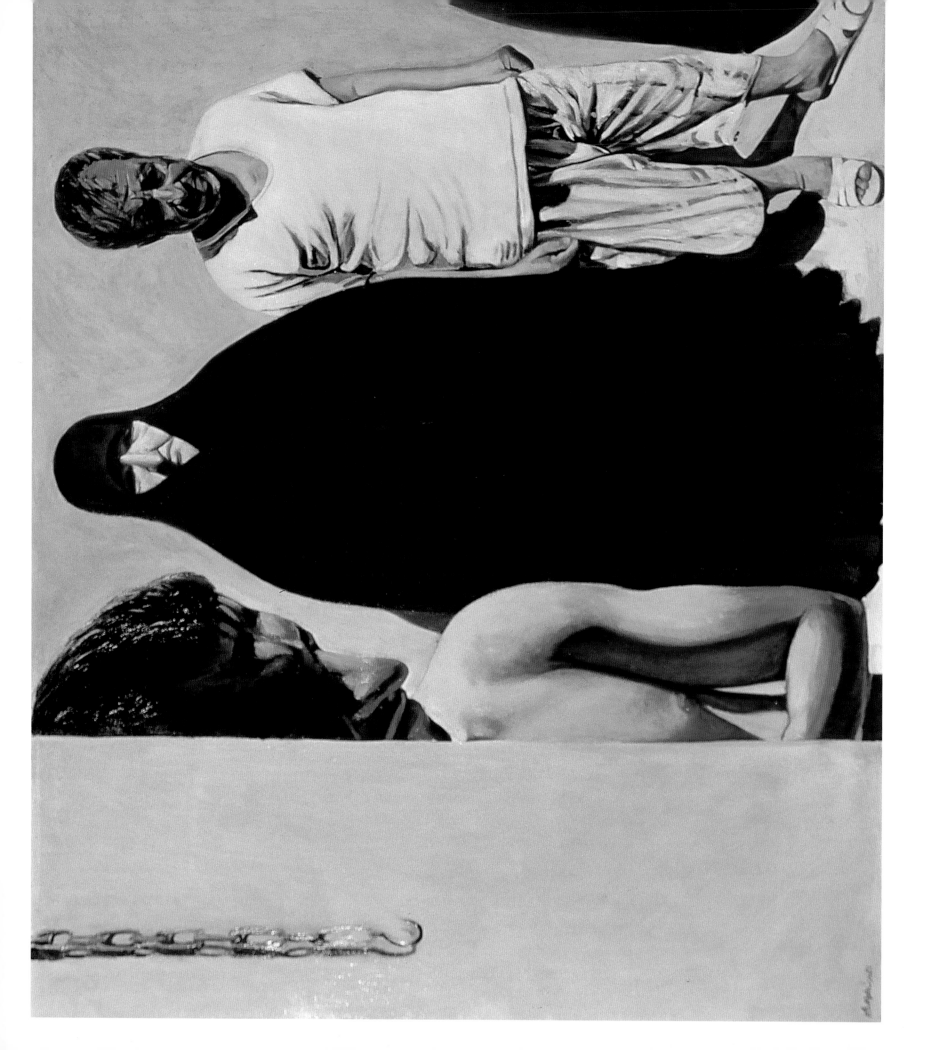

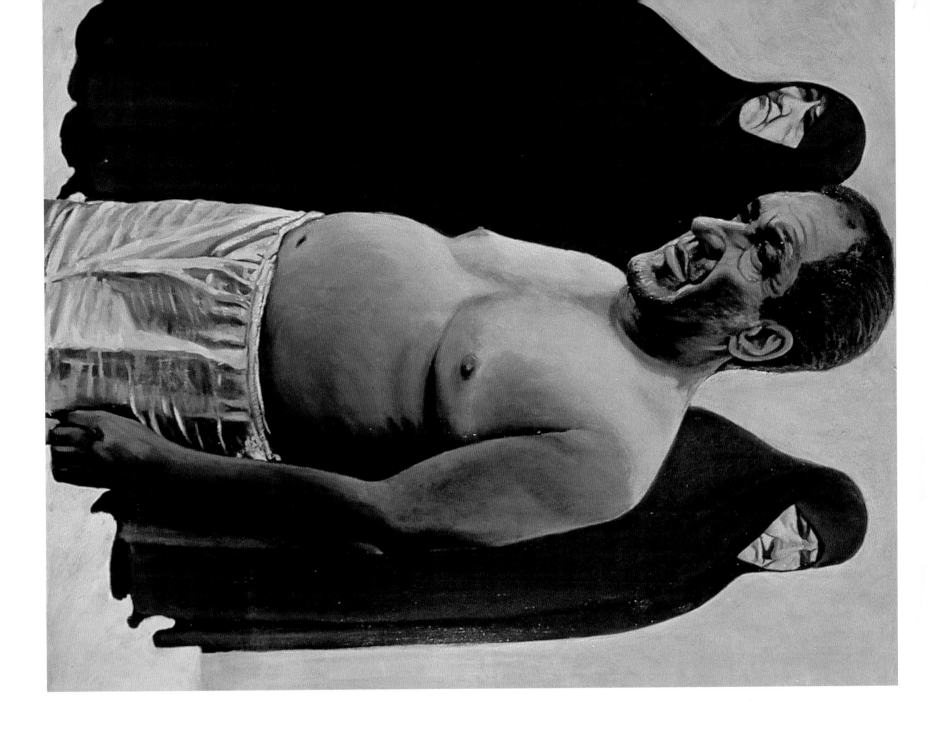

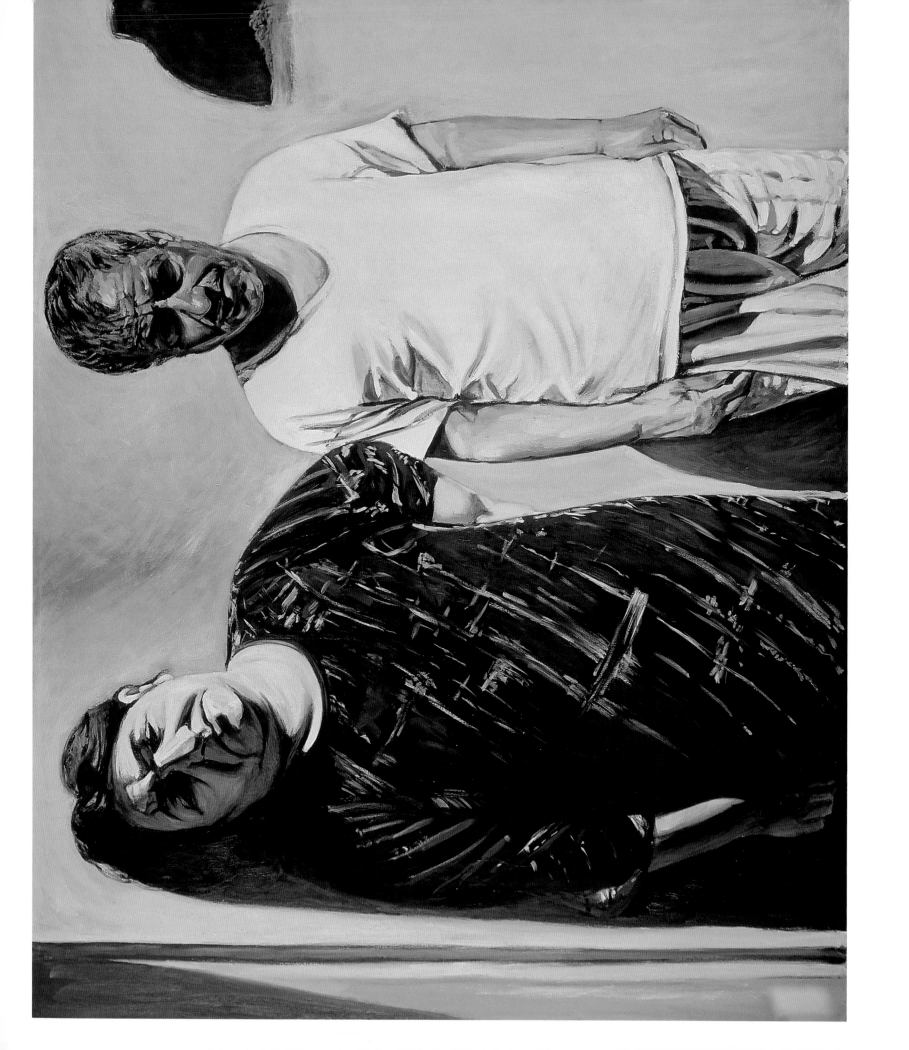

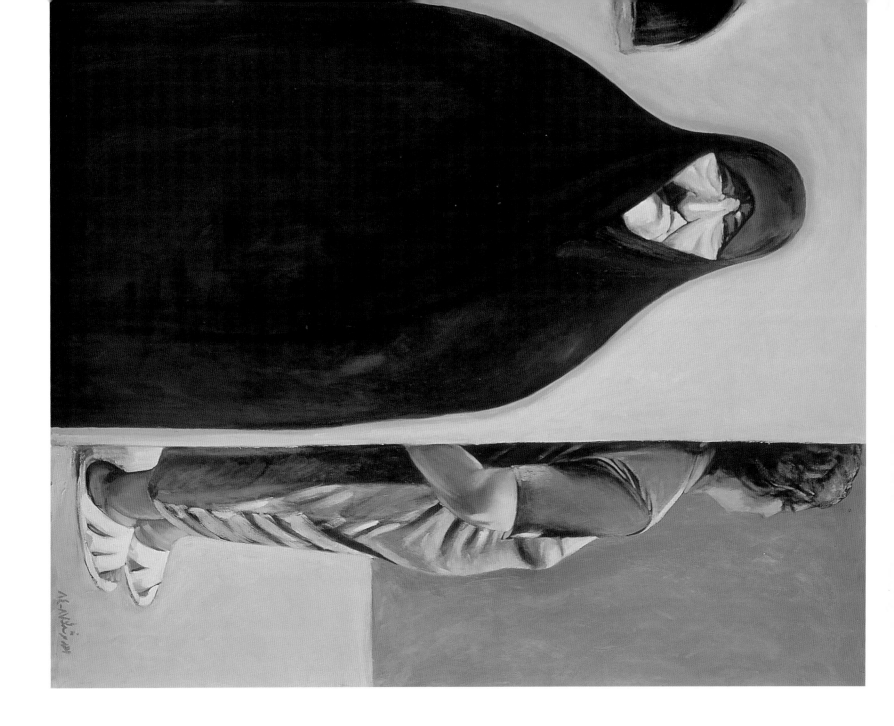

٥ 102

أحمد مرشدلو Ahmad Morshedloo
بدون عنوان Untitled
٢٠٠٨ 2008
تكنيك رنگ روغن روى بوم Oil on canvas
١٨٠ × ٣٨٠ سم 180 × 380 cm

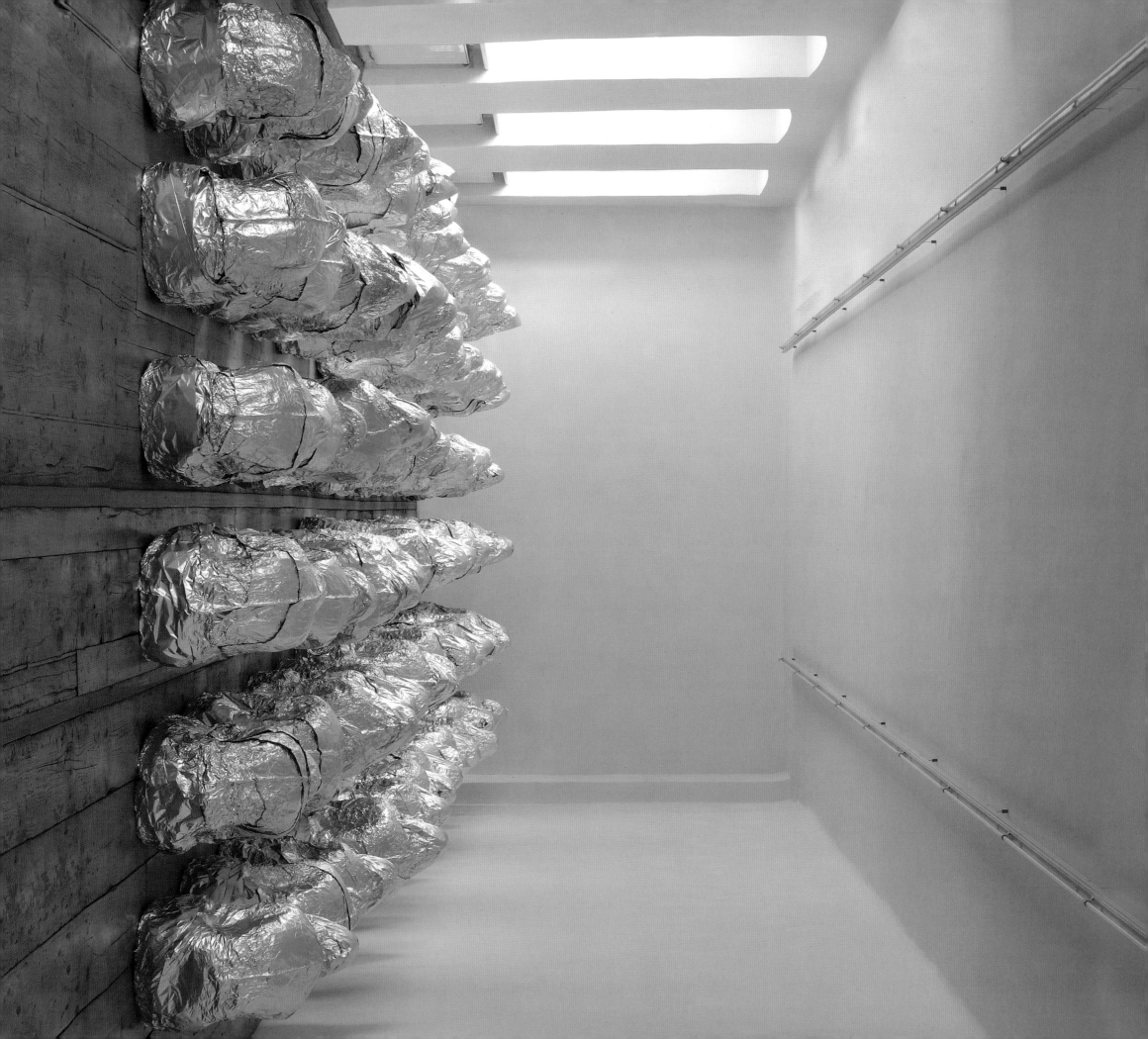

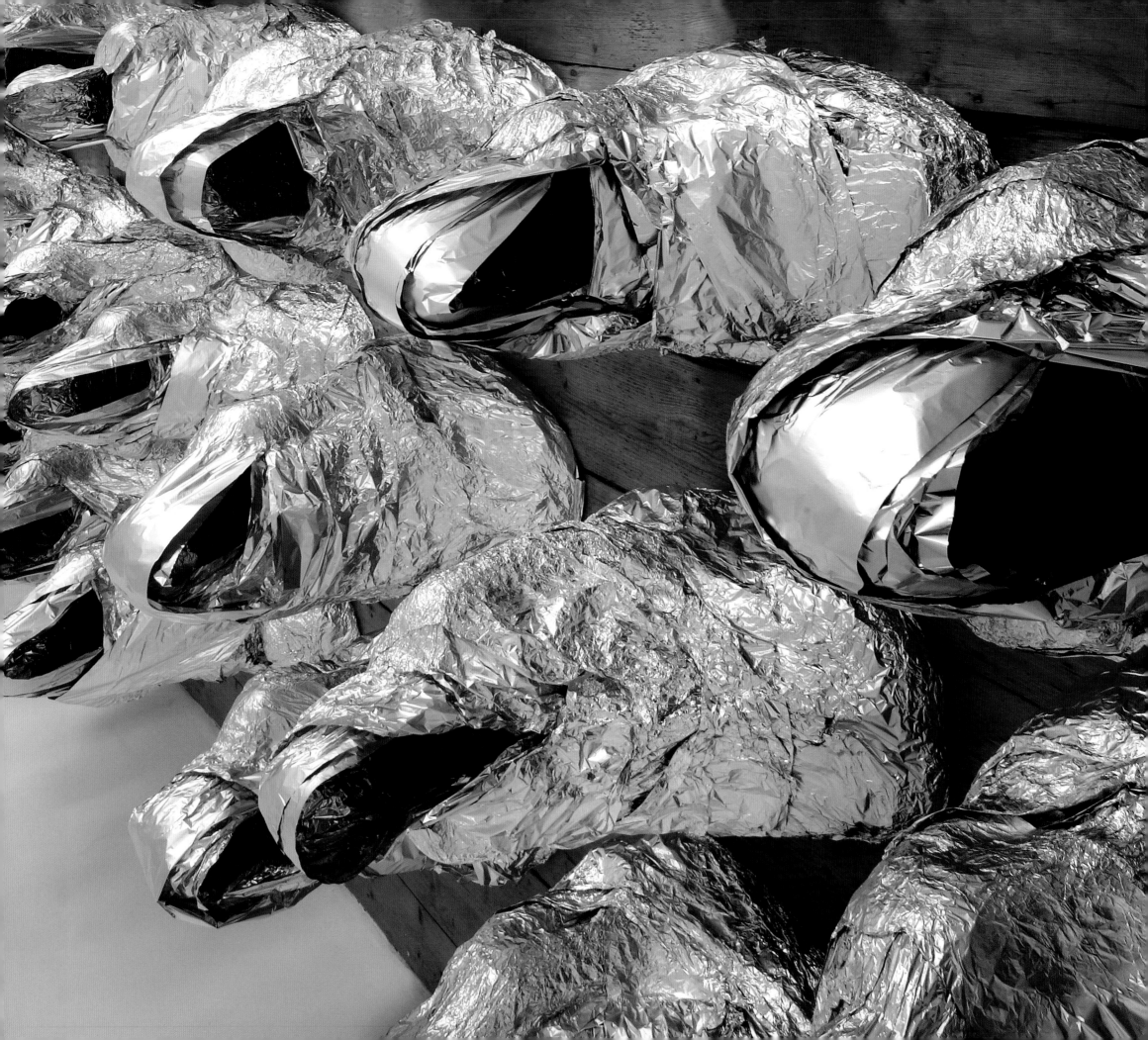

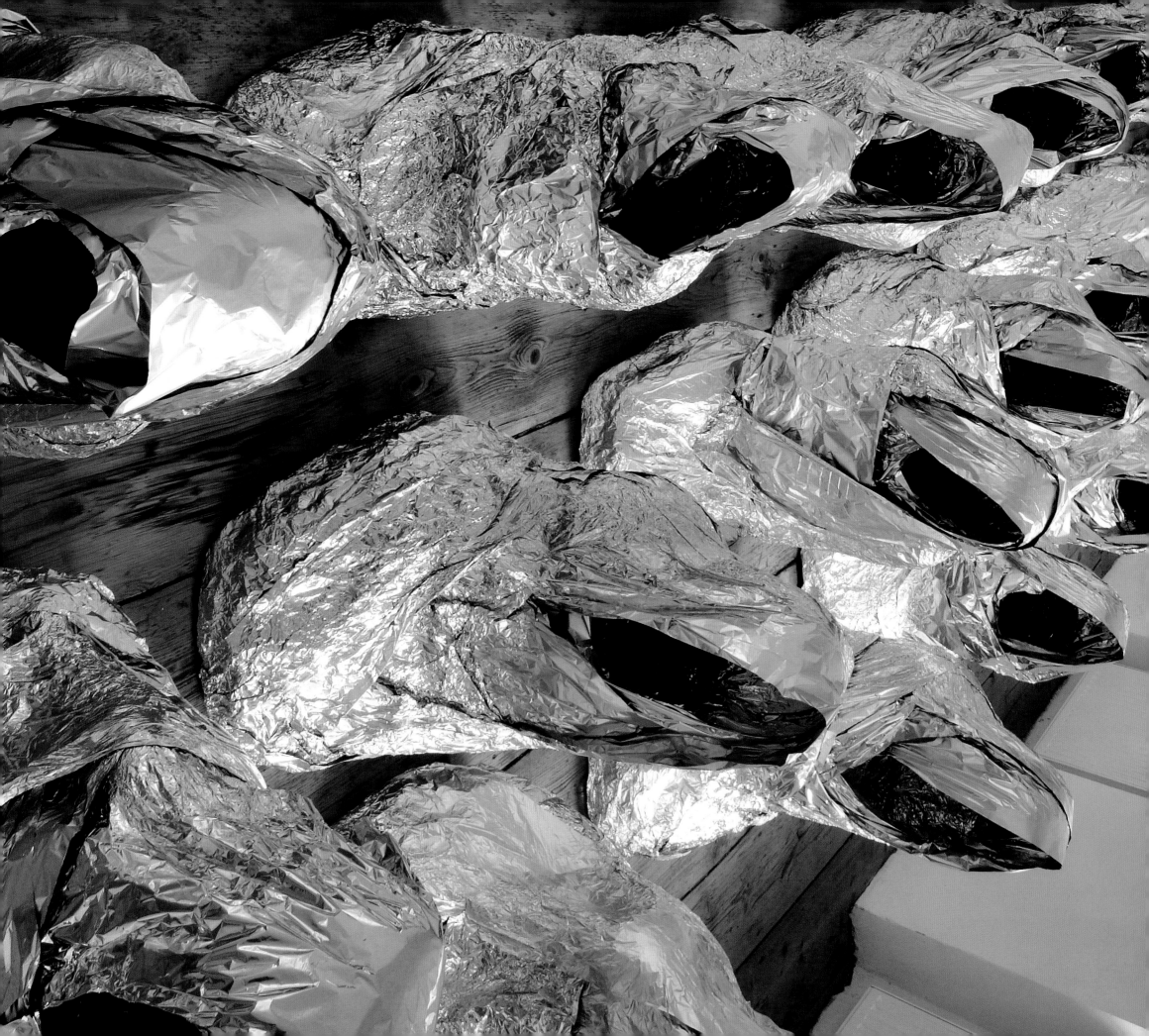

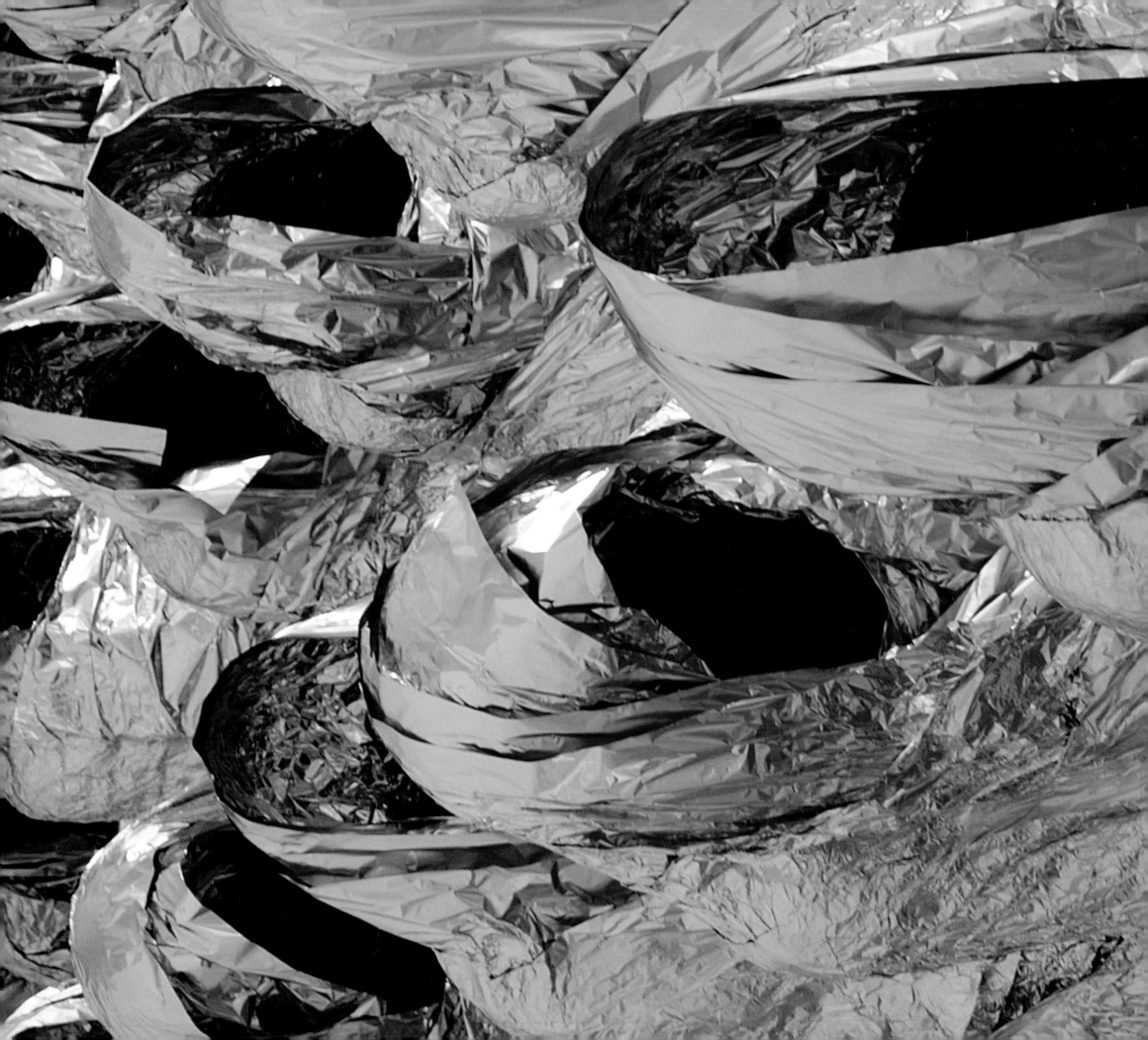

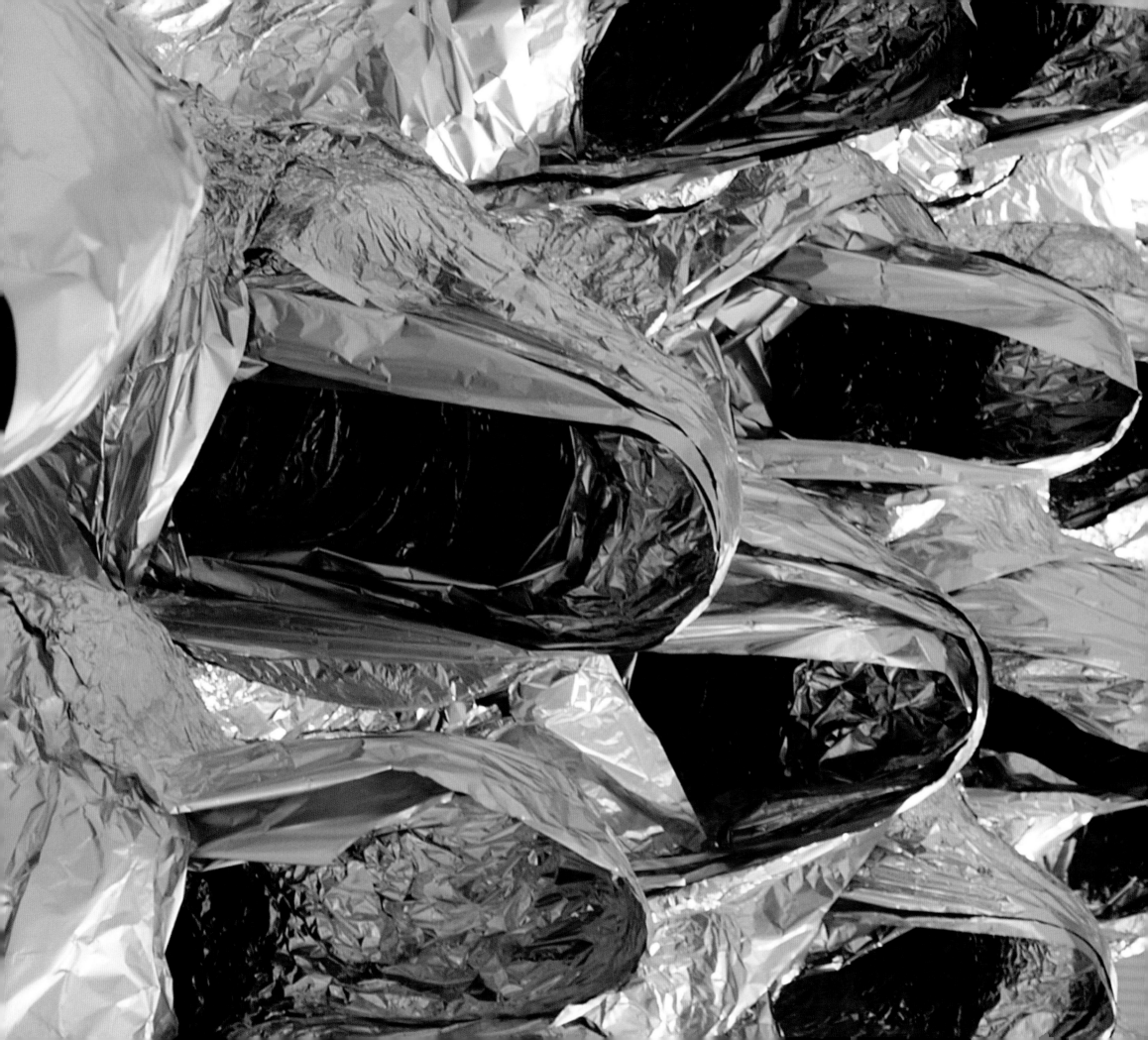

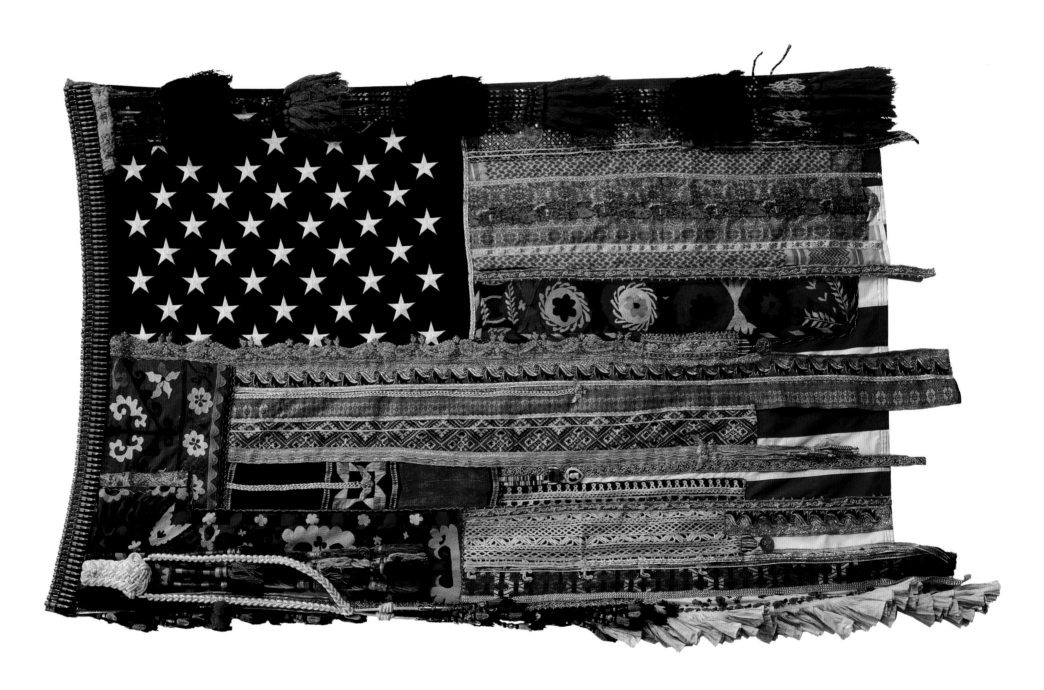

106 \

Sara Rahbar
Flag #19 "Memories Without Recollection"
2008
Mixed media textile
203.2 × 116.8 cm

سارا رهبر
علم رقم ۱۹ "ذكريات من دون تذكّر"
۲۰۰۸
منسوجة من الوسائط المختلطة
۲۰۳٫۲ × ۱۱٦٫۸ سم

ولد في عام ١٨٧٩ في طهران، ايران
يعيش ويعمل في ايران
روكني حاززاده ٥-٦-٧

ولد في عام ١٩٧٥ في طهران، ايران
يعيش ويعمل في طهران، ايران
رامن حازراده ٧-٨

ولد في عام ٢٨٩١ في طهران، ايران
يعيش ويعمل في طهران، ايران
برباد كولشيري ٧٧-٧٨

ولدت في عام ١٩٧٤ في طهران، ايران
تعيش وتعمل في طهران، ايران
شادي غديريان ٣٩-٩-٥٥

ولدت في عام ١٩٧٤ في طهران، ايران
تعيش وتعمل في طهران، ايران
شيرين نجم ١٨-١٨

ولد في عام ١٩٧٦ في طهران، ايران
يعيش ويعمل في نيويورك، الولايات المتحدة
علي بني صدر ٧٧-٧٧

ولد عام ١٩٧٠ في دوغني (ساين-سانت-دينيس) باريس، فرنسا
يعيش ويعمل في باريس، فرنسا
قادر عطية ٢-٣

ولدت في عام ١٨٩١ في تونس، تونس
تعيش وتعمل في نيويورك، الولايات المتحدة
نادية عداي ٧٩-٨٨

ولد في عام ١٩٧٥ في بغداد، العراق
يعيش ويعمل في برلين، ألمانيا
أحمد السوداني ٩-٩٨-٩-٩٠

ولد في عام ١٩٦٣ في النجف، العراق
يعيش ويعمل في دنفر، الولايات المتحدة
حليم الكريم ١٠-١٠

ولدت في عام ١٨٩١ في مدينة حلب، سوريا
تعيش وتعمل في بروكلين، نيويورك، الولايات المتحدة
ديانا الحديد ١٠٤-١٠

ولد في عام ١٩٦٣ في لبنان
يعيش ويعمل في بيروت، لبنان
مروان رشماوي ٤٣-٤

ولدت في عام ١٩٧٩ في طهران، ايران
تعيش وتعمل في نيويورك، الولايات المتحدة
سارة رحبر ٤

ولد في عام ١٩٧٤ في مشهد، ايران
يعيش ويعمل في مشهد، ايران
أحمد موريشيدلو ٥-٧

ولدت في عام ١٨٩١ في طهران، ايران
يعيش ويعمل في أمستردام، هولندا
طلا مدني ١٣-١٨

ولد في عام ١٩٦٥ في طهران، ايران
يعيش ويعمل في طهران، ايران
فرشاد لباف ٢٢

ولدت في عام ١٩٧١ في طهران، ايران
تعيش وتعمل في نيويورك، الولايات المتحدة
لالة خورسيان ٤٣-٤٢

ولد في عام ١٩٦٤ في لبنان
يعيش ويعمل في دبي، الامارات العربية المتحدة
جفر خالدي ٥٠-٨٢

ولد في عام ١٨٩١ في بغداد، العراق
يعيش ويعمل في اريزونا، الولايات المتحدة
هيف قهومان ٢٤-٩٢

ولد في عام ١٩٧٩ في الخليل، فلسطين
يعيش ويعمل بين رام الله ولندن
وفا حوراني ٨-٩

ولد في عام ١٩٦٣ في القاهرة، مصر
يعيش ويعمل في القاهرة، مصر
خالد حافظ ٤٤

حتى خريطة.

يقدمون فوتوغرافية "الحقيقة" التي نراه في أقوائه. وهو يقدمون نراه في أقوائه وهو الطبيعة المزدلفة التاريخ والشكل نجاح القادتل ممن على شكل ورثقة أو

أخذت الخريطة هذا الشكل من الذي رسمها هنا نرى الطبيعة القوطوصورية للنشر ندمات الشرقية أو العربية للنشر ندمات أو المسلكة المسلحة

مروان رشماوي شاره خارجة من الأسود، وقد نحت خارجات من مناطق بيروت الستين. كيف أخذت الخريطة هذا الشكل

رشماوي الإهتمام المستمر تمكن أعمال

في بيروت بمعالجات بسبب تركيبته الحالية ونرى الإهمال الفني الذي شيئ على خلفية التاريخ المضطرب للبلاد. ونرى مرحلية بيروت بسبب

وبالرغم من أن المعالجات الجيوسياسية ليست سمة ظاهرة في كل الإهمال الفني الشرق الأوسطية – فيخص القائنين الذين نكر ناهم هنا يرخضون فقط بالتخريب، والمضي الآخر لكونهم نوائا في الأحصل كتقطة أضافة إلى أحد ثنيات كقطة إلى التاريخ وطبيعته التطورية للبلاد. ونرى المضطرب الفنى

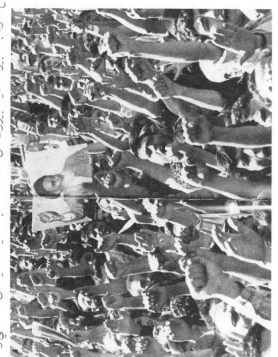

وبيود بنا ذلك إلى معرضنا الحالي "بدون نقاب"، والذي يحمل معه مواجهتنا على القوى في النقاب الذي يربطه المرء بشكل تلقائي بغنه المنطقة من العالم، وهو الأمر من ذلك، أنه الطقس الذي أصبح رمزا للاختلاف. ونتشير هنا المعروفة ألمحرر، خطورة التحرير بجميع أشكالها، غموضه الرمز.

وبالرغم من أن المعالجات الجيوسياسية ليست سمة ظاهرة في كل الإهمال الفني الشرق الأوسطية – فيخص القائنين الذين نكر ناهم هنا يرخضون فقط بالتخريب، والمضي الآخر لكونهم نوائا في الأحصل كتقطة إضافة إلى أحد ثنيات نستنشف ربي في هذه الإضافة إلى أحد أهم الإضافات إلى المعارض الفني التي

ويطرح الفنان الجزائري قادر عطية عمله بشكل سري أسئلة تتعلق بالتقاليد والتكاليف. ومن خلال ١٠٠ عمل فني مغطى وتغولب – من ورق الإلمنيوم – يلمح الفنان إلى القوالب التقليدية التي نجد فيها أنفسنا في بعض الأحيان ...سواء كانت دينية أو تتعلق بالنزعة الإستهلاكية رمزا "القصص التاريخ الكبرى" وبالرغم من هذا الأشكال أو غير ذلك، الذي ظل طويلا موضوع الإشكال ذات مبادرات مستقلة مثل جالبري تاوفياوس في الأردن، منصات عمل وأخلاقي لجيل جديد من القائنين وسوف نستشف أبوظبي خلال خص سنوات من خلال خص بمعالجات تحمل مزدهرا من المعارض الفني التي

وليست هذه البداية. حيث نقوم فنانون من الشرق الأوسط اليوم بتحطيم الأفكار السلبية النمطية جميعا على إعادة التفكير بينا الجزء من العالم ويرغضوننا حاليا موضوع الكلينيوس الطقس بعض حاليبري تاوفياوس في القاهرة ومعرض أشكال خلال خص سنوات، بينما نستنشف الموارد الثقافية تحمل مزدهرا من المعارض الفني التي

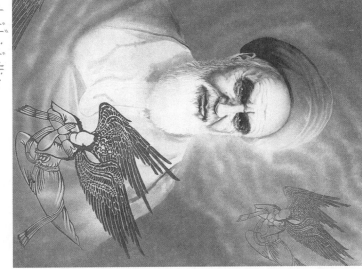

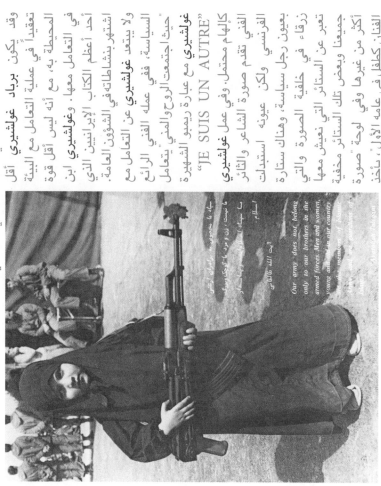

"JE SUIS UN AUTRE"

Our army does not belong only to our brothers in the armed forces. Men and women, young and old, in our country...

Saatchi Gallery

Booth-Clibborn Editions

بدون عنوان

فنّ جديد من الشرق الأوسط

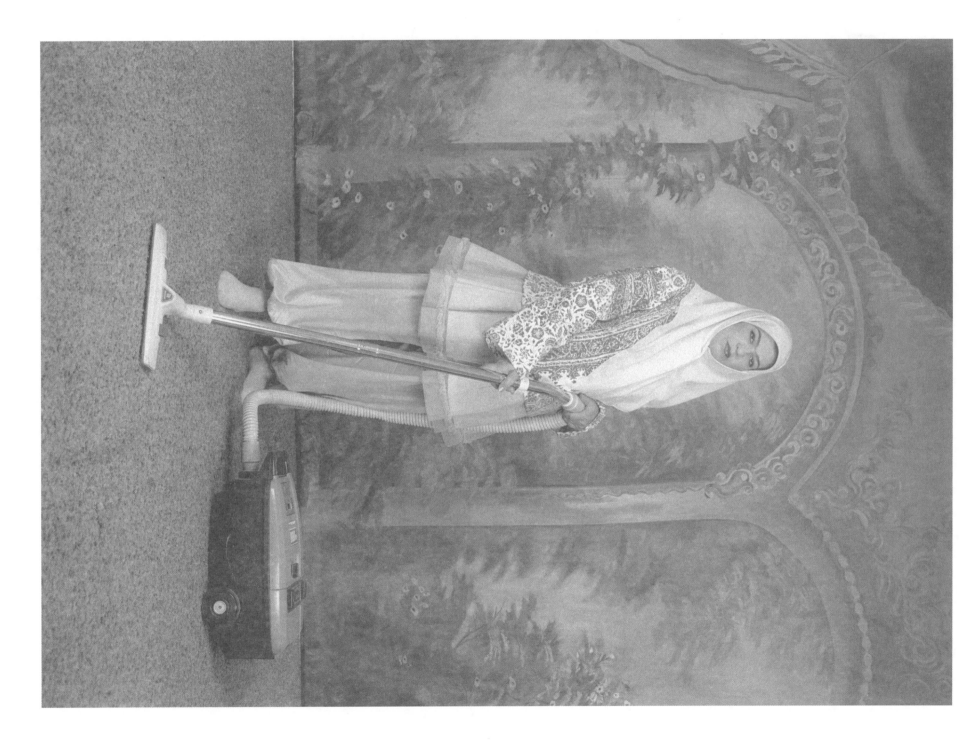

Shadi Ghadirian
Untitled from the Ghajar Series
1998–1999
C-print
203 × 152cm

قلاب شيري غديريان
بدون عنوان من سلسلة القجر
١٩٩٨–١٩٩٩
مطبوعة سي
٢٠٣ × ١٥٢ سم

نور قلبی